Ordinary Miracles

Grace Wynne-Jones

Published by Accent Press 2007

ISBN 1905170645/9781905170647

Printed and bound in the UK

Cover design by Joëlle Brindley

The publisher acknowledges the financial support of the Welsh
Books Council

Dedicated to the luminous memories
of my parents and dear brother, Vere

PRAISE FOR ORDINARY MIRACLES

'Ordinary Miracles has that rare combination of depth, honesty and wit…and all of this backed by a deliciously soft, gentle and loving humour…If you try one new author, try Grace Wynne-Jones.' - OK MAGAZINE

'Ordinary Miracles is about relationships and love and sex and a little bit of guilt. Jasmine is a worried and witty heroine…an engagingly high-spirited and perceptive debut.' - THE IRISH INDEPENDENT

'Wynne-Jones's sense of humour and the self-mockery of her heroine makes it both funny and touching.' - TIMES LITERARY SUPPLEMENT

'The belly-laugh being a rare enough commodity on this planet, this promises to be one of my favourite novels of the year…very very funny.' - In Dublin

'Grace Wynne-Jones writes up a storm of wit in her first novel…a fine new writer.' - RTE GUIDE

'She has an assured style and a wonderful insight into the separated lady's lot…I couldn't put it down. I literally read it from cover to cover.' Muriel Bolger, 'No Jacket Required' RTE RADIO ONE

Acknowledgements

A very big "Thank You" is due to Lisa Eveleigh of the Lisa Eveleigh Literary Agency for being such a supportive, insightful and talented agent. Heartfelt thanks also go to Hazel Cushion of the wonderful Accent Press for her savvy, encouragement and dedication. I am also extremely grateful to Joëlle Brindley for the wonderful jacket artwork. Warm thanks are also due to Marian Keyes, Katie Fforde and Catherine Alliott for enjoying the book and saying nice things about it!

Many others have also helped along the way in one way or another: Kate, who was so encouraging and kind, Aidan Mathews, who has helped me a great deal with my writing, Dermot Bolger, Ray Lynott, Philip Casey, who has not only provided much support but also designed my website, Jo Frank, Clare Ledingham, Karina Casey, Joe Keveny, Nicola Warwick, Alberto Villoldo, Eve Dolphin, Maura Clesham, John Cantwell, Karen Ward, Anne Regan, Michael Dalton, Noirin Callanan, Colin Morrison, Suzanne Power, Margrit Cruickshank, Janetta Mellet, Eunice Borland, Anna Lee, Bernadette O'Sullivan, Margaret Burns, Margaret Madden, John and Eleanor Casey, Jo Nolan, Carmen Cullen, Puddy, Stanley Warren, Maura Egan, Angela Corbett, Aideen Quigley, my four brothers, who got such a kick out of their 'little sister's' first novel being published, my dear and special Mum and Dad who encouraged me so much with my writing when they were alive, the very wise Paddy McMahon, plus the many other pals who offered me much kindness and encouragement.

And of course I must mention the character 'Jasmine' herself and our mutual 'friends' who gave such help and guidance in their own way, and who seemed so keen to have this story told.

'To be young, really young,
takes a very long time.' Picasso

Chapter 1

I CAN'T BELIEVE I'LL be forty next month.

Forty seems something you should be ready for – not something that lands smug and like-it-or not in your life – along with Gillian McKeith.

Bruce bought me one of her books to boost my morale. It's not the kind of publication I would have purchased myself. I tend towards books with embarrassing titles such as *No Need to Panic: Courageous Acts of Change in Women's Lives.* Still, it was a kind thought. One of the occasional small acts that show Bruce may still love me in his way, though there isn't much romance left in our relationship. 'You know what, Jasmine,' he announced happily on our nineteenth anniversary, 'one of the great pleasures of marriage is being with someone you can fart with.'

When he came he used to shout 'Oh God!' These days he just says 'Ah'. He scarcely glances at me when I'm in the shower. When we first got married he used to love the way I squeezed spermicide around the inside of my diaphragm. I did it with such fierce concentration, he said, that I looked like I was making an airfix model. Now he likes watching me watch television. He says I make funny faces without knowing it.

I like that he likes that. And I like that he thinks he can sing when he can't. But like doesn't make my heart leap. Like isn't what that woman felt when that photographer from the *National Geographic* landed on her doorstep in Madison County. Of course it's nice to day-dream that exactly the same thing might happen here in Glenageary

but, frankly, there aren't enough bridges. There are lots of burned ones all right, but you can't photograph those.

Now that my daughter Katie's at college in Galway the mornings seem very quiet. I miss that moment when, having got her off to school, I made myself a cuppa and turned on the radio. Back then time to myself was something I snatched and savoured – now there's a lot of it about and I must work out what to do with it.

Of course I have my animal rights and adult literacy, and then there's the housekeeping and fantasising about the actor Mell Nichols. And there's missing people – missing myself even – that takes up a lot of time.

Sometimes, when I feel like this, I go upstairs and open the cupboard where I keep Katie's toys. I gave some away but I've kept the ones I liked. I wind up the little hen and watch her pecking her way along the carpet and falling over, and then I give Teddy a hug and tell him not to be lonely, that I still care.

You wouldn't think to look at me that all this stuff is going on in my head. Apparently I appear very settled and cheerful – not at all wistful. The thing is I don't think I can keep all this to myself much longer.

I think it may start leaking out.

It's time for my morning cuppa. I plug in the kettle and turn on the radio, where a woman is talking about how her husband urinates in the bath. Then the news comes on and I remember I'm supposed to be meeting Susan and Anne at eleven. I wonder if I should change out of my jeans, but I don't have time.

I haven't seen Susan in years. She's been a nurse in Africa. She's been leading the kind of adventurous, wandering life I said I was going to lead too. I really, really, don't want to see her.

'Hello Susan – great to see you!' I say as Susan opens the door of her Ballsbridge garden flat. She's looking wonderful. She's wearing jeans. She hasn't changed her hair, but then she has no need to. It's dark and luxuriant. She puts it up in a chignon from which tendrils and curls escape to frame her pretty, thoughtful face.

'Great to see you too!' she exclaims, and gives me a hug. 'Anne's already here.' I wave a greeting to Anne who's sitting on a calico sofa surrounded by handwoven Persian-type cushions. She's perched there like a bewildered sparrow who's found its way into a tropical garden.

Susan, Anne and I went to school together. After she qualified as a nurse Susan went travelling but sent letters, and of course Anne and I attended each other's weddings. Then we went our separate ways.

And now Susan has organised a reunion, because that's the kind of person she is. And while I know it might be therapeutic and cheering to relive the day we all skived off school and went to see *Gone With the Wind* in seats so close to the screen we could almost feel Rhett Butler's breath – the first thing that comes to my mind as I sit down beside Anne on the calico sofa is the man who urinates in the bath.

'Were either of you listening to the radio this morning?' I say as I look around the sun-filled room which is uncluttered and spacious and painted a colour I didn't know existed let alone would work. A room full of African artefacts and unexpected little touches. 'Because this woman was on about her husband.'

'Do you mean the one who's having an affair with his chiropodist?' asks Anne.

'No, the one who urinates in the bath when he's drunk.'

3

'Oh yes – because it's easier to aim at.' Anne laughs in a hollow sort of way.

And before you know it we're not talking about all the exciting things Susan has done in Africa, or how I got involved with adult literacy and animal rights, or how Anne became a Montessori teacher. No, we're talking about men – their selfishness and emotional tourism. The way they so seldom know where to find the clothes pegs or the clitoris. How they fumble around all right – but you have to tell them in the end.

Anne and I talk about men while Susan, who is single, listens respectfully.

'He keeps saying, "What do you want me to do about it?"' Anne is talking about her husband.

'Typical,' I reply.

'I just want him to listen. To try to understand.'

'Absolutely.'

'I mean emotions aren't like cars are they?'

'No. No.'

'You can't just open up the bonnet and pump in a bit more oil.'

'Exactly.'

Suddenly Susan jumps up from her crushed velvet cushion and says 'Sorry to interrupt but what's it to be – tea or coffee?'

'Tea please,' I say.

'Me too,' says Anne.

I know Susan's been bored from the eager way she heads for the kitchen. And then a funny thing happens. I suddenly realise I've been bored too. Extraordinarily bored in fact. I've been having these conversations about men with women like Anne for years now and they never seem to get anywhere. If I have to say one more thing

4

about men this morning my head's going to grow terribly heavy and land, thud, on the coffee table.

I get up and start to wander round the room. 'As I was saying,' says Anne who's really getting into her stride, 'he never seems to listen.'

I go over to the mantelpiece and pick up an African carving of a woman with huge breasts. 'Ballsbridge is a funny name isn't it?' I say. 'Balls-bridge – I wonder where that came from.'

Then Susan comes back with the tea and we talk about Africa until I blurt, 'I'll be forty next month.' It's been building up inside like alcoholism at an AA meeting.

'My goodness of course! I'm glad you reminded me,' Susan exclaims.

I'd forgotten we'd met when we kept birthday books. When we knew the ages and birthdays of everyone, including hamsters and dogs.

'I must get you a present,' Susan continues.

'Oh, there's no need really.' I'm embarrassed and grateful.

'Of course there is,' says Anne, adding, 'you know something Jasmine, you haven't changed a bit.'

This being the kind of stupid thing friends sometimes say to each other I smile and finger my Turkish puzzle ring. Then Susan says casually, 'Oh, by the way, I read that Mell Nichols is doing a film here.'

'Mell Nichols is here – here in Ireland?' I almost spill my tea.

'Yes – he's filming in County Wicklow, only it's supposed to be Yorkshire.' Susan has always been a stickler for detail. 'He's playing a farmer who falls in love with the local postmistress – that's Meryl Streep – only she disappears in mysterious circumstances. You've always had a soft spot for Mell, haven't you Jasmine?'

'Well – yes – I do think he's rather attractive,' I mumble, wondering if this is the moment to reveal that my soft spot has somehow turned into hard, burning passion. That in recent years Mell and I have spent sweat-soaked nights feverishly exchanging bodily juices and soul-filled intimacies. That the only small stumbling block to our perfect relationship is that Mell doesn't know anything about it.

'I never really got over Clark Gable' – Anne is twisting her wedding ring dreamily, 'I'll never forget that day we all went to see *Gone With the Wind.* Never.'

And then, because it's sunny, we all go into the garden which is gratifyingly messy but bears the first traces of care. There are small clumps of begonias and climbing nasturtiums. 'I probably won't stay here long but it's nice to brighten it up a bit,' says Susan.

And I know wherever Susan goes she'll brighten things up a bit because that's her way. And maybe she could brighten me up a bit too, if I could stop myself wondering where I went wrong and she went right. If I could face the mess and mystery of my own life – see that even weeds can bear small flowers as they sprout through crazy paving.

Chapter 2

AFTER LEAVING SUSAN'S I wander round Ballsbridge for a bit and think about Mell Nichols. The fact that we are actually in the same country at the same time has certainly increased the intimacy of our relationship. But it's somehow added to its poignancy too. Because when I'm not swooning in his arms knowing he'll love me for ever I know something else entirely. I know I am a lonely middle-aged woman who he wouldn't even look at. I know that even though he is on the same planet and in the same country, we will probably never even meet.

But I'm not going to let myself dwell on this escapist nonsense any longer. It's a waste of time and time is precious because one day we're all going to die. It's important to remember that and it's surprisingly easy not to. So now I'm trudging down Pembroke Road and looking at people's doors and doorbells and the windows with lined curtains and the dirty ones without lined curtains that are most likely rented. I'm trying to live in the moment – to be aware of each green leaf and footstep – but my mind keeps going back to Anne's remark about my not having changed.

While preposterous on one level, it seems to me to have a certain ring of truth about it. To be pedantic, while change has inevitably occurred, further change seems urgently called for. I can't keep drifting like this. I need to make some decisions. I'm glad I don't pass a hairdresser's because I would almost certainly go in and attempt to entirely change my persona.

My hair was styled in the 'Gypsy Look' when I met Bruce – a look that included long flouncy skirts and embroidered boleros. Bruce thought I was wonderful.

'What I like about you, Jasmine,' he used to say, 'is that you're so natural.' There was just one teensy-weensy problem, he said. I couldn't co-ordinate my colours. I got my pastels mixed up with my primaries and wore too many shades at once. This was sending out confused messages when I was not, in fact, a confused woman. Bruce is in television so he's a visual sort of person.

I married him in cream. I'd been to a colour consultant who told me winter people can wear white and black but, as a summer person, they would drag me down. As it happened my father had to virtually drag me down the aisle anyway as I was having second thoughts – I was only twenty. I kept pausing to admire the flowers at the end of each pew, and smile at friends in their wedding best, but actually I was hoping my crazed past boyfriend Cyril would lurch drunkenly over the choir balcony and screech that I was a great screw and his for ever. In the ensuing uproar I would have fled and found my way to a monastery or ashram and pledged my life to Jesus, or Buddha, or whoever was running that particular establishment.

It's an option I still keep open.

It's beginning to drizzle as I take out my mobile and call Charlie about next Monday's march. 'I don't want to be in charge of the pig,' I tell him.

'She's called Rosie.'

'I know she's called Rosie and I'm not leading her down O'Connell Street.'

'Okay.'

'I just wanted to get that straight, Charlie.'

'Well you have.'

Then I hang up and since the rain is now bucketing down, I go into Jurys hotel where I mingle with American tourists. I don't say anything. I just stand near them in the

shop listening to them bellow about Belleek china and Aran sweaters and pretend I'm in California.

I have actually been to California. Susan and I went there one summer when we were students. We worked in a café that had a big grand piano in it and lots of books. The café was in the hippy Haight-Ashbury district of San Francisco. We worked like dogs but we felt like cats – feline and free. That's where we met the man we earmarked to take our virginity.

Doug lived in a geodesic dome in Mill Valley. The road to his dome was up a steep hill. There was a sheer drop on each side. 'Leave everything behind – let go' was tacked to a tree at the bottom, and when you got to the top there was another notice that said 'And that too'.

And I suppose that's what we did for a while – the days melted dreamily into one another like the big globs of mozzarella on our Big Sur sandwich specials.

Doug didn't take our virginity because it turned out he was gay. This was just as well because being sexually inexperienced we'd thought we could share him. So we longed and listened to him instead and off-loaded our purity elsewhere.

One night, when we were sitting on the hill overlooking the redwoods, Doug told us about taking LSD. He said it was like getting lots of information at once but so fast it didn't quite make sense. He knew it was important but he'd taken the shortcut and maybe you needed the long way round to get the whole message.

And then he said that some people, and he felt sure Susan and I were among them, could look at, say, a table, without taking LSD, and see that it was just a mass of moving molecules. He felt sure that if we sat and stared at it for long enough we would eventually see all the little molecules just

whizzing around and know that everything, and everybody, is just energy in the end.

The silence was so strong on the hill that night you could hear it. We looked up at the huge inky sky above us and all the little golden stars and thought what an incredibly amazing, magical place the universe was.

The next day we flew home to discover the Irish nation had spent the summer discussing who should be allowed to sell condoms.

During these reminiscences I have moved to the reception area of Jurys hotel. It's still raining outside and I'm sitting on a sofa. I'm having a quick gin and tonic and a sandwich before I go to the supermarket and wondering if life will ever feel magical again.

I'm also wondering who first decided to associate ice cream with sex and whether I'll get away with a large tub of chocolate chip and hazelnut for dessert – some of Bruce's colleagues are coming round to dinner. I really really wish they weren't.

Then I look up.

I look up and I look straight into the eyes of the man I have craved hopelessly – passionately – for the past ten years. He looks at me in a bored sort of way, then turns back towards the reception desk.

Chapter 3

I'M A RATHER NERVOUS hostess. Even after months of having Bruce's production colleagues and actors round to dinner I have still not learned how to talk about the Algarve and not burn the stuffed tomatoes. I have still not learned how, for example, to listen to Cait Carmody drone on about how her brassière burst during a particularly poignant scene at the Abbey without jumping up in the middle crying 'Oh my God the olives!'

Of course what Cait and Bruce and the rest of them are not to know is that while they are relaxing from, though probably still discussing, things Thespian, I, with no dramatic training, have been flung onto centre stage. It's bad enough trying to get props, such as olives or fettucine carbonara in place, I have to get the lines right too. And so much relies on improvisation.

Before Bruce left 'national broadcasting' he did most of his entertaining in restaurants. But now he's formed his own production company he's had to tighten his belt and do some entertaining at home. In a way I'm glad he's left national broadcasting because I was getting tired of his tirades about the place. His descriptions of a day there sounded like something out of *I Claudius*.

When I told him this he said *I Claudius* was precisely the sort of quality drama he could have created if his former employers had had any guts and vision. When he starts talking like this a sort of weary look comes over his face because I know, at heart, he doesn't think I will ever truly comprehend the entire complex saga.

National broadcasting were so sorry to see Bruce go they gave him quite a lot of money. And the speeches at

his farewell were almost euphoric in their appreciation. He was, it seemed, a linchpin in their entire operation. One wondered how they would ever manage without him.

And the funny thing now is national broadcasting are making more drama again. So Bruce is getting very buddy buddy with lots of people he professed to despise. They're really being rather nice to him and it looks like they may fund his independent film – *Avril: A Woman's Story,* which is set sometime during the Second World War.

As far as I can gather, Avril lives on the west coast of Ireland with her aged uncle and collects rather a lot of seaweed. The seaweed is fertiliser for the farm she's managing single-handedly and one day, on the beach, she meets a man who's on the run from England for espionage, only he's innocent. Avril somehow knows this and he becomes her lover. And then it turns into a thriller that hasn't much to do with Avril at all.

Avril is now the 'Other Woman' in our marriage. Bruce is obsessed with her – what she'd wear – whether she'd take the local bus to town or walk to save the few shillings. I can't help wishing he'd just once shown the same interest in me, and I grow rather tetchy when he asks whether a woman of her young years would wear a headscarf and whether she should lose her virginity in the hayloft or the sand-dunes.

Cait Carmody is going to play Avril and that's why she's coming to dinner, along with Eamon, who's going to play her lover, and Alice, who seems to be doing just about everything else. Alice is the production co-ordinator and enormously efficient. She's been working with Bruce for years. I once asked her why she doesn't produce films herself and she said she couldn't stand all the crap. I've always liked Alice.

So now here we all are sitting round my new distressed pine table. We are eating salad and slightly burned lasagne. As Cait asks me whether the dressing is Paul Newman's or my own, I suddenly realise I haven't put the ice cream in the fridge so I rush into the kitchen and bung it in the freezer. Then I pour myself a gin and tonic because the wine doesn't seem to be calming my nerves. It goes down very quickly and so I have another and pinch myself to make sure I'm not dreaming about what happened in Jurys this afternoon.

When I return some minutes later I'm amazed that I have the presence of mind to explain that the ice cream is going to be a little more mushy than usual.

Naturally everyone says that's just the way they like it and then, as we all start to tuck in, Bruce brings up Avril. He's wondering how Avril can get food to her lover without her uncle suspecting.

'Surely he can just go to the shop and buy some,' I say with a vehemence that makes me aware of how much I've drunk.

'Of course he can't, Jasmine,' Bruce says patiently. 'He's living in a hayloft. Agents are looking for him everywhere.'

'Seaweed's quite nourishing.' I'm smiling now.

'Oh, really!' Bruce drinks the last dregs of his ice cream wearily and asks Alice if she's made arrangements for the location recces next week. Then he gives Cait a long, knowing look – one of many he's been giving her all evening. He's trying to shut me up – shut me out. But I'm not having it.

'It seems to me,' I begin, slurring my words slightly, 'it seems to me that Avril has such a sod-awful life she should start worrying less about these – these men and more

13

about herself. It seems to me she should move to Dublin and start – start a massage course or something.'

'A massage course?' Alice is intrigued.

'Yes – a massage course,' I say. 'A friend of mine, I can't quite remember who now – she – she did a massage course. Aromatherapy. None of that sex parlour stuff. She has her own house now. Hey – I've got a new tide for you – *Avril: The Aromatherapist!*'

Then I collapse into giggles and knock over my wine and Bruce goes off to the kitchen to get the coffee and a cloth. Cait follows him in 'to help' and we hear whispers followed by the clatter of crockery and giggles and then silence which goes on for some time.

'How's Katie?' Alice asks rather too cheerfully.

'Oh, she's fine, I hope,' I reply. 'She's in her first year in Galway studying anthropology…no, no psychology. I really miss her.'

'And the animal rights – how are they going?' Eamon chips in.

Semi-inebriated as I am, a small shiver has gone up my spine and I am aware that something is happening in the kitchen that I need to be aware of.

'Oh, much as usual.' My tongue suddenly feels very heavy and unwieldy. 'We're marching with a pig down O'Connell Street on Monday. She's called Rosie. She's a lovely pig.'

'I'm sure she is,' says Alice, who's looking uncomfortable.

'A lovely pig,' I repeat. 'Very sensitive – very loyal.'

'How very nice,' says Eamon. 'Ah good – here comes the coffee.' For Bruce is at last returning followed by Cait who has slightly smudged her lipstick while collecting the cloth. The cloth she uses to clean the spilt wine off the

table. She does this very carefully and ostentatiously while the rest of us move to the sofa and armchairs.

I go to my favourite chair in the corner. It's not particularly comfortable but it used to belong to my father. I sit there, as far away from them as I can get, and wish Dad was alive so I could tell him.

Tell him that for one moment in Jurys Hotel this afternoon I looked into the eyes of Mell Nichols.

Tell him that I think my husband may be having an affair with Cait Carmody.

Tell him I miss him and wish I could believe he's still around.

Susan believes he's still around. Susan believes in Guardian Angels too. She says we all have someone watching over us all the time.

I get up. 'Excuse me for a moment,' I say, going into the kitchen. 'I'm just going to get my Hermesetas.'

But I don't. I go out the back door into the garden where I look up at the huge inky sky above me and search for the little golden stars.

I search and search – but the night is cloudy and I can't see them.

Chapter 4

'LOOK, I TOLD YOU I don't want to be in charge of the pig.'

'I know. I know. I'll be back in a minute. I'm just going for a pee,' says Charlie, leaving me under Clerys' clock with Susan and Rosie, who is grunting excitedly and straining at the leash.

Susan's come along because she rang me up this morning saying she was lonely. She's been away so long she doesn't know many people here any more and wanted company. Still, I doubt marching down O'Connell Street with a pig was quite what she had in mind.

'He's quite dishy, isn't he?' Susan is munching a Yorkie bar and eyeing the lingerie in Clerys' window.

'Who?' I ask.

'Charlie – he's quite handsome.'

'I dunno, I suppose he is in a hippy sort of way.' I sigh. 'Look ,Susan, I know I roped you in at the last moment but I need some help here.'

'What do you want me to do?'

'Help me hold on to this pig for one thing – she's incredibly strong.'

'My God she really is,' says Susan as we both try to prevent Rosie from darting across the road. Her nose is quivering in the direction of Moore Street market.

'She smells the fruit.' I'm panicking a bit now. 'If she makes up her mind to go I'm not sure we can stop her.'

'I know what I'll do. I'll sit on her,' announces Susan who's always been a woman of action.

'Don't sit down too hard.'

'No – no – I'll just sort of straddle her and hold on.'

16

'Good idea.'

Rosie is squealing with frustration now and we've got a small audience. They're gawping at us and some are laughing.

'Giddap there horsey,' a man calls out.

'Hello piggy piggy,' says a toddler who is herself on a leash and being dragged away by her mother.

'Is this a bacon promotion?' asks a woman in a headscarf. 'Because if it is I'd like a coupon.'

'No, this isn't a bacon promotion. This is a demonstration against factory farming,' I reply grimly as Rosie's trotters slither and dance with impatience.

'Is this something to do with the Orwell adaptation at the Abbey?' asks a young man with a ponytail who's just joined us.

I'm about to explain again when I see Charlie. He's talking on his mobile across the street. He's frowning.

'Well this is a fine time to make phone calls,' I snap as he returns and Rosie gazes up at him adoringly. She starts snuffling at his pockets and he produces a carrot which she munches happily, thoughts of escape now obviously postponed.

'And where's everybody else? I thought there were going to be at least twenty people,' I continue irritably. 'Someone was going to bring placards, weren't they? Where are they?'

Now that Rosie has calmed down the small crowd has begun to drift away.

'Sorry, folks.' Charlie gives Susan and me a wry smile. 'There's been a mix-up. Sarah thought the march had been moved to next Monday so that's what she said when she phoned round. I should have phoned her myself to confirm things. We'd best call it a day and go back to the van.'

'But I can't understand it.' I'm almost bursting with indignation. 'I specifically phoned Sarah myself to confirm that

the march would start at 11 a.m. – under Clerys' clock – on Monday, the 17th.'

Charlie and Susan look at each other.

'I did,' I insist. 'I really did.'

'This isn't Monday the 17th,' Susan breaks the news gently.

'What?'

'This is Monday, the 10th.' Charlie looks me straight in the eyes so I can tell he isn't lying.

'It can't be. I checked my diary.'

Charlie will not be swayed. 'You must have been looking at the wrong page.' Charlie's trying to look solemn, but I know he wants to laugh.

'Oh my God, what a mess!' I moan. 'This isn't funny Charlie!' I glare at him indignantly.

'I never said it was.'

'I know, but your eyes are smirking. Don't tell me they're not, 'cos they are.'

'When you two have finished, can we get out of here?' Susan pleads. Rosie is getting restive again.

'Oh bugger it anyway!' I moan.

'Oh shit!' exclaims Susan, because Rosie has just crapped on the pavement and she's been splattered.

'That's the word for it all right,' says Charlie, grimly pulling Rosie towards the van.

In the van I burst into tears. 'Now, now,' says Susan. 'I often mix up dates myself. We'll just come back next Monday – my new job doesn't start for a while, so I'll be free.'

'My life's a mess. I don't even know what day it is.' I'm weaving a soggy Kleenex round my fingers. 'They should fatten me up and sell me as Pedigree Chum.'

'What sort of talk is this? I thought we were supposed to be against factory farming,' says Charlie who's exchanging concerned, puzzled glances with Susan as he manoeuvres

Rosie into the back. She's snorting with excitement at the prospect of a drive.

'At least battery hens produce eggs!' I wail. 'At least they do something useful.'

'And in completely inhumane conditions,' says Charlie, who has written numerous articles on the subject. 'Free range is much more You, Jasmine. Really.' He's trying to cheer me up. It usually works – but not today.

'You're not taking me seriously!' I wail hysterically.

'Yes, I am.' Charlie sounds a bit exasperated now. 'But you really are over-reacting. It's only a march, Jasmine. We can come back next week.'

'I'm nearly forty and what do I have to show for my life? Nothing!' The words are coming out between sobs and I can't seem to stop them. Charlie stares at me thoughtfully and then looks at Susan. She takes the cue.

'Now, now,' she soothes.

'It's all right for you.' I look at her tetchily. 'Your life is straight out of the Rose of Tralee.'

Susan decides not to be offended. 'Now, now, Jasmine,' she says. 'What about the poor little animals you've been helping? What about adult literacy? What about Katie – not to mention your marriage?'

'Yes, it's best not to mention my marriage.' I've stopped sobbing and am looking at a man who's selling brightly coloured scarves from a pavement stall. The kind of scarves Katie sometimes ties round her hair.

'And why is that?' asks Charlie, who's now seated.

'Because' – I pause for dramatic effect – 'because my husband's having an affair with Cait Carmody.'

'Do you mean the actress?' asks Susan.

'Yes, yes – her.'

'Ah, so this is what it's all about,' sighs Charlie. 'I think this calls for a cuppa at my place.'

'Yes,' agrees Susan. 'But let me buy some Bewley's cherry buns first.'

Charlie's house is a bit past Bray and is big and messy, rather like himself. It's in good repair because Charlie is a practical sort, but apart from the expensive hi-fi system by the large sitting-room window, it's pretty bohemian. There are lots of large cushions around the place, but they are not plumped up. There are lots of posters too, but they're not framed. If Charlie had to leave this place with one suitcase he could do so because Charlie knows what he loves. The rest of the stuff would go back to the charity shops and second-hand stores where it came from, apart from the hi-fi system which he'd probably sell, and his tapes and CDs which he'd take with him.

Most of the music Charlie plays is afficionado stuff – lots of jazz by people with weird names. He will grudgingly admit to having once had a crush on that blond woman from Abba – Ag something or another. He still occasionally puts on 'Dancing Queen' to cheer himself up.

Charlie's a freelance recording engineer. He's forty-seven and is, as Susan said, quite handsome, only I've known him so long I don't really notice it. He's tall and rangy and has thick brown hair that covers his ears but doesn't reach his shoulders. I suppose his outstanding feature is his eyes. They're blue and very intense.

I met him through animal rights five years ago and, frankly, I think he's the reason I'm still involved in it. I'm not as passionate about it as he is. I care, but that's not quite the same thing.

Charlie's solid, kind and fun to be around. When we're photocopying fliers, or gumming down envelopes, we get to talking about all sorts of things. We're not in the least bit romantically interested in each other, which really helps.

'You can have camomile, rosehip, fennel, mango and peach or just plain tea,' Charlie calls out from the kitchen.

'Just plain tea please,' Susan and I answer loudly.

'Gosh, he's into aromatherapy too,' says Susan, who's looking at the burner on the mantelpiece. 'I thought I smelt something when I came in.'

'Ylang-ylang with a drop of geranium,' Charlie calls out.

'And what does that do?' she asks.

'It's uplifting and balancing.'

Susan looks at the incense holder and the postcard of Buddha. 'Are you a Buddhist?' she asks going into the kitchen to help him bring out the tray.

'Sort of,' says Charlie.

'The same as me,' Susan smiles.

Once everyone is seated I get a grilling. I'm feeling very sheepish because I haven't had an outburst like this in years. Quiet desperation is more my sort of thing.

'How do you know Bruce is having an affair?' asks Susan.

'Because he kept giving her funny looks at dinner – and they were kissing in the kitchen.'

'Did you see them?' asks Charlie.

'No, but Cait's lipstick was smudged when she came back with the cloth.'

'The cloth – what cloth?' asks Susan. And then I have to go into detail.

'So you're not absolutely sure?' says Charlie after two fennel teas, four oatmeal cookies and a Bewley's bun.

'No – I suppose I'm not – it's just a feeling.' I'm looking out the window into the rambling garden where Rosie is snuffling around her large fenced pen. 'I'm sorry to have made such a fuss, but I do feel better,' I add. 'It's been sort of building up inside. It's not just Bruce, it's other things too.'

'What other things?' asks Susan. 'Go on Jasmine, you know you can tell us.'

'Well, I'm not sure I can really,' I say pulling at a tassel on one of Charlie's Indian cushions. 'A lot of it's hard to put into words.'

'Go on,' says Susan whose persistence earned her every Girl Guide badge known to man. 'Just give us some examples.'

And then, because truth along with ylang-ylang, geranium and now pine incense pervade the room, I tell them about Mell Nichols.

'So you see it's all rather pathetic really.' I laugh feebly when I've given them the details about my ten-year passion, apart from the fantasies about wild sex in stalled lifts. 'I looked into his eyes for just a moment, and then he turned back to the reception desk in a bored sort of way. That was the extent of it.'

'So you now realise you and Mell may never be an item.' Charlie is smiling at me kindly.

'I always knew that but I wish it hadn't been rubbed in.' I'm smiling a bit myself now.

'Everyone has fantasies, Jasmine.' Susan is leaning forward earnestly. 'I, for example, keep having these incredibly vivid dreams about Daniel Day-Lewis.'

'Really?' This is cheering news.

'Yes. I find myself with him in this huge country house and I'm sure he's going to seduce me, only it turns out he thinks I'm there to French polish the mahogany dining table.'

'The mahogany dining table...' repeats Charlie, eyebrows raised.

'Yes. It's not very satisfactory.'

'I'm tired of dreaming.' I'm stroking Charlie's cat, Satchmo. 'I'm tired of having to drift off into some place in

my head every time I want to feel happy – every time I want to feel loved. It just doesn't seem right somehow.'

Charlie pats my arm as he gets up and goes to the window. He stands there, shoulders squared. 'She's my role model' – he's pointing to the garden.

'Who?' Susan asks.

'Rosie.'

'Come off it, Charlie.' I go over and stand beside him. Rosie's scratching her right buttock against the fence – a look of deep contentment on her face.

'See what I mean?' Charlie smiles. 'No inner angst there. Rosie just goes with the flow, and she's never even been into Waterstones.' He's teasing me about all my self-improving books.

As he turns towards me he knocks over his saxophone which has been propped up by the curtain. He picks it up to put it somewhere else, only Susan says, 'I didn't know you were a musician.'

'He was in a jazz band for years – weren't you Charlie?' I say. 'Go on – give us a tune.'

After fiddling about a bit, Charlie raises the saxophone to his lips. And when the notes come out they fill the big sunbeamed room with a bruised kind of happiness and a sweet kind of sorrow.

'That's lovely, Charlie,' I say as he looks over. 'It really is.'

I glance at Susan, who's looking at Charlie in a way I've never seen her looking at anyone before.

Then I gaze out the window at Rosie, who pauses from her scratching to look at him with a similar intensity.

Chapter 5

'HUH – HULLO – IS THAT – that you, Jasmine?'

Bruce is on the phone. From the rasping, broken noises he's making I can tell he's given up on words and is trying sound effects. He wants me to know that he's in agony and I must return. He also wants to know how to make shepherd's pie. He asks me this, I presume, to let me know that if I don't return soon he will learn how to live without me. That he's taking methodical steps in this direction and may soon even know how to put on the duvet cover alone.

'How much mince do you need for two?' he demands after I've wearily given him the instructions.

'I dunno – two pounds I guess – and make sure it's premium. The other can be fatty.'

'I'm having Eamon round, that's all.'

'How nice.'

Bruce pauses for a moment to prepare his party piece.

'Everyone's talking.'

'About what?'

'About you moving in with Charlie.'

'It's not like that. He offered me a place to stay, that's all.'

'But you don't need a place to stay, Jasmine – you have your own home – here – with me.'

'And Cait Carmody.'

'Oh, come on, Jasmine – that's all over now.'

'Have you any idea what it felt like – finding her fake diamond hair grip in our bed?'

'I know. I'm sorry.'

'There I was, off at my adult literacy conference hoping you were managing alone, and…'

'Jasmine – we need to talk.'

'No we don't.'

'Of course we do. Katie's very upset.'

'No she isn't. Not very. I spoke with her yesterday.'

'Oh.'

'Look Bruce, I'm taking a break, okay? Other people take holidays from work – well, I'm taking a holiday from my marriage. I may come back or I may not. Now fuck off and leave me alone for a while.'

Then I slam down the phone.

A rather nice recent development is that I've become quite rude. Up until now other people's rudeness always seemed like something I had to deflect, not counter. I used to think this was because I am a mild, sensitive person who desperately seeks approval. Now I see that anger spits and crackles inside me like a venomous volcano and could engulf entire continents.

Deep down I must have always known it was there. After all I regularly practised the art of telephone invective during my years as a purchaser of household goods – fulminating about flexes and fibres – berating anonymous individuals about the indecipherability of manuals and delayed deliveries. And now Bruce is getting a long overdue blast.

At least it's good that he's acting contrite because, in my experience, guilt turns some people nasty. My first great love, Jamie, for example, was a total sod after he dumped me. The whole thing almost made me jump under a train at the time and now I can hardly remember what he looked like.

Though I feel angry and hurt with Bruce I don't think I could summon enough outrage to cut the sleeves off all

his suits or pour paint over his new Volvo. Of course newspaper exclusives and chat shows might be quite lucrative but a career as a distraught wife, though in some ways satisfying, isn't quite what I'm after.

The thing is I don't feel that surprised. Bruce and I have been leading fairly separate lives for quite a while, especially since Katie left for college. And then of course I myself have been having wild sex with Mell Nichols for many years. It's more a dull ache than a sharp pain really – and Charlie's been just great. He listens to me until my jaw aches and makes big log fires I can stare into. I wish he'd go out with Susan. He and Susan would really hit it off.

I still can't believe I actually did it – actually got up and left Bruce and my home.

It's my home I miss. I long with a passion for my walnut cabinet where I put my most precious things. Katie's first mittens and her tooth fairy teeth are in there. So is the painted stone, and the birthday card she made when she was five. It has a drawing of a cake with candles on the front and says: 'Hapy burtday Mumy from yor dawter Kate.' She was a rather precise child. The card was made with great care. She'd ruled lines in pencil to make the words straight and then tried to rub the lines out, only some of the words got rubbed out too. You can tell which words she had to go over because they're darker and bits of the rubbed out ones still show through.

I also miss my Dad's chair, the teapot I decorated with rosebuds at ceramics class, my special mug, my hot-water bottle and…well…I suppose everything really. I've always had a rather over-developed sense of nostalgia. It's even provoked comment on occasion – most recently from one of Bruce's guests.

'You're obviously a woman of eclectic tastes, Jasmine,' he said.

'Really?' I replied as I tried to remember the difference between eclectic and esoteric and hoped he wasn't going to say something rude about my *boeuf bourguignon*. I'd just cooked him dinner.

We were in the sitting-room and Bruce was in the loo. Since he'd furtively grabbed a copy of the *Radio Times* on his exit, I knew his return was not imminent.

The man then stood up and scanned my bulging bookshelves. 'Bruce says most of these books are yours,' he said. 'From what I can gather, Jasmine, your interests include fly fishing, English porcelain, the hostelling movement, the natural history of the whale, the construction and maintenance of the ketch, bee keeping and art deco – not to mention backpacking in Nepal and the development of the Quaker movement.'

'A lot of those books aren't mine really,' I said. It seemed a shame to disabuse him but I'm usually found out when I lie. 'A lot of those books belonged to people who are gone.'

'Gone? Gone where?'

'Gone. As in passed away. As in released from this mortal coil.'

'Oh, you mean dead?'

'Yes,' I answered, wishing he didn't have to be so blunt about it.

Then Bruce came back and they started to discuss business, while I wondered how to make room for books, and maybe even a life, of my own choosing.

I'm not very good at loss, you see. When my parents, or an aunt or an uncle died, I was the member of the family – there's always one – who was more stricken by the large, loaded, black plastic bags than their coffins.

'No! No! That can't go to charity!' I'd screech, swooping down on *Australian Marsupials: A Field Guide,*

or that ornament of a desert oasis that made a sandstorm when you shook it.

I haven't just confined my nostalgia to books and ornaments. There are piles of other things too, including my parents' best plates, which I used every day. Those plates can even make scrambled eggs a poignant experience.

So, given this weight of memories and mementoes, I'm absolutely amazed that I managed to leave my home with just two large suitcases and two canvas holdalls. Fury does indeed concentrate the mind.

A number of things came together and made me blow my fuse.

I'd decided to give Bruce and Cait's behaviour at the dinner party the benefit of the doubt because Bruce was so vehement in his protestations of innocence. Then he forgot my fortieth birthday. I'm sensitive about my birthday. In some weird, unreasonable way, I feel that if people close to me forget it it's as if they've forgotten I was born. I usually play safe and tip them off in advance, but this year I didn't give Bruce any subtle hints. I decided to put him to the test.

To make up for his oversight, Bruce suggested that we visit Katie in Galway that weekend. We were going to stay in a nice hotel and have candlelit dinners. But then he cancelled this at the last moment because of some problem with *Avril: A Woman's Story;* and he fell fast asleep in bed while I was dolling myself up on Saturday night.

Saturday night was sex night in our house. We occasionally managed it on other nights as well but, frankly, sex between us had grown rather dutiful. There was a touch of the aerobics class about it.

So, you can imagine what I felt like when I found Cait Carmody's fake diamond hair grip in my marriage bed. I was a perfect candidate for Oprah Winfrey.

When Bruce came home that night I tried to bar his entry to the house. I shouted expletives at him through the letter-box; he remained extremely calm and reasonable, as though one of his actors was throwing a slight tantrum. So, after a while I let him in and told him I wanted him to pack up and leave. Only he said that he wouldn't. There were tears in his eyes and when I found myself feeling sorry for him I decided I'd leave instead. Bruce's feelings have always carried considerable weight in our marriage. If I'd stayed any longer I knew I'd end up consoling him because I was heart-broken.

There was a bleak, unreal feeling about the night I left. A strange kind of hush amidst my histrionics, as if it had just snowed. We should have been talking in Swedish, with sub-titles. The only thing that made me hesitate was Katie. I really, really want Katie to have a happy home. But she's a sensitive girl. She'd guess something was up if her mother barricaded herself in the attic. And she's hardly ever home now anyway.

So I phoned Charlie. I could have phoned Susan but she has a flatmate now, so I'd have had to do all my crying in the sitting-room. Charlie's house is big. He often said he should find someone to share it.

At first I found staying at Charlie's place very strange. That only lasted a week or so, and now I've really settled in. I was tempted to start tidying but, thankfully, that feeling also passed. I slop around in old jeans and big borrowed baggy jumpers and avoid answering the phone. I doze a lot and my television viewing includes re-runs of *Pets Win Prizes* and *Baywatch*.

My memory isn't that great at the moment – for practical things anyway. I find I have to write little notes to myself like 'wash hair'. I have, however, become a dab hand at lentil

soup. I leave Charlie, who's a vegetarian, to deal with the tofu burgers. Occasionally we cheat and buy Linda McCartney's vegetarian spaghetti bolognaise. George was my favourite Beatle, but Charlie liked John Lennon.

It's great having a shoulder to cry on, but by this stage Charlie's must be wringing wet. I'm glad he doesn't get alarmed by my sobbing. Bruce just tended to get exasperated.

Sometimes I think I'm like Alice in Wonderland and that my tears are going to flood this place, but Charlie says not to worry. He says that, if necessary, we can use his cousin's canoe which is stored in his garage.

I know it may sound silly, but one of the upsetting things about being older is that I no longer feel attractive when I cry. When I was younger there was more style to my tears. They had a dramatic, almost hopeful feel to them. I felt sure that if some man saw me – probably someone suave and older – he'd want to make me feel better. He'd be moved by the photogenic quality of my despair. He wouldn't have to know me or anything, it would just sort of happen.

'And what would the man do?' asked Charlie, when I told him this.

'I'm not quite sure.' I sniffed into my handkerchief. 'He'd just care and be incredibly protective. He'd say something like "There, there, my dear, don't worry. You're young. You have a lot to learn."'

'He'd probably offer to teach you it too.' Charlie sounded rather cynical about my knight in shining armour. 'Frankly, Jasmine, I think you're better off with me.'

I'm only beginning to realise what a good pal Charlie is. He can even look interested when I'm dredging up the mind-numbingly minute details heart-break seems to require. For example, the fact that a door was half ajar when Bruce said something should not be worthy of comment, but I

mention it anyway. The fact that Bruce then unwrapped a Milky Mint or ran his hands through his hair seems important too.

It's like I'm relating every frame of some weird art-house movie. I've even said things like, 'And then I decided I had to leave him. I didn't take the big brown suitcase because the canvas holdalls were roomy and so much lighter.'

'When I'm leaving a relationship I usually use a fold-up trolley for the heavier items,' Charlie commented, his blue eyes twinkling mischievously.

Being a gentle but firm sort, Charlie doesn't tell me to shut up when he's had enough – maybe after an hour or so. He just offers to make us some tea. He pours mine into the mug he's bought me. It's got a big teddy bear wearing a T-shirt on it. The T-shirt says 'So Where's The Picnic?'

While we're drinking our tea Charlie usually suggests a diversionary tactic, like renting a DVD, or going for a walk. At first I'm a bit pissed off, but after a while I'm relieved. I think Charlie knows this. He only interrupts my monologues when, deep down, I've had enough of them myself.

Sometimes, when we're out walking, Charlie tells me a bit about his own romantic disappointments. It's nice that he knows I need some reciprocal revelations. He doesn't wallow in them like I do though – his are more light-hearted and anecdotal. You can sense he's polished them up over time, and sanded down their sharper contours. He is attractive, so I'm sure he's disappointed quite a few people himself.

Music has been his real passion for a long time now, and of course that's awfully seductive to some women. They start off by loving that passionate, intriguing commitment to something other than themselves. Then, when they can't somehow get at it, they can end up hating it too.

Maybe that's why the woman Charlie almost married was also a musician. They lived together for years – until Rosie arrived.

'It's either that pig or me,' she told him.

He hasn't gone into detail about the ensuing drama, but it's pretty obvious who won out. The pig thing was probably just the tip of the iceberg anyway. They're still friends though. After a frosty patch she took to calling round and pouring her heart out about her new boyfriend. Then she went to live, alone, in Stockholm. Just as well really – it would be a bit much having us both whimpering and wailing on his sofa.

I suppose staying here is a bit like a convalescence, but it would be unfair to Charlie to let it drag on too long. I'm paying him some rent, but not enough. I'm using the money Bruce and I put aside for a conservatory.

I think I'll try to get some temporary secretarial work. In fact I've been practising my word-processing on Charlie's computer, but typing a short letter still feels like flying an aeroplane. Charlie's not much help because he doesn't seem to understand the thing either. He tries to obscure this fact with smatterings of obscure terminology, but I see right through it. Learning about computers is, it seems, not that unlike learning about love. As a novice one presses all sorts of buttons that veterans know to leave alone.

And then of course there's Katie.

Charlie says Katie can stay here any time – that there's plenty of room. I keep telling her this on the phone. I also went to visit her in Galway last week. I said I felt like a break, but actually I wanted to check out her new flat.

When Katie first went to Galway, Bruce and I found digs for her with a nice family in Salthill. The lady of the house was very bonny and beaming and the place seemed like a home from home. So, naturally, I was rather worried to discover that, after just one month, Katie had decided that a home from home was not what she needed.

32

'Mum, I'm not a child any more,' she kept saying as I snooped round the small flat she's sharing with a girl called Sarah.

'Are you eating properly?' The cliches leapt off my lips. 'And what about that nice warm coat I bought you? It really is quite cold these mornings.'

'Mum, I'm not a child any more.'

'Here, I brought you a few things,' I said, handing her a huge bag of sensible food. 'That muesli's home-mixed and it's full of fibre. Fibre is very important.'

'Oh, Mum, please don't bring up bowels again. It's so obvious.' She grimaced long-sufferingly, as only an eighteen-year-old can.

'I don't think bowels are that obvious, Katie. Young people frequently forget all about them.'

'No. No. Don't be so dense, Mum. It's so obvious you're avoiding the subject.'

'What subject?'

'You and Dad.'

She was, of course, right. We talked about my 'displacement activity', as she called it, over some of my currant cake and tea. As far as I could gather, though Katie is obviously upset about her parents' separation, the budding psychology student part of her also regards it as a rather interesting case study – though of course this could be just a defence.

She informed me that if I had been getting more 'positive reinforcement' in my marriage – that is if Bruce had 'rewarded me' more often for my wifely attentions – then his affair would not have had the same impact.

Pigeons, it seems, can be trained to detect flaws in products on assembly lines through the judicious application of positive reinforcement, which in their case is usually grain.

She related all this with such scholarly enthusiasm that I hadn't the heart to point out that I found the pigeon analogy in our conversation far from flattering. First year psychology is bound to change her world-view somewhat. I'm grateful I was spared Freud. He pops up next term so I'm probably due a lecture on penises sometime soon.

Yes – all in all – Katie has been very understanding. But that may be because she herself has dropped more than one bombshell in the recent past. The latest was delivered last week. I was going on and on about hoping she wasn't too upset and that I'd always be there for her and that sort of thing when she told me she thought she might be a lesbian. Frankly it's something I wished she could have kept to herself until she was sure, but then I have been telling her for years that she can 'tell me anything'. She's really taken me at my word and so far 'anything' has included a herpes scare, a crush on a priest, a short-lived wish to become a social worker nun, and now this.

I'm beginning to wonder whether there isn't something to be said for good old repression and secrecy after all.

As to the latest announcement – I don't have anything against lesbians *per se*. In some ways it makes a lot of sense and in an ideal world nobody would give a fig who was loving whom. But the world is not ideal and Katie is quite sensitive.

She's also beautiful. I know I'm her mother and therefore biased, but it's true. Katie's hair is wispy and golden white, like an angel's, and she has these big clear kind blue eyes. For years all she wanted to do with her life was live in a croft in Scotland with a seal – she'd read *Seal Morning* by Rowena Farre. At one point she used to spend entire weekends in a tent in our garden poring over books about subsistence farming and edible berries, with poodle Sammy acting as surrogate sea mammal.

She had her own little vegetable patch in the garden and assured us, with twelve-year-old conviction, that she could happily live off the carrots and potatoes which she boiled up – with me watching from the kitchen window – on her small Primus stove. However the sandwiches and hamburgers which I left on the window-sill were always eaten, a fact Bruce and I thought it wisest not to comment upon.

So much has changed. So much has been happening lately that I've been tempted to exchange my periodic tizzies for a prolonged and full-blown panic.

'What form would this panic take?' asked Charlie. 'I mean, is it going to be an underground thing – like obsessively ordering kitchen accessories from cable TV – or something more dramatic?'

'I don't know,' I mumbled sadly.

'Well, you'll have to work that one out first and I tell you something Jasmine, the options are vast.'

'I suppose they are.' I looked at him anxiously.

'I mean, in your case a fairly common scenario would be heavy alcoholic intake followed by deep, drunken existential angst and late night dash in taxi back to unfaithful husband.'

I pulled a face. 'Yuck.'

'Or fast, desperate involvement with some extra-ordinarily unsuitable man. That's quite popular too.'

'Yuck again.'

'Or you could be more enigmatic. You could, for example, run down the road in your nightie screaming the 1989 Norwegian entry to the Eurovision Song Contest.'

I couldn't help laughing. 'And why on earth would I want to do that?'

'Exactly,' said Charlie, giving me a broad smile.

Susan says my confidence has taken a knock and I need to get out and about to boost my self-esteem. She thinks

coming along with her to a yoga and meditation class is just the job, and so now here I am in my tracksuit bottoms and sweatshirt.

This is my second visit and I'm just about getting the gist of things.

I know, for example, that in Room 5B of St. Benedict's High School for Girls we are supposed to be heightening our awareness of our life-force and life-purpose. I also know that we are being bathed in the glow of collective oneness and a feeling of harmony and balance with all things, and that swallowing sounds really noisy in a silent room.

'Are you comfortable?' asks Arnie, our teacher. This is just politeness – rather like the woman on BBC radio's *Listen with Mother* who used to say 'Are you sitting comfortably? Then I'll begin.'

We're all lying flat on the floor on foam mats and the air is thick with the smell of apple tarts from domestic science class. Susan beside me is furtively sucking a Fisherman's Friend because she has a slight cold.

'We'll go straight to the meditation tonight,' says Arnie, who is not American but has a slightly American accent. You can tell just by the way he sits, with his back straight and knees comfortably but athletically crossed, that he's no couch potato.

Arnie then puts on one of his CDs. Strange sub-aquatic sounds emerge from the player – whale songs and the bubblings of some synthesiser and then pan pipes and little drumming sounds that grow louder and then burst into a hypnotic, rhythmical beat.

'Listen to the music,' Arnie says softly. 'Don't try to relax. Trying is not relaxing. Just let go.'

Funnily enough that's much the sort of thing Bruce used to say to me during our initial love-makings. 'Just relax,' he'd say. 'Just let go.' 'Where will I go to and if I get there

36

will I get back?' I used to wonder. I did occasionally manage this intrepid journey. The small sweet explosions left me feeling rather adrift and forlorn as Bruce, having been available for hugs and comment for the obligatory five minutes afterwards, then fell into a deep untroubled sleep. We got better with practice though. In fact for a while in our marriage, sex was even fun.

But I'm not supposed to be thinking of sex. Our thoughts, says Arnie, are like birds flying through a clear blue sky. Though we may see them passing we are not to follow them. 'Leave your mind and the rest will follow,' he murmurs. And I try to – I really do – but instead I get all these images. They're jerky at first – like an old newsreel – and then more real than life. First there's Charlie's cat coughing up a hairball, head hanging limply then seized with a husky spasm; then come the clumps of mascara that gather under Katie's eyes after she's been crying, followed by – goodness – that fat German man in yellow shorts reading *Catch 22* on the ferry to Poros. And then a fish – a huge yellow fish with blue stripes that smiles.

There are twenty people in the room – twenty-one if you count the studiously serene Arnie. The room is quite small and after a while grows rather hot and stuffy. When, after our session, someone comments on this Arnie says it might be something to do with our collective energies. But he also adds that the ventilation in the room isn't good and that he'd asked Mrs Wakefield – the school principal – if the air-conditioning might be left on after 7.30 p.m. He looks slightly less serene as he says this.

The subject of air-conditioning is reassuringly prosaic, for the other comments the session inspires are very strange indeed. Mildred, who runs a small tea shop in Rathgar, reports that the cells of her body felt as if they were dissolving into radiant light, and a man in a purple sweater says energy

exploded out of him when the Richard Clayderman tape was on, and had ricocheted around the room. Warm loving energy it had been – 'Did any of you feel it?' he asked. I'm trying to turn a giggle into a cough when Susan says yes, she had felt the energy. 'Thank you, Eric,' she says, giving him a calm but beaming smile. Then piles of other people start reporting tinglings and glows and I begin to wonder if the warm drowsiness I'm feeling is the afterglow of Eric's warm loving energy or lack of oxygen. Not wanting to be left out I mumble something about the yellow fish with the smile.

'I'm not really sure about all this,' I say to Susan as we collect our coats. But she doesn't want to talk about meditation, she wants to talk about Charlie. She wants to know would it be all right with me if she invited him to a film. 'Of course it would. Charlie and I are just pals,' I answer. 'You and he would really hit it off. Remind me to buy a packet of wholewheat spaghetti on the way home, will you?'

But Susan is so busy talking about when she should phone Charlie and what film they should go to that she doesn't remind me. So I have to add wholewheat spaghetti onto the 'We Need' list in the kitchen. The list that already contains soya sauce, wholemeal flour, toilet paper, olive oil, and Charlie's most recent addition: love.

Chapter 6

THE COLLAPSE OF MY marriage is taking longer to adjust to than I'd thought. I was fine when I was slopping around indoors, but now that I have to go out more regularly I find myself assailed by sudden panics and deep despondency. For example, as I take the bus to my word-processing course I feel sure that I reek of rejection, and not just 'Eternity' – that's the name of Charlie's aftershave. I feel sure that all eyes see the forlorn crumpled creature that I am; not the bright brave female I am trying to be. I fear meeting people I know, and I have a serious dread of bumping into Cait Carmody.

It turns out quite a lot of people look like her, which is most inconvenient. The mere sight of a back bearing long brown hair makes me scurry across the street, or dart desperately into a newsagents. Naturally this prompts further strange looks from people who recognise a haunted woman when they see one. Sunny days are easier because then I can wear dark glasses.

Another pressure is feeling I have to look good all the time so that, if I do meet Cait Carmody, she'll see instantly that I am a person with a solid sense of my own attractiveness and self-worth. Actually I'm not sure she'd have time to study me too closely, because I might take a swing at her with my handbag. 'That's for the "Artichokes Supreme" you bitch!' I'd screech – because I can't get over how she could screw my husband and still regularly, and brazenly, sit down at my dinner-table. I can't quite forgive her for all the hours I spent poring over Nigella Lawson's recipes trying to do imaginative things with food, while she and Bruce did imaginative things in bed.

I'm sure they were imaginative, the things she and Bruce did in bed, and, who knows, they may have involved food too. Not artichokes of course – most probably bananas or cream. She's frequently been cast in sensuous dramas that call for much writhing and moaning, so I know she's not inhibited. They probably even talked about me sometimes while smugly spooned together.

Actually, when I think about this, cutting the sleeves off all Bruce's shirts and pouring paint over his new Volvo do not seem like such bad ideas. When I think about this, I forget the occasional strong temptation to return to my comfortable semi and resume my detached marriage.

And yet, despite all this, I'm having lunch with Bruce today.

It's not lunch so much – it's more a small act of revenge. Bruce has been ringing up imploring me to meet him 'anywhere – anytime', so I've chosen this extraordinarily expensive French restaurant and I'm going to order their top wine and most expensive courses. I've been there once before with him and some of his colleagues and I didn't really like it.

It's the sort of place where people say *'Très bien'*, *'Oui'*, *'Formidable'* and *'Merci'* a lot, and then look frightfully pleased with themselves. Though the Parisian waiters appear most solicitous, you know that on some level their patience is wearing thin.

There is one thing I like about the place though, and that's the ladies' toilet. Toilets were frequently places of refuge for me when I went out with Bruce and his colleagues, and the one in the restaurant we're going to today is particularly spacious and restful. Even though I was there over a year ago, I can still remember that it contained a number of comfortable upholstered chairs of the simple, trim, expensive variety, and a vase full of

exotic flowers. The soaps smelt of lavender, and a large box of tissues in a container covered with raw silk was thoughtfully provided for prolonged bouts of weeping.

Still, there are some hours to go until lunch, and I'm now sitting in a room on the second floor of a Georgian building near Grafton Street playing with my mouse. My mouse is small and white and attached to a computer. I've learned that by moving it around and clicking it I can make the computer do all sorts of interesting things. I'm currently using the paintbox mode and drawing large yellow circles on the screen.

'Please leave your mice alone,' says our instructor, Mrs Riordan. 'There will be plenty of time to play with them later.'

'A big egg timer has just appeared on my screen,' wails a man in a yellow jumper.

'Well just leave it there, Eoin and it will go away,' says Mrs Riordan. 'I'll explain all about the egg timer soon.'

This two-week course is for adults who want to learn about the latest office software, but it feels a lot like kindergarten. I think it would be fair to say that we have all, in some ways, regressed.

For example the woman with the bun strays into spreadsheets at every opportunity and then insists she 'didn't touch a thing'. And the mischievous-looking man with the ancient cord jacket – an aspiring journalist, I believe – is obviously attention seeking. He keeps reading the manual and asking complicated questions we're supposed to get to on Friday. A girl with a stud through her left nostril says her mouse isn't clicking properly, and everybody at one time or another has said the room is too hot or too cold.

41

Mrs Riordan has a large ruler which she uses to point to relevant information on the flip chart, but as the class progresses she waves it about in a more ominous manner. Apart from this she is resolutely cheerful, and even joins us during tea-breaks.

Tea-break is, of course, the height of the morning and takes place in a small room nearby. It is while I am guzzling down my fourth digestive biscuit that Eoin, the man in the yellow jumper, asks me if, one evening after class, we might go for coffee together.

I suppose I shouldn't be too surprised because I have, after all, taken off my wedding ring and we've had a couple of conversations about greyhounds, which Eoin breeds. But after nearly twenty years of marriage the realisation that I am, in fact, being asked out on a date, stuns me into silence.

'I'm sorry…maybe I shouldn't have…' Eoin mumbles awkwardly, and I know I have to say something.

'We could have a cup of tea together I suppose,' I smile warily.

'Ah yes, I forgot you're a tea drinker,' Eoin beams. 'When will we do it? Tomorrow?'

'Mmmmm – all right.'

'Fine. We might go to a film too – afterwards.'

'Maybe.'

Then I say I'd better dash to the loo before Mrs Riordan rings her little bell. It's not a loo to linger in. It's full of stern messages about not flushing sanitary towels and tampons down the toilet. But I don't mind.

I'm a bit late meeting Bruce for lunch. I was on time but when I realised this I went into a newsagents and read *Hello* magazine for five minutes, and then I went to the post office and queued up for a stamp.

Bruce has chosen a secluded spot at the back of the restaurant. He's chomping anxiously on a bread roll and has poured himself a glass of wine.

The waiter, who's already called me *'Madame'* twice and taken my coat, is now leading me towards the table in a swift, urgent manner. I loiter behind him, and then I have to speed up because I see he's pulled the chair back for me and is waiting for me to sit down. As he shoves me towards the table, and my husband, I attempt a wan smile.

'Hello Bruce.'

'I'm so glad you came, Jasmine. I really am.' Bruce looks tired.

I pick up the menu. 'I think I'll have *"Crevettes Martinique"* for starters. *Crevettes* – that's prawns isn't it? And…' I scan the prices…'and *"Lobster Provençale"* with…'

'Put that menu down for a minute and look at me, please.'

'We'll have to order fast because I've got to be back at my computer course by 2.15.'

'Computer course. That sounds interesting. I always said you were wasted just looking after the house.'

'No, you didn't.' I'm unfolding my napkin which is made from thick linen and is very stiff.

'Yes, I did Jasmine, but you obviously don't remember. Still, that doesn't matter now. What matters now is us.'

'Anyway, I wasn't just looking after the house. I was looking after Katie, and you, and – and your bloody dinner guests.' I shoot him a venomous glance.

Bruce winces slightly and picks up the bottle of wine.

'I hope you don't mind but I ordered this already. It's Chilean. The Chileans are making very good wine these days.'

'Good for them.'

'Remember that time we went round the vineyards of Bordeaux and got completely blotto at that wine tasting?'

'Mmmmm.' I'm staring at a painting of a picnic in a forest. The people have gone and the food is half-eaten. I really, really, want to get up and walk out of this restaurant. Feelings are exploding inside me like popcorn. I want someone to hold and comfort me and say loving, reassuring things. If I break down that's what Bruce will do. He'll say all this wonderful stuff, and I'm shit scared because I'll want to believe him.

'Jasmine!' Bruce is getting irritated. 'There's really no point in us meeting if all you're going to do is say "Mmmm" and stare into the distance.'

'I wasn't staring into the distance. I was looking at that painting.'

Bruce glances at the painting then he says, 'How are you, Jasmine?' He says it slowly, emphasising each word, while also trying to establish eye contact. I look at his mouth and wonder at how such an innocent-looking orifice could disgorge so many lies.

'That film editing seminar in Paris didn't last a week did it?' I hiss.

'What?'

'That film editing seminar in Paris – it was only for a weekend. You spent the rest of the time with her, didn't you? Admit it.'

'Oh for God's sake, Jasmine, do we have to go through all this again?'

'Yes.'

'Okay, I admit it. Cait did join me, but we were also discussing a possible documentary project in Lyons.'

'So you went to Lyons with her?'

'Yes.'

'And Bordeaux too, I suppose.'

'No, no, we never went to Bordeaux.' Bruce is quite vehement about this.

'And what about that time you went to Cannes for the Festival? Did she come too?'

'No. No. Cait didn't come to Cannes. I was only involved with her for a year. It's all over between us now. Really.'

'A year,' I think. 'A whole year.'

The interrogation continues for a while, upon my insistence. I insist because, lately, I often sit bolt upright in the middle of the night with a new and nasty suspicion which demands corroboration.

'That really does about cover it,' says Bruce, who's tapping a spoon against his thumb and looking even more weary.

'And what about the Interflora docket?'

'Those roses were for Aunt Emma. She was eighty.'

'I can check that, you know.'

'Go ahead.'

Then the waiter comes over with his little notepad.

'Don't dare order the veal,' I scowl.

'Of course not.'

As Bruce gives the waiter our order he doesn't say *'Très bien'* or *'Formidable'* once. He looks rather forlorn and lost in fact. As I finish my second glass of wine I feel myself reluctantly softening.

'How are you managing – financially I mean?' Bruce asks after I've told him about my course.

45

'I'm using the money we put aside for the conservatory.'

'Oh.'

I crack open a bread roll. 'Considering all the extra hotel bills and airline fares you must have incurred lately I assumed you wouldn't mind.'

'How's Charlie?' The question is sharp and asked with a tight smile.

'Charlie's fine. Susan's going to ask him to a film. She fancies him.'

Bruce smiles more broadly at this news, and then I move the discussion on to Katie before he can. Bruce knows Katie is my weak spot and he plays on it.

'She seems fine,' I say. 'We talk a lot on the phone.' Since he hasn't mentioned lesbianism I don't bring the subject up. But this time Bruce doesn't try to fill me with fears about Katie's welfare. He agrees that she seems to be enjoying university. And, because the Chilean wine is making me mellow, I decide to answer the question he asked earlier. 'Yes, I do remember that wine tasting in Bordeaux,' I say. 'It was very nice.'

'Yes it was, wasn't it?' Bruce is enormously pleased. He leans forward conspiratorially. 'And what happened later that night was even better.'

This is obviously meant to flatter and reassure me, but instead it reawakens my rage.

'Don't talk to me about sex, you bastard!' I say, just loud enough for the couple at the next table to hear. 'Don't dare bring up memories of when I was naive enough to think you loved me…you unfaithful…you – you lying little shit!'

'Shhhh, Jasmine. People can hear you.'

'How could you? How could you kiss her in our kitchen! How could you have sex with her in our bed!'

I'm aware of a solemn presence beside me and look up to see that the waiter is waiting to serve us our first course. I smooth out my napkin while he does this and then, for a moment or two, he and Bruce talk about the Chilean wine.

'It's surprisingly robust, isn't it?'

'*Oui monsieur.*'

'And not at all bitter.'

'*Oui monsieur. Bon appetit.*'

As the waiter departs the couple at the next table both give us swift, excited, glances. Bruce looks down disconsolately at his *"Terrine de Volaille"*.

'Let's try not to fight. Okay?'

'Okay.'

'You've every right to be angry. I would be too.'

Though misery has removed my appetite, I'm determined to eat at least four of my *crevettes*. Bruce also seems to be masticating with some difficulty.

'I want you to know,' Bruce is leaning forward again, 'I want you to know that I never discussed you with her. I knew you wouldn't like that.'

'Thanks a lot.'

'I know it seems strange to bring it up, but it's the kind of thing that preys on people's minds.'

'How do you know?' I'm surprised at his perspicacity.

'A woman on the radio was talking about it.'

'Yeah – there's a lot of it about. I suppose everyone else knew about you and Cait before me. I suppose they were all sniggering and gossiping behind my back.'

'Hardly anyone knew about it.'

'Who knew about it?' I almost spit the question at him. I'm quivering with indignation.

'Oh, come on, Jasmine…'

'Tell me.'

'Just Eamon and Alice…we work so closely together it was impossible to keep it secret.' Bruce is leaning forward again. 'Jasmine, please come back. I miss you. Cait isn't even playing the part of Avril any more. It's all over between us. She's working on a film in Belgium.'

'So she's out of the country?' I manage a fifth prawn at this news.

'Yes. I should never have got involved with her. It was a…a silly fling. Come back. Do. You've made your point.'

'I don't know. I need more time.'

'I love you, Jasmine.'

I stare him straight in the eyes. 'Look Bruce, if you don't want a kick under the table keep off that subject, okay?'

'All right.'

'Anyway, if getting involved with her was so silly, why did you do it?'

Bruce rarely squirms, but that's what he does now. He looks down at the table cloth, as if for inspiration. Then he looks back at me.

'Do you want an honest answer?'

'Yes.'

'I like her. She's encouraging and interested in what I do.'

'And I'm not?'

'No. Not really. You think *Avril's* a load of crap, don't you?'

'I never said that.'

'But you made it pretty obvious. It's a big, big thing for me, Jasmine. I don't think you quite understand that.'

'I do understand that.'

'Then why did you make all those withering remarks?'

'I'm sorry.'

'I've always liked being married to you, Jasmine. But when you're with me half of you seems to be somewhere else.'

He's right. Oh my God he's right.

'I'm sorry if I've given that impression.' I sigh. 'How is *Avril* coming along anyway?'

'We start filming in two weeks.'

'That's great news. Well done.'

Bruce pushes a small box towards me. I open it. It contains a silver brooch in the shape of a cat. The cat has diamond eyes.

'They're real diamonds,' Bruce says. 'Not fake ones.'

For a moment I'm at a loss for words. 'Th – thank you Bruce, it's lovely. I really like it.' I put the brooch on.

'Katie said you would.'

'Katie?'

'Yes. I went to Galway to look at some locations last week. We chose it together. I didn't show my appreciation of you enough in the past, I know that now.'

And suddenly I know, I just know, Katie's been talking to him about positive reinforcement…and pigeons.

I wonder if I should tell him Katie thinks she might be a lesbian, but I decide against it. As the second course is served I wonder if I should mention my tea date with Eoin tomorrow, but I decide against that too.

It's funny but suddenly I'm quite enjoying this lunch. It's nice sitting here with Bruce, my brooch, and our second bottle of Chilean wine. There's a poignant, illicit feeling about it. Bruce hasn't been so attentive in years.

'I always know when you're drunk. Your face goes all fuzzy,' says Bruce. It's an old joke that always makes us laugh.

Then he grows more serious. 'Come home with me. Come home with me right now.'

'And what'll we do when we get there? Watch *Teletubbies?*'

'I have something rather different in mind.'

Bruce can be very sexy when he wants to be. His voice gets a bit husky and his eyes grow dark and tender. It's been so long now. It would be nice to be held close. The anger would make it exciting. Yes, it would be nice to thrash around again under our big duvet. To fuck. To forget.

And then the image of the fake diamond hair grip swims before me. It's lying there, stuck into a peach coloured pillowcase, just like the day I found it.

'I can't believe you'd even suggest such a thing!' I get up and fling down my napkin. 'Have you no sensitivity at all?'

The couple beside us are openly gawking.

'Jasmine, come back. I didn't mean to –'

'I'm not a pigeon!' I yell. And then I grab my coat.

Back at the computer course I make myself a strong cup of tea. Then I tell Mrs Riordan I have a period pain and go and sit in the ladies'. The toilet paper is that shiny stupid stuff that's no good for tears, and I only have one paper handkerchief with me.

I should have taken some tissues from that big box in the restaurant loo…but I really didn't think I'd need them.

Chapter 7

EOIN HAS FOUR REMARKABLY long hairs growing out of his left nostril. I somehow didn't notice them before, but now I'm sitting opposite him in a café they loom very large. It's a damp, drizzly evening. I was fine while we were walking here and talking about databases, but as soon as I sat down I felt like a woman in a Russian novel. I long for my lost innocence like those women long for Moscow. I long for the time when the sadness I felt was at least familiar – and the people who played a part in it were too.

It's at times like these that I truly wish I'd never found that hair grip.

Eoin is trying to be cheerful and friendly. The fact that I manage the occasional smile seems a triumph of the human spirit. There's no shorthand between us like there is between me and Charlie. Sometimes it feels like the letters in our words aren't even joined up. Every so often I find myself losing heart and stopping mid-way.

'I think I'll have a toasted san…'

'What?'

'Sandwich. I think I'll have a toasted cheese and tomato sandwich.'

'Fine. I think I'll have one too. That's a nice brooch you're wearing.'

'Thanks.'

The café is no frills and brisk. There's neon lighting, bentwood chairs, and small round tables with plastic cloths on them. Our table rocks and has a streak of coleslaw.

'I suppose we'd better queue,' says Eoin.

'It always amazes me that they don't have a place to put the tea-bags,' I fume as we return to our table. 'I mean what are we supposed to do with them? Just let them stew in the cup?'

'Here, use this,' says Eoin, shoving a saucer towards me.

'Thanks. I've really got to do something about this table. It's ridiculous the way it rocks.'

I march up to the counter and yank a fistful of napkins out of the small steel container. Then I come back and wedge two under a table leg and use the rest to get rid of the coleslaw streak.

Eoin takes the evening newspaper out of his jacket pocket and spreads it sideways on part of the table.

'There doesn't seem to be much on,' I say after a swift, uninterested glance.

'Well, I can tell you there's a darn sight more on here than is on in Moate.' Eoin comes from there. He's staying in a B&B whilst he does the course. 'What about Tom Cruise's latest one?' he asks.

'I dunno – I'm not that keen on impossible missions.'

'Or the one with Mell Nichols? That's supposed to be good.'

'I've rather gone off him. Actually, Eoin, I'm not really sure I want to go to a film. I'm rather tired. Maybe I should just go home.'

'Ah no – once we're sitting in the cinema, you'll enjoy it.'

I consider mentioning that I'm married, but I don't feel up to the explanations. Anyway Eoin's got the bit between his teeth now. He probably wouldn't take marriage as an excuse. He's not married. I checked. He's younger than me – mid-thirties I'd say.

'What film would you like to see, Eoin?' I dread the answer this question may evoke, but it is my turn to show some interest.

'The one with Cameron Diaz – that's a thriller. Or the one with Kate Winslet. That's a comedy about a woman who tries to murder her husband.'

'Okay. Let's go to that one.'

In the cinema queue I say it's nice that men and women can just be friends these days. That they can, for example, go out to a meal or a film just as buddies with no strings attached. I know it's not particularly subtle, but Eoin is wearing a lot of aftershave. I bring up the greyhounds at every possible opportunity.

'I quite enjoyed that film – it wasn't bad at all,' I say afterwards as we cross the street outside the cinema. There's a lot of traffic and Eoin links his arm through mine protectively. Once we've crossed the street he keeps his arm there so, in order to disengage us, I pretend I have to look in my handbag for my scarf.

'I bet you'll be glad to get back to your greyhounds next week,' I say. 'Who's looking after them?'

'A neighbour.'

'That's nice. You've nothing to do with coursing, I hope.'

'Why's that?'

'I'm involved in animal rights. I've marched with a pig down this very street.'

'Ah no – I've never touched coursing myself. Just the track racing, that's all.'

'Have you any races coming up?'

'There's one next month.'

'That'll be exciting. Do you think you've got a winner?'

'Ah I dunno, maybe. D'you fancy going for a drink?'

53

'Well now, Eoin, I think I'd better be getting back. I live past Bray. It's a long journey.'

'Just a quick one.'

'No. No. It's very kind of you but I'm quite tired.'

'I like you, Jasmine.'

'Thank you, Eoin. You're a nice person too.'

O'Connell Street is full of couples who are talking and laughing.

'No, I mean I really like you. I can talk to you.'

'Thank you, Eoin. That's a nice thing to say. We can talk lots more tomorrow…in the tea-breaks.'

'I want to talk to you now.'

'Well, I'm afraid we can't talk now, I have to get my bus.'

'What number bus is that?'

I tell him and it turns out his bus leaves from a stop nearby.

'I'll wait with you,' says Eoin. 'I wouldn't leave a woman alone this time of night on a dark street.'

'It's not a dark street. There are lots of lamps.'

'Ah well – even so I'll stay.' He takes my hand protectively as we cross a road and then he doesn't let it go, so I pretend I have to blow my nose.

At the bus stop he takes my hand again and pulls me gently towards him.

I pull away. 'No, Eoin. This isn't that kind of date.'

'Ah com'on, Jasmine – just a hug. Just a nice warm friendly hug. It's a cold night.'

'It's quite mild actually.'

'You know what I mean. Com'on.' He gives me a tender, teasing smile.

'But it's so public here.' I look down the dark, almost empty street.

'No it isn't.'

'Well – okay. Just a quick one,' I say grudgingly.

But when he puts his arms around me I stop resisting. He's big and strong and warm and protective and I find myself burying my face into his navy woollen jacket. We're okay together, as long as we don't talk and I don't look at his left nostril. I need some comforting. I really do.

'You're lonely Jasmine.' He's stroking my hair. I try to nod but my head is somewhat restricted by his elbow. 'It's all right – everyone's lonely sometimes.'

'Oh God, is it that obvious?' I'm thinking, but then he adds 'You're lovely too. You're lovely and I like you a lot.' He lifts my face and I know he's about to kiss me.

I pull away again. 'No. No. Sorry Eoin, I can't do this.'

'Why?'

'I thought we were just friends. And…and anyway, there's something you should know.'

'What?'

'I'm married.'

'Oh.' Eoin opens his mouth as if to say something, then he closes it again. Herds of buses are passing. I have to keep a sharp eye out so that mine doesn't speed by too.

'It's all right,' Eoin is gently brushing a stray hair from my face. 'I'm almost married myself.'

'You're what?'

'I'm engaged. The wedding's after Christmas. My, we're a right pair, aren't we, Jasmine? A right pair.'

'A right pair of eejits,' I think but what I say is, 'Here's my bus.' For indeed my bus is thundering towards us. I stick out my hand and it screeches dramatically to a halt. I get on hurriedly, holding tightly to the handrail while I do so. The driver's one of the wild, late night boyos who put the pedal down like Jensen Button. With a roar of diesel I'm on my way.

Eoin looks a little sad. He smiles and waves as the bus lurches onwards. I give one quick wave myself then I climb to the top deck and sit down. I feel a bit bewildered and irritated, but gratitude is somehow creeping in too. 'He really likes me,' I think as I career towards South Dublin. 'He "thinks I'm lovely". Me. Jasmine Smith.'

An empty Coke tin is clattering to and fro under the seats.

'Still, he should have mentioned his engagement.'

The coke tin is getting louder.

'And I suppose I should have worn my wedding ring.'

I can't take the noise of the coke tin any longer...the hollow clatters and empty tumblings of its crazy dance across the floor. I get up and try to catch it. People are watching me, but I don't care.

The tin is cornered. I shake it to check it's really empty, then I take it back to my seat. I put it in my carrier bag, along with my software course manual and notebook, an empty packet of crisps and *No Need to Panic: Courageous Acts of Change in Women's Lives*.

I stare dully out the window. Suburban homes are flashing by. Homes of couples – some of whom are closing their bedroom curtains. Oh, the safety of it – and the danger too.

'That was me once,' I think. 'Look at me now, grateful for a few easy words from a stranger. What am I becoming? I hardly know him. I hardly like him for God's sake!' I feel the panic rising.

'Oh God, please don't let me become the kind of woman who settles for just a warm body.' I glimpse a mother tucking in her child.

'Let me not be driven to one-night stands with men over for rugby internationals.' I'm mouthing the words

silently, like a mantra. 'Let me believe in love again. Please.'

A man in the front seat has started to hum. I can't make out the tune at first, then I recognise it. It's 'When They Begin the Beguine'. He's off key and a bit drunk. Every so often he belches.

My dad liked that song. I haven't heard that song in ages. They had guts and style, those old songs. A form, a feeling you could turn to. I remember the black-and-white photo of Mum and Dad and Aunt Bobs and Uncle Sammy outside the Metropole, the four of them dressed up for a dance. It's strange to think they're all gone now – even the building. I have so many old photos. So many faces that I saved from the black plastic bags. One day I must sort them – put them into albums. I must.

I can see the face of the man who's humming. It's reflected in the window. He's got his eyes half-closed and his shirt half-open. His expression is soft and dreamy. Soon I'm dreaming too.

I'm dancing alone and then…then someone comes along and I stop.

He's hugging me. I feel I know him so well.

He's burying his face in my hair and pressing me so close.

As if I'm someone precious.

As if we've both been waiting for this moment for a long, long time.

Chapter 8

'THE THING YOU HAVE to realise about men,' says Susan, 'is they're all married.' It's Saturday morning. We're in Charlie's sitting-room eating freshly made white toast which, after all the wholesome wholemeal bread I've been having lately, is a great treat. I dashed down to the shop earlier to buy the freshest, most fibreless loaf I could find.

'Of course they're not all married,' I say between munches. 'It's statistically impossible. Anyway, Charlie isn't married. That's one for starters.'

'You know what I mean.' Susan is not pleased at being denied the pleasure of her sweeping generalisation. 'Once you get to our age most of the men we meet are married.'

'Or engaged.'

'Very few of them are engaged, Jasmine. Eoin is obviously a late-starter.'

'Women don't talk like this in America.' I've always found this a comforting assumption.

'Yes they do. They talk like this everywhere.'

'No they don't,' I persist. 'Remember those fortysomethings we met in California? They were all changing careers, and men, and going to Alaska or Hawaii or someplace. They were as happy as clams.'

'How do you know clams are happy?' Susan asks peevishly. 'That's a very American remark.'

'Look, are you trying to make some point here?'

'Well,' Susan looks a bit furtive. 'Actually, I suppose I am in a way.'

'And what is it?'

'I don't want you to completely dismiss the idea of going back to Bruce.'

I glower at her. 'I haven't completely dismissed it. I think about it a lot.'

'Good. I'm glad to hear it.'

I look out the window at Rosie. She's lying on her side in her pen resting in the sunshine. Rosie rests a lot.

'I don't like this picture you're painting, Susan.' I chomp my toast feistily.

'I'm not painting any picture.'

'Yes you are. You're trying to make out that I'm facing a lonely, loveless life brightened only by one-night stands with men over for rugby internationals – if any of them will have me.'

'I never said anything about rugby internationals,' Susan protests.

'Have you any idea what it's like? Discovering that your husband has been fucking someone in your own bed?'

'I should imagine it's pretty awful.'

'Yes it is. So ease up on the easy advice. Okay?'

'Okay.'

'Because you've no idea what it's like.'

'Okay. Okay. You've made your point.' Susan is buttering herself another slice of toast. So much for our war on cellulite.

'That's what Bruce says to me. He says, "Come back Jasmine, you've made your point".'

'Well, maybe you have.' Susan is sitting in the lotus position. She's much better at yoga than me. She's getting all philosophical now and I'm not sure I can stand it. 'Lots of marriages survive infidelity, Jasmine.'

'Really. So when did you become such an expert on the subject?'

A pained expression flits for an instant across Susan's face. Then she looks at me sternly. 'We're talking about you, not me. I know you won't like me saying this, but sometimes I think all this isn't just to do with Cait Carmody. Sometimes I think something else is going on too.'

'Oh, do you? Well that's a great help, Susan. That really is. Could you tell me what it is? I'd really like to know.'

Then I stomp into the kitchen and get the box of Snack bars Charlie bought the other day. He knows I like them and they're cheaper in boxes. 'When you buy in bulk you eat in bulk' as my father used to say.

Susan follows me into the kitchen and finds me tearing off a wrapper. 'We're not going to attract too many men over for rugby internationals if we pig out like this.' She smiles and reaches into the box. 'I'm sorry if I upset you.'

Susan is looking rather miserable. In fact now that I think about it, she's been miserable all morning.

'What's wrong Susan?'

'Nothing's wrong.'

'Yes, something is.'

Susan's eyes are dull and her mouth is curled down at the corners.

'No. No. It's nothing.'

'Come on. You can't fool me.'

'Oh, all right. It's Charlie.' She releases this information most reluctantly.

'What's Charlie done?'

'He's not done anything. That's the point. When we went to that film it was so obvious.'

'What was obvious?'

'That he doesn't fancy me. At one point I tried to take his hand but…Oh, Jasmine…'

'What?'

'He pretended he was looking for something in his pocket.' Susan takes a forlorn bite out of her Snack bar at the memory.

'Oh, Susan.' I put my arms around her. 'I'm so sorry.'

'It's all right.' Susan gives me a brave grin. 'He was very nice otherwise. Dating's not easy at our age, is it? Explaining yourself to people over and over again. Sometimes I wish I'd married Eddie Moran and got it all over with.'

'Not Eddie Moran.' I'm aghast.

'He was rich. I could have got away from him. Trips abroad. Days spent in hairdressers.'

I'm staring at Susan as though she's just grown two heads. 'Susan, I'm gobsmacked. I – I can't believe you'd exchange all those years abroad for marriage to a man who sang "I Did It My Way" off-key every time he got drunk.'

'I get lonely.'

'Well so do I, but I think we have to practise some discernment here. I mean, if men didn't have penises, would we really bother with them? Sometimes I think I'll just buy myself a nice big vibrator and make do with that.'

'Oh, Jasmine,' Susan giggles. 'That's not fair. There are some nice men around but most of them are married.'

'Oh, no – we're not back on that again!' I'm beginning to wonder if Katie isn't on to something with her lesbianism after all.

Then Susan says she has to go. She's got a lunch date with a man who put an ad in the personal columns of the *Evening Herald*. She announces this just as she leaves.

Why do I sense there's something Susan's not telling me? It's been there all morning – hanging in the air.

As Susan drives away I realise that staying in this house with Charlie and his music must be getting to me. As the door creaks closed it sounds rather like the opening bars of Gershwin's 'Rhapsody in Blue'.

Chapter 9

KATIE'S COMING TO STAY this weekend. I've been asking her for ages, but now that she's agreed I'm in a tizz. She's bringing Sarah, the friend she's sharing a flat with. Charlie's house is big enough for them both to have their own rooms. I think it's best that they have their own rooms.

One of the rooms is used for storage, so clearing it has been quite hard work. When I was moving a box some photos fell out of a blonde woman with small breasts and brown pubic hair. In most of them she was reclining dreamily on a bed, but in one she was looking over a balcony onto a beach. 'Greece – August 1980' was written on the back.

Charlie wanted to move the stuff for me, but I said I wanted to move it myself. So he went off and made a phone call and then came back just as I was lugging a huge wooden crate full of skiing equipment.

'Do you ski?' I asked, somewhat accusingly.

'No.' He was leaning lazily against the banisters.

'Then why do you have all this stuff?'

'I thought I might leave it around – a ski here and snowshoe there. You know, create hints of an athletic, thrusting alter ego.'

I looked at him suspiciously. 'Well, there's not much point leaving them in this box then, is there?'

'No, I suppose not.' He smiled wryly. 'Actually, they don't belong to me. They belong to my cousin.'

'The one with the canoe?'

'Exactly.'

'And I suppose he owns all the tennis rackets and rock climbing equipment in there too?'

'Yup. He's gone abroad for a while – he took his hang-glider.'

I began to heave the box again. Charlie looked on.

'Are you just going to stand there watching?' I grumbled.

'Well, you said you didn't want any help.'

'Just take this end will you?' I pushed the box at him.

'All right,' Charlie grinned. 'But only if you feel it won't undermine your macho image.'

We got the stuff cleared pretty quickly after that.

'Thanks, Charlie,' I said later, while we were eating. 'You were right, it was nice to have some help.'

'I've found that's often the case.'

'But I'm beginning to feel guilty. I've relied on your kindness for long enough. I've got to decide whether to find a place of my own or move back with Bruce.'

I thought Charlie would be relieved to hear this, but in fact he looked a bit surprised.

'Stay here as long as you want,' he said solemnly.

'You keep helping me, Charlie. What can I do to help you?' I didn't mean to make it sound so impatient – angry almost.

'You do help me. You help me a lot.'

'How? Tell me one thing I've done that's been of assistance.'

And then Charlie looked at me tenderly, as if to say, 'If you don't know I'm not going to tell you.'

And of course I did know. I don't know how I could have fooled myself into thinking that I didn't. We're growing closer, Charlie and I. We're incredibly comfortable with one another. I need his friendship. He understands me better than anyone. And I've grown so fond of Rosie, too.

Talking of Rosie, she's taken to coming into the house. Charlie and I actively discouraged this but, undeterred, she always looked hopefully at the back door each time she passed it. Then, one evening, she started to butt the door with her snout. She's let out of her big pen at regular intervals for rambles round Charlie's garden.

We told her to stop butting the door and she did. But as she stood there, quietly looking up at us, it was clear she was deeply offended.

Charlie's found an old thick rug for her to sit on when she comes in. She joined us for *Coronation Street* the other night. She sat there very quietly, like a child who's been allowed up way past her bedtime. Every so often her ears twitched, and her small eyes were bright with barely contained excitement.

'The picture of porcine pleasure,' said Charlie as he leaned over to scratch her back.

'Maybe,' I replied. 'But I think we should draw the line at *Eastenders.*'

I was scared that she might crap all over the carpet, but Charlie said she uses a corner of her pen as her toilet and is quite fastidious. This turns out to be true. Last night, when she and Charlie were playing with one of those squeaky plastic toys for dogs, she suddenly raced towards the door and started to squeal urgently. The minute she was outside she bolted into her pen, relieved herself, and then smugly trotted back into the house. I think I'm going to have to start being strict because the other day I found her looking, rather longingly, towards my bedroom.

I'm glad I got Katie and Sarah's rooms ready early this week, because one of the agencies I signed up with has phoned to offer me some temporary secretarial work. I hope I sounded calm and business-like as I took down

the details, because I felt like a cross between a Pepsi and a Rennies commercial. Part of me wanted to jump into the air and another wanted to clutch my stomach.

I'm rather surprised that they contacted me. There were piles of young, motivated women filling in forms in all the agencies. In fact some of them almost knocked me over on stairs and in corridors. They smiled hasty apologies, but still scythed their way forwards as they did so. I don't blame them. Despite their smart suits they looked vulnerable. The job market is so competitive. Every mother knows that.

Charlie told me to be creative in my form filling. He told me to make the most of all the voluntary work I'd done and use words like 'liaise' a lot. This was good advice because the last time I worked full-time was nineteen years ago. It was in a small family planning clinic. I was never quite sure of my title but, facing one of those forms, I decided 'Office Manager' sounded good. And not that far-fetched either, because I was the only person in the office.

And now, despite having belatedly discovered that 'liaise' has two i's in it, I'm in another office which overlooks St Stephen's Green. It's a big modern building with lots of plants and glass.

My boss is a rather distinguished small, trim man who's near retirement age and prefers 'mature secretaries'. He's held lots of important posts and is now in a consultative position with this particular organisation. This does not appear to be too taxing and can accommodate late arrivals, long lunches, and early departures. So far, I've spent most of my time here taking down long letters to friends of his in shorthand. These are not just friends, they are also business contacts, but to read the letters you wouldn't think so. Many of them are to

people who live abroad, and they're dotted with reminiscences of dinners in palm-fringed restaurants on the Riviera and such places.

Mr McClaren, that's his name, explained to me that he sends these letters out a month or two before Christmas so that, when it comes to the cards, he can just send his best wishes and sign his name. He's very methodical, is Mr McClaren. He likes things to be done in a certain way. For example he only likes a certain blend of tea, and he likes that tea to be served in bone china cups at a certain time in the morning, and a certain time in the afternoon. He also likes a certain brand of austere looking biscuit. As I tend his china, or dash out for his *Daily Telegraph* and *Irish Times,* I sometimes feel as though I've been entrusted with the care of a benign but rather fastidious creature. And indeed, when Mr McClaren peers at me through his bifocals across his large, leather covered desk, he does sometimes remind me of a marmoset.

Thank goodness the course covered the software I'm using, so the word-processing's been fairly okay so far. If I do make a mistake Mr McClaren is very nice about it and marks it in black ink with his fountain pen. He has big, confident, not quite scrawly writing, though his occasional artistic flourishes render some sentences illegible. Bruce has this tendency too. I can't help thinking that when someone leaves you a note that is unreadable it is, in fact, communicating a great deal.

So now I'm looking at one of Mr McClaren's corrections and wondering if he really wants to say, 'Please send my regards to Mabel and tell her she has great tits in wine.' As I check back over other examples of Mr McClaren's writing I notice that, though he sometimes does not dot his i's, he also often only partially forms his a's, and his e's and s's are sometimes indistinguishable. From

this I deduce that Mabel has 'great taste' rather than 'great tits' in wine. This is rather a pity because images of a more abandoned Mabel momentarily relieved the tedium of a long afternoon.

Mr McClaren is at one of his club lunches and the other secretary in this office, Bronwyn, does so much dictaphone typing that she scarcely ever speaks. Her boss is a young, tall, driven woman called Ms Armitage who has endless meetings. So, apart from typing reams of letters, poor Bronwyn keeps having to bring huge trays of teas and coffees and chocolate digestives into Ms Armitage's office. It also turns out that Ms Armitage doesn't have time to talk to a large proportion of the people who phone her, so Bronwyn keeps having to tell people she's 'at a conference' or has 'just gone to a meeting' – which is probably true anyway. But the callers are clearly no longer accepting these excuses without a protest. They keep asking when Ms Armitage will return so that they can phone back.

Mr McClaren's world is very sedate in comparison to Ms Armitage's. In fact I feel something of a memsahib as I sit here, leisurely unwrapping the new paperback I bought at lunchtime. It's called *Lesbianism: Old Myths – New Realities.* I hope it may give me some insight into Katie's sexual predicament.

Katie and Sarah are arriving this evening. I'm glad I had to come to the office, because otherwise I'd be dashing round the house in a panic. I've been hoovering and tidying every evening this week, and worrying hard while I did so. When I told Susan I didn't know why all these worries surfaced so suddenly, she said that they've obviously been there all the time. I've been repressing them, she said. Repressed worries are, apparently, like a jack-in-the-box. They stay quietly hidden for a while, then they suddenly jump up and leer at you.

My attitude towards this forthcoming weekend with Katie and Sarah somehow reminds me of a booklet that I found in our house when I was twelve. It was about what to do in the event of a nuclear holocaust.

The main thing I remember from it is an illustration. The nuclear family featured had collected all its essentials in one small corner of the house. They had constructed a sort of semi-triangular shed, using planks and blankets that sloped from floor to ceiling. Squatting in this sad little cubby-hole was their attempt at safety. Obsessive advance planning and frantic polishing seem to be mine. I've even taken to scattering diluted fabric conditioner on the carpets to make them smell 'Summer Fresh'.

Though my marriage is now a wasteland, some vestige of family life must somehow be salvaged for Katie's sake. If I do not manage to do this she will, of course, turn into a drug addict who feeds her habit through prostitution or petty crime. I've had recurring and graphic dreams about this lately in which court scenes are prevalent.

'It's all my mother's fault,' a tear-stained Katie tells the judge. 'She left my father because he borrowed her hairdryer.'

I stand up in the dock to protest. 'No, no, your honour, it was a hair grip! He took my fake diamond hair grip.'

While I say this Cait Carmody appears in a short skirt and starts serving *hors-d'oeuvres* to the jury. And when I look at the judge more closely I realise that, under his wig and false moustache he is, in fact, Bruce.

At this stage of the dream I usually wake up in a cold sweat and take one of those little pills Susan got me from her Chinese herbalist. Then I lie in bed for a while and feel foolish.

'Hundreds – thousands of women find out their husbands have been having an affair and don't make such a

69

fuss about it,' I think. 'And anyway, if I'd been a better wife he wouldn't have strayed. My lingerie has always been too sensible and Bruce so likes suspenders. I should have taken more interest in *Avril* too. Just a little more effort would have done the job. Just a little more dedication.'

At times like this my thoughts sometimes stray to the sock I tried to knit at primary school. The teacher kept making me rip up the heel and start again. 'Try harder, Jasmine,' the teacher kept saying. 'Follow the pattern – that's all you need to do.' I never did finish that sock. This was a pity because it was in quite nice blue wool. I suppose deep down in my ten-year-old heart I knew that knitting the perfect sock was not my calling. Deep down in my ten-year-old heart I suspected that socks would be things I could buy.

I've been buying lots of books lately that purport to 'Change Your Life' – though frankly I'm beginning to suspect that I can't go into Waterstones about this one. I'm beginning to suspect I'll have to somehow work this one out on my own. Books do help though. Crisis seems so much nicer between covers.

I'm admiring my new book on lesbianism, and its shiny blue cover, when Mr McClaren appears by my desk. He glances keenly at the book and then at me. 'I – I got it for – for a friend,' I say with a blush as I shove the book back into its bag.

'Interesting subject,' remarks Mr McClaren, who is still looking at me. 'I'll have my tea now, and then we'll get on with some letters.'

'He would come along just then,' I fret as I go to the company's small kitchen. 'And he's probably ultra-conservative too.'

While Mr McClaren is drinking his tea I drink mine. I'm growing rather fond of his favoured blend and the light, fine

70

bone china cup that I sip it from. Yes, there's something rather restful about Mr McClaren's steady, though civilised, self-interest. This comes as something of a surprise to me. I do not normally take to people who expect to have their whims and pleasures so readily serviced. I'm not at all sure that being able to boom, 'Book me a table for two at La Forenza's, and then collect my dry cleaning – and sharpish,' should identify someone as a candidate for top management.

But Mr McClaren doesn't boom and I don't want to think about all that now. I need a bit of calm and quiet, and since these also seem to be Mr McClaren's current priorities, we can comfortably share the same clearing.

When I go into his office to take down some more letters he's unwrapping a parcel. It contains a small oil painting that he's just bought.

'What do you think of it, Jasmine? Stand back. Give me your honest opinion,' he says, almost as if talking to an equal.

It's of a naked woman with a big orange bottom. 'I – I think it's very nice,' I mumble.

'Yes – it's the expression on her face I like,' says Mr McClaren, who is studying my face with new interest.

'Is that chair comfortable?' he asks as I sit down. 'Because you can use the one by the window if you'd prefer. It has a straighter back. My usual secretary prefers chairs with straight backs.'

'No, thank you. This chair is fine,' I say. It seems that his doubts about my sexual proclivities have moved me up a number of notches in Mr McClaren's estimation.

When I get home I find that Eoin has sent me a letter. He gave me his card towards the end of the course. I thanked him and said I didn't have a card myself. Then he said that was all right because he'd write down my address. He said

this in a tea-break, and so I hoped he'd forget by the time he got hold of pen and paper back in the classroom. But he didn't. It went straight into his address book.

Now Eoin says that his greyhound is running in a race in Shelbourne Park and so, since he'll be up in Dublin again and staying the night, he'd like us to meet. He says he now knows we can only be friends, but it would still be nice to go out for a drink.

I know – I just know – he'd arrive at the pub doused in aftershave.

Just as I'm wondering how to tell Eoin politely, but clearly, to fuck off, the phone goes. It's Bruce and he sounds rather put out. Apparently Eamon, one of the actors in *Avril: A Woman's Story,* saw me with a strange man at the cinema. He saw the man link his arm through mine as we crossed the street. We looked very close and friendly, apparently.

Eamon wasn't going to tell Bruce this, but then he did because he thought Bruce 'should know'.

'If you've become involved with someone else you should have told me,' Bruce says petulantly.

'I haven't got involved with someone else.'

'Who was he then?'

'Just a friend from the course.'

'Rather a close friend, by the sound of it.'

'Well he isn't.'

'Look, Jasmine, I'm getting pretty confused about all this.'

'Confused about what?'

'About you moving in with Charlie and…and going out on dates.'

'I've only been out on one date with Eoin – and it wasn't the kind of date you mean.'

'So Eoin's his name is it?'

Bruce can be like a terrier when he gets going. He has a jealous streak in him and it's been the cause of numerous arguments in our marriage. I used to find his insecurity irritating but reassuring. I figured that if he were so concerned with loyalty then he, himself, wouldn't stray.

'I'll give you until next month to come back – otherwise I think we should separate,' Bruce continues. 'You've made your point and I've finished with Cait, so I've kept my side of the bargain.'

'What bargain?'

'It's pointless this game-playing. Either you're prepared to give our marriage another go, or you're not.'

I'm so angry I can't even speak.

'Jasmine – are you still there?'

'No,' I reply. 'No I'm not.' Then I start deep breathing. This is something I've learned from my yoga and meditation class and it's surprisingly helpful when you feel like attacking someone with a chain-saw. The alternative is to scream at Bruce down the phone, and I'm not sure I have the energy. He'll ring back if I hang up.

'Jasmine, I know you've every right to be angry with me, but surely enough is enough. I really do feel like I've reached the end of my tether.' Bruce is sounding more and more self-righteous. He's also been drinking. His words sound slightly muffled and he sighs in strange places.

And then a weird thing happens – I start to laugh. Great big belly laughs that boom down the phone.

'Jasmine!' Bruce shouts. 'Jasmine, calm down. You're getting hysterical.'

'No I'm not,' I splutter. 'It's you who's hysterical Bruce. You really are a hoot.'

'I'm going to hang up now. We'll talk later when you've calmed down.' Bruce has assumed the soothing tones of a helpline volunteer.

'Yeah, go ahead. Hang up. That's a good idea.'

But he doesn't hang up. He says, 'I know you won't like me saying this Jasmine, but it seems to me that some of this – just some of it – has to do with the…the change.'

'What change?'

'You know – the – the menopause.' Bruce says the word cautiously.

'I haven't started that yet Bruce. The only thing that gives me hot flushes is you.'

There's a point in prolonged and fruitless attempts at communication when you just give up, and I've reached it. The effect is quite bracing. Suddenly I'm no longer swinging fearfully on a tattered rope bridge. Suddenly I know this chasm is too wide, to deep, to cross. I'm turning round. I'm turning back. Whatever I say now, it doesn't matter.

'I mean, I'm not saying I don't understand how much I've hurt you. But I don't know how to make up for it – what to say. Your behaviour lately has been so – so – out of character.'

'I'm glad you think you understand so much.' I've stopped laughing.

'Well, I do try.'

'Because it seems to me you don't understand much at all.'

I can almost hear Bruce deflating, like a pricked balloon.

'Anyway, I've got to go now,' I continue.

'Why?'

'Katie will be arriving soon. But I think you're right about us separating.'

'I didn't say we should separate.'

'Well I think we should. We don't understand each other any more.'

'I think we do.'

'No. If you did understand you wouldn't dream of making such a fuss because I went with a friend to the cinema.'

'How am I to know he's just a friend?'

'You'll just have to trust me. He is interested in me, but I'm not interested in him.'

'Okay – okay. I believe you.'

'But I can't believe you any more, Bruce. Don't you see? That's what happens when you lie and lie to someone. How can I know if you mean anything you say?' I'm amazed that I say all this so calmly.

The phone goes silent. I don't like this silence. It's sad.

'I've said all the wrong things, haven't I?' Bruce sighs.

'Yes, you have.'

'I didn't mean it – the bit about you having to come back in a month. I was just trying to push you. I didn't know what to do. What should I do, Jasmine? Tell me.'

'I really don't know, Bruce. I wish I did.'

'I've been a pig, haven't I?'

'Don't let Rosie hear you say that.' I smile. 'She prides herself on her sensitivity.'

'Maybe we should go to a marriage counsellor.'

'Maybe. Let's talk about all this another time. I'm partly to blame too. I like to think I'm not, but it seems maybe I am.'

That silence again. 'I've been watering your plants.' Bruce's voice is softer, calmer now.

'Thank you, Bruce.'

75

'Did you know that basil must be watered in the afternoons?'

'I've read that label too. I'm not sure if it's right.'

I feel drained when I hang up. But lighter. As though I've been travelling so long I don't care if I arrive any more. As if all this stuff about life and relationships making sense is a bit of a joke anyway. What I need to do now is cut some carrots and get the potatoes on to bake.

Somehow everything gets done. It's like I'm watching myself do it. Then the doorbell rings.

I don't panic. I walk slowly into the hall. A normal family weekend, that's what we're going to have. A nice cosy time. I square my shoulders and prepare my smile as I open the door. And there stands Katie. My dear, darling Katie, with a rucksack by her side.

'Mum!' Katie throws her arms around me. 'This is Sarah.' Sarah is petite and olive-skinned. She has short black hair and almond-shaped eyes.

'Hi Sarah!' I beam. 'You're very welcome.'

But Sarah doesn't seem to be responding. Her round, friendly face appears to be frozen in shock. She's looking at something behind me, and her pretty eyes are growing wider and wider. Then I feel something nudging at my sleeve.

I must have left the back door open because it's Rosie.

Rosie wanted to welcome them too.

Chapter 10

ROSIE'S BEEN A GREAT success with Katie and Sarah this weekend. Katie's convinced that Rosie shares her passion for the songs of Brian Allen, though frankly I think she's using it as an excuse to keep playing the bloody things.

She brought loads of his CDs with her. Apparently Rosie wiggles her tail every time Brian's big hit, 'Do It To Me Baby. Do It' comes on. 'Peel off those panties – peel them down,' Brian croons at full volume in his deep, authoritative voice. 'Let's just do it. Let me into you. Oh baby! Oh baby! That's right. That's right, baby. Yeah – com'on.' Then he lets out an awful screech, and the rhythm section mimics the sound of bedsprings.

As we sit down to dinner Brian is still moaning and groaning in the background. 'I hope he uses condoms,' I say as I dish out the shepherd's pie – I made a lentil casserole for Charlie. 'Let's give him a little rest, shall we? He must be exhausted.'

'Oh, Mum, don't be so anal,' says Katie.

'What did you say, young lady?' I almost drop my serving spoon.

'Anal – as in uptight.' She gets up reluctantly and goes over to the hi-fi, which she turns off.

'Look, we're eating now, okay?' I say firmly. 'The only orifice I want to be reminded of at the moment is my mouth.'

This makes Sarah giggle and Charlie smile. Katie, however, goes into one of her sulks.

'And to think your favourite song was once "The Teddy Bears' Picnic",' I muse as I watch her stabbing her shepherd's pie sullenly with her fork. 'Still Brian is very

obviously heterosexual, so maybe you've decided you are too.'

After dinner Katie and Sarah ask Charlie about his work. Katie was a bit cool with Charlie at first.

'Hello, Kate,' he'd beamed when he first met her.

'Katie,' she corrected him sternly.

After a while she opened up though. She and Sarah are really impressed by all the bands he's worked with as a recording engineer. He hasn't actually met Brian Allen, which of course would be the icing on the cake. He has, however, met a trombonist who worked on Brian's first album.

'Really!' Katie almost jumped off the sofa with excitement. 'What did he say Brian was like?'

'Very professional,' said Charlie, somewhat guardedly. 'Very approachable and friendly. He went out for a drink with some of the lads after the session. Likes a particular brand of German lager apparently.'

'Which one?'

'I'm afraid I've forgotten its name.'

'Oh.' Katie sounded disappointed.

Charlie brightened. 'And butterscotch. I remember being told he liked that too.'

'Butterscotch.' Katie repeated the word reverentially.

I got up to go to the loo. As I reached the door I heard Charlie ask her, 'So, how are things at college?'

I wanted to linger outside the door to hear her answer, but I knew Katie would sense this. She doesn't let me get away with much. Even so, none of them seemed to notice when I returned. They were in a huddle and I heard Katie whispering earnestly, 'I'm not that surprised, but it's still hard to accept.' Then she looked up at me and said, 'Oh, you're back.'

'I can go out again if you want.' I tried to make it sound light-hearted.

'Oh, don't be silly, Mum!' Katie exclaimed, half-bashful. She looked over at Charlie, who smiled supportively. Then she got up and gave me a hug.

'Anybody want a cuppa?' Charlie asked.

'Oh yes, please,' Katie beamed. 'Can I have mine in the teddy mug?'

'Well, your mother usually uses that one,' he looked at me wryly. 'But I'm sure she won't mind just this once.'

'What does a recording engineer actually do?' asked Katie, when we all had steaming mugs before us and were helping ourselves liberally to choccy biscuits.

'Fifty per cent is technical,' Charlie answered. 'You know – pushing faders and adjusting levels – making sure things sound good. The rest is psychological.'

'Really?'

'Yeah. Musicians get a bit uptight in the studio sometimes. It makes them feel better when I come along and adjust the mikes a fraction or something. Half the time it's not necessary.'

'So why do you do it?'

'Anything that helps them helps me. I understand what they're going through.'

'Charlie's a musician.' I always have to add this bit of information. He never mentions it for some reason.

'Really!' Sarah gets enthusiastic then. 'What do you play?'

'The saxophone, mainly.'

'I play the guitar. Do you have a guitar here?' Sarah looks round the room.

'Yeah, I do. Upstairs someplace. I'll get it if you like.'

'Would you?' Sarah bounces delightedly on her floor cushion.

And we end up having an impromptu concert with Charlie playing his saxophone, Sarah the guitar, me tapping on the table and Katie shaking a jar of lentils. Rosie, our audience, sits on her rug near the door and watches us all with rapt attention, though she occasionally scratches her ear against a chair. Satchmo, Charlie's cat, has wisely decided to go outside for a stroll.

Then the top of Katie's jar of lentils comes off. They scatter all over the place and Katie and Sarah collapse in a heap on the floor in a fit of giggles. Charlie looks over at me then, in a strange way that makes my stomach lurch. I really didn't expect him to look at me like that. I don't know what to do. I look away, and then back at him, only he's now looking at the girls. It's probably just my imagination.

When I look at the girls myself I see that Sarah's arm is lying across Katie's breasts in a very comfortable, familiar, way.

'Oh shit,' I think. 'And just when the evening was getting all apple pie too.'

That night, when everyone has gone to bed, I hear Katie sneaking into Sarah's room. This is, of course, something I had feared, but there's nothing about how to deal with it in *Lesbianism: Old Myths – New Realities*. So I just lie there, rigid with indecision, while my head swims with lurid pictures of my daughter licking another woman's vagina. I wonder if they've brought a vibrator and lubricator with them, and what it feels like to hug bare breast to breast. In fact, if my daughter weren't involved, I would have found the situation quite interesting. But as she is involved, I quickly work myself into a state.

It's hard enough adjusting to the idea of my wide-eyed innocent daughter having a sex life at all, let alone this one.

I want to charge into Sarah's room and shout…'Stop it. Stop it at once!' like I used to when Katie and her friends had dramatic and noisy pillow fights.

But they wouldn't stop it, I know that. They'd just do it somewhere else. I'd alienate them – that's what I'd do. And Katie wouldn't visit any more.

'If only Bruce were here,' I think. 'Then we could sit and fret together.' Since we've masqueraded as 'liberal' parents for years, it seems only fair we should share the heat as Katie calls our bluff.

'Well at least she can't get pregnant,' I think forlornly, as I pace round my room. All my self-help books tell me to emphasise the positive. 'What am I going to do? I can't go back to bed with this going on.'

I know what Bruce would do. When he can't sleep he watches television. He'd tune into an old black-and-white thriller about giant cockroaches terrorising a hairdresser's or something, and tune out. But I can't tune out. I have to talk to someone.

Thankfully Charlie is still awake when I tap on his door.

'Charlie – Charlie – can I come in?' I whisper urgently.

'Yes. Yes. Of course. Just a moment.'

He's doing up the top button of his jeans as he opens the door. I stumble gratefully inside. 'What is it? You look worried.'

'Yes. Yes I am.' I whisper. 'Close the door first then I'll explain.'

'I've closed it.' Charlie looks at me expectantly and I look at Charlie's bed. It seems very big and it makes me uneasy, especially since Charlie isn't wearing anything apart from jeans. I move to a chair by the door and sit down, shoulders hunched.

'Katie' – my voice comes out as a croak. 'Katie is, at this moment in…there…' I gesture in the general direction of Sarah's bedroom.

81

'In the bathroom?' Charlie is seated on the edge of his bed. He seems somewhat bemused.

'No – no – not the bathroom! Of course she's not in the bathroom.'

'Sorry – it just seemed a remote possibility.' He's trying not to smile.

'This is serious, Charlie.' I take a deep breath. 'She's in Sarah's bedroom. They're having sex.'

'Are you sure?' Charlie often asks me that question.

'Yes. Yes. Of course I am. I heard her.'

'Moaning or something?'

'No, no. I heard her go into Sarah's room. Why else would she go in there? She told me herself she thinks she might be a lesbian. What should I do Charlie? What should I do?' I look at him pleadingly.

Despite my distress I can't help noticing that Charlie has a great body from the waist up – and below it too most probably – only that bit's covered. His chest is really broad and well-built and has just the right amount of muscle. I wish he'd cover up.

Charlie calmly reaches for a T-shirt.

'Well, Jasmine,' he says. 'It seems to me you could go in there and tell them to stop, which you have every right to do since they are your guests.'

Charlie pulls the T-shirt over his head as he says this. The hair under his arms is very fine and bushy, and I see that he has a mole under his right nipple.

'Or you could just let them get on with it and talk to Katie about it tomorrow.'

'What would you do, Charlie?'

'I'd probably talk with her about it tomorrow.'

'Yes. That's what I'll do. I'll talk with her tomorrow.'

I feel a great surge of relief as I decide this. Then I notice Charlie's eyes wandering appreciatively and I realise my night-dress is extremely short and rather see-through.

I jump up, arms crossed. 'So that's decided then. Thanks. Sorry for disturbing you.'

'You didn't disturb me.' Charlie gives me an amused, affectionate look. 'Or maybe I should say you did, but not in quite the way you mean.'

'Oh God,' I think. 'That look that made my stomach lurch wasn't in my imagination after all.'

He gets up from the bed and moves towards me. 'You look lovely,' he says.

'Do I?'

'Yes.'

He's standing right in front of me now. The space between us feels electric. It's like he's a magnet and any moment now I'm going to be drawn – wham – into his arms. I feel as though we're both going to ignite with sexual tension. If I don't get out of here fast Katie will find two little heaps of cinders on the floor.

'Well, I suppose I'd better get back to bed,' I say. I'm shivering, but it isn't because of the cold.

'Yes, perhaps you'd better.' Charlie's eyes hold mine. They're like headlights, and I'm caught like a rabbit. I've often seen affection in those eyes before, but now there's something more. Determination. Amusement. Passion. Love? I'm almost dizzy with longing and fear.

'Don't be frightened,' he says. His fingers brush my cheek ever so gently.

Then they trace my eyebrows and my lips. They move tenderly along my nape and down to my breasts. He touches my left nipple, making little circular movements that send a tingle straight to my heart.

I want him. I wish I didn't but I want him so much.

83

And then I hear Katie coming out of Sarah's room. She's tapping on my door. She's saying, 'Mum, can I come in for a moment? I want to ask you something.'

'Oh God!' I moan. 'What am I going to do? She can't find me here. She'll go into my bedroom if I don't answer.'

Charlie's face stiffens with frustration, then he sighs. 'Hide behind the curtains,' he says. Then he opens the door.

'I think I heard your mother go downstairs,' he says to Katie.

'Thanks, Charlie. I'll have a look.'

'The coast is clear. Now go into the bathroom,' Charlie whispers urgently.

Katie comes back upstairs just as I bolt the bathroom door.

'She's not there, Charlie.'

'Have you tried the bathroom?'

Katie bangs on the door.

'Hu – hullo. Who's there?' I whimper.

'Are you deaf or something, Mum? I've been calling you.'

'Really? Oh, sorry. I was in the shower.'

'It's rather late to be having a shower, isn't it?'

'I – I just felt a bit grubby. I'll be out in a second.'

I splash some water over my face and hair and wrap a bath towel round myself. Then I peer out the door.

'What is it Katie?'

'Sarah's got her period.'

'Oh. Is there some reason I should know this?'

'Yes. She forgot to pack her sanitary towels. Do you have any?'

'I'll bring her some in a moment, okay?'

'Thanks, Mum.'

84

I find the sanitary towels and go to my bedroom and put on my dressing-gown. Then I approach Sarah's room with some trepidation. Katie's gone back in there. I knock on the door.

'Come in,' Katie calls out breezily.

And there they are, both lying on the bed, watching a small black-and-white television.

'I didn't know there was a television in here.' I'm beaming with relief.

'Yeah – we found it at the bottom of the wardrobe,' says Sarah. 'We're watching *Little Britain.*'

'Well, don't stay up too late, will you?'

They look like two contented kids, all snug and cosy. I smile indulgently and go back to my room. Then I sit on my bed in a daze, thinking about what just nearly happened.

'It was my fault of course,' I think. 'Going into his room wearing a see-through nightie. Any man would have thought it was a come on. But Charlie isn't any man. That's becoming uncomfortably clear. He's so – he's...no, no. I can't allow myself to think like this. Life's too much of a muddle as it is.'

I banish the incident from my mind, but it returns, uncensored, just as I drift off into sleep. It's been so, so long since I felt like that.

My toes curl at the memory.

Chapter 11

SUSAN SAYS SHE'S GOING to write a Mills and Boon novel. She was going to try one of their 'Medical Romances'. Now it looks like she might turn her hero into an engineer, a rancher, or a film director. She's not sure if she's going to go for the frequent sex or sex at the end format, but it's going to be set in Africa.

A lot of those novels are set in exotic locations. While the heroine feels the hardness of the man she despises – the man who has crept up on her and forced her to kiss him with a fever of passion that grips her entire body – there are usually cicadas chirping in the background. We have long discussions about when the hero should pounce on the heroine, and where. We both agree that he has a huge penis.

Susan has decided to try her hand at romantic novels because she wants to live somewhere warm. The Irish winter is getting to her. She's working in an old folk's home at the moment – the place where my Dad spent his last five months – and I think that may be getting to her too. She's up to her neck in bed pans and walking frames and incontinency pads.

'Life is so short, Jasmine,' she says. 'So short.'

There's an old lady in the home whom she insists I must meet. She's a real character, apparently. She's unsure of how she spent the last half hour, but she knows an enormous amount about hunt balls. Hilda – that's her name – also wanders. They have to keep the front door on one of those small chains to prevent her from gallivanting off on her walking frame. Susan thinks this is most unfair.

86

She thinks Hilda should be allowed to gallivant if she wants to and take her chances with the traffic.

I've been putting the visit off because I know it will bring up memories and I'm not sure I'm ready to deal with them yet. All those hours sitting at Dad's bedside wondering if he knew I was there. The hot, stuffy feel of the place and the sense of time hanging heavy in the air, along with the smell of baking and talc and urine. Sometimes, when they changed Dad's pads, I used to go to the television room and sit with the residents. A lot of them didn't know what was on the television – they just sat there on enforced breaks from their beds.

There were some people I could talk with, though, and they usually wanted me to change channels. The remote control was a complete mystery to them and they perked up hopefully as the pictures switched from news to snooker to antiques to chicken casseroles.

'Is that the programme you want?' I'd ask eventually. 'Yes. Yes. That's the one we like,' they'd say. It was usually some gameshow. It seemed to me a terrible injustice that the last years of their lives should be spent watching people win automatic washing machines.

But what should they have been doing instead? What should we all do with these precious years we've been given? That's the question that's been dogging me for the past year. Susan's right, all this stuff I've been going through isn't just to do with Cait Carmody. It was so much easier when I thought it was.

I've bought a book about visualisation. One of the things it says is that visualising things as you would like them to be can help you clarify your life values and goals. So I've been visualising piles of things, including life on the Mediterranean. It's a really great fantasy – I can

almost smell the jasmine, like Mum must have when she was pregnant with me.

She was on holiday in Greece. A man suddenly appeared in front of her at a market and handed her a jasmine blossom. That's how I got my name. Mum told me that story so many times, and when she did a wistful, dreamy look always came over her face. Sometimes it seemed as though that man with the jasmine blossom was my real father. He somehow understood my mother very well. How she longed for the grand, unpremeditated gesture. How little my father understood this, though he loved her very much.

I never quite worked out if she loved him but I do know that, in later years, she hated to watch him eat. He had a large, enthusiastic appetite and as he swept the food into his mouth she averted her eyes and a pained expression came over her face. When she did this I often wished she'd go away for a while and find out what she wanted. I felt that would be easier for us all than watching that expression on her face.

My visualised Mediterranean hide-away is always sunny. And the view from my visualised veranda is just gorgeous. It stretches from the sunflowers in my garden to the orange and olive trees dotted on the hills, and the shimmering sea in the distance. My kitchen is made from wood and full of nourishing things in jars and tasty things wrapped in foreign looking paper. I buy them at the local shop. It's a lovely shop. Friendly and full of chat and totally without malice.

The icing on the cake is knowing that a gorgeous man lies – at that very moment – in our big wooden bed covered with a fabric I have not, as yet, fully designed in my imagination. It may be rich and Indian or a light Liberty fabric – that has yet to be decided.

I make us some coffee – I can drink rich dark coffee in the Mediterranean and it doesn't affect my liver. And I cut

a large slice of cake without guilt because my thighs are now cellulite-free.

He calls to me – my gorgeous man. And of course I go to him. Happily. Unafraid. All of me. I don't leave part of me in my head planning what I'll do when he says he's not ready, or I'm not ready, or he needs his freedom, or I need my freedom, or he's married, or I'm married, or we're both too mixed up, or something else that's never said but feels like greyhounds streaking through a wet Sunday in a Godless world. The world isn't Godless. Not here.

And I go into the bedroom – which is warm and full of dappled sunlight – and I sit on the bed and offer him cake and coffee. But he strokes my cellulite-free thigh instead.

His hands are big and gentle and climb towards my crotch. And my mother's voice doesn't tell me he'll ditch me when he's done with me. My mother's voice doesn't say – 'You're married' or 'You should be married and living near me in a devoted manner.' Though my mother is dead her arms are full of jasmine blossoms. My mother has better things to do and is doing them.

My gorgeous man is a great lover. We try all sorts of positions in a loving, passionate way. He looks into my eyes. He wants to get closer – and closer – until we forget.

Forget that if we go too far, too deep down this road, we may not want to get up at all. That we may want to remain moored for ever, bathed in the soft slithery warmth of bodily juices. That the world outside may seem even more humdrum and cold and silly than ever. That we may want to grind against each other endlessly – hoping that our molecules will merge and we won't ever have to say things like: 'I need two planks of plywood and an electric drill,' or 'Of course friendship is what it's all about in the end.'

But it's okay here in the Mediterranean. Our love-making isn't about forgetting. Or remembering. It just is.

It's like plunging into a great, powerful ocean and soaring back up again into the light. It's like being moved and dragged by giant, friendly waves under a smiling moon and not once wondering why – or how you'll get back to the shore, or if you'll be all alone when you get there. Alone like on *Desert Island Discs*.

'I'd like "I Will Survive" by Gloria Gaynor because it reminds me of this man I met.'

It's not like that here. He's not going to go and neither am I. We're meant to be together and know it. Even if I were old and grey with wrinkles he'd still love me. He won't have an affair. I prepare salads in a big earthenware bowl and I love to watch him eat them. I love his appetite for me – for life.

The nice thing about the life I have somewhere in the Mediterranean with this gorgeous man is that after we've made love we get up without dread. We get up and do the things we need to do, and they don't drag us down. We know life's not always cherry pie and cream. I get on with my things and he gets on with his. We have our own space, and we have our own enthusiasms. There are friends too – good friends. They come round for big meals which we both prepare. I'm a good cook when I'm in the Mediterranean. I can even make cheese soufflé and hold a conversation about water irrigation.

They're much better than my fantasies about Mell Nichols – these hours I spend in the Mediterranean. Quite a bit of the time I'm on my own, wandering through my scented garden, swimming in the sea, weaving, sunbathing. I don't have to slurp Factor 18 all over myself here either. The ozone layer is just fine. I use natural dyes in my weaving – I make lovely big woven pictures that sell well in the big city, which I have not named. I haven't named my

gorgeous man either. I haven't even really seen his face. I know it's a nice face, but the image is never clear.

It's all a dream anyway. A dream, that's all it is. People don't live like that. People don't love like that. Love…we only have a few paltry linguistic labels for that thing; the thing that hurls us like a bob-sleigh into the depths of our own hearts.

Susan thinks my Mediterranean man sounds great. I think she may snitch bits of him for her novel. When she isn't going on about every man on earth being married, she's very romantic. Deep down she's sure she's going to meet Mr Right, rather than Mr Right Now. I myself am beginning to doubt this because Susan is very fussy. But how can I tell this to a woman who still believes that 'Things Happen' after a Badedas bath?

Susan's just phoned. Hilda, the hunt ball woman from the home, has just escaped. She says I must help find her before the police are called. If the police are called Hilda's movements will be even more restricted, but if we find her fast maybe no one will notice her bid for freedom. The home is only down the road from Charlie's house. She must be somewhere in the vicinity.

We spend over an hour in Susan's car checking the roads and the local pubs and hairdressers. 'She can't have gone far,' Susan keeps saying. 'I hope she's all right.' We're just about to give up and call the boys in blue when Susan spots Hilda sitting in a large Mercedes talking to an extremely handsome man. He seems to be enjoying the conversation immensely. Every so often they both throw their heads back and laugh.

'Hilda! What on earth are you doing?' Susan shouts at the car window. It turns out the man, who's called Liam, spotted Hilda staggering along on her walking frame and offered her a lift into Bray. They were just about to go into

a pub for a quick gin and tonic and wonder if we'd like to join them. Susan fumes and fusses for a while and then, since her nursing shift is over, she says okay. She'll have to ring the home first though and explain that Hilda has been taken out by 'a friend'.

Two hours later we're taking Hilda back to the home in Liam's posh car. Susan and he are talking away like they've known each other for years. Hilda is telling me about the time she swung from a chandelier in Dromoland Castle. Liam comes from Ireland but lives in France. He's divorced and has a business in Provence.

'Where did you say your business is?' I need to have the information repeated.

'Provence – you know – by the Mediterranean.' Then he turns to Susan and says, 'You'd really like it there.'

Susan and Liam keep turning towards each other at the exact same instant. One minute Susan is shy, the next she pats his hand as she gives directions. They're going to go to bed together one day soon – maybe even tonight. And it won't just be for sex. The attraction between them is making even me feel giddy. He's warm, is Liam. In fact he's not at all unlike Susan herself. It seems entirely fitting that Hilda should have brought them both together. Susan could only love a man who could care about someone like Hilda. Someone who it's all too easy to forget.

We must cut quite a dash as we crunch our way up the gravel of the home's driveway.

'I must change. I must change,' Hilda announces as we help her out of the car.

'Why Hilda? You're fine as you are.'

'No I'm not. I can't go to the Duhallow Hunt Ball like this!' Hilda protests. 'I want my velvet dress. And I don't like the hotel where they're holding it this year. The staff

have a very arrogant attitude.' Hilda time-travels sometimes when she's tired.

'I tell you what,' says Susan, 'why not have a little nap in the hotel first? You must be tired after your walk and you'll need your energy for the dancing. You can change later.'

They're still discussing this as they disappear through the front door.

When I get back to Charlie's I find that he's upset because Rosie has peed on her rug. There's a message to call Katie. I call her. She believes she may have left a bottle of massage oil by Sarah's bed.

Chapter 12

SINCE I WAS AN only child myself I thought it would be nice for Katie to have a brother or sister. Bruce and I tried for another baby for years, but it never came. We never really found out why. I went through an unsettling time of having thrush and cystitis, and then my periods decided not to follow the calendar and came and went as it pleased them. This naturally led me to believe I might be pregnant many times when I wasn't. Katie's pram and buggy and baby clothes and cot are still stored in the attic. I'm going to have to give them away one of these days.

Some of the numerous experts we consulted said I might have something wrong with my tubes. We tried various treatments. We also thought we might adopt at one stage, but Katie was ten by then and seemed happy enough on her own. So we stopped our obsession with fertility. I was getting extremely tired of rubber gloves and spatulas and scrapings, and thermometers to check if I was ovulating. It was all a most messy, undignified business. It quite put me off sex for a while.

Bruce tried to be understanding. On one of his business trips abroad he also bought some pornographic magazines. He secreted them under tax returns and letters in a drawer of the big desk in his study. I found them one day when I was searching for a telephone number. I'm not sure why I thought the business card of the carpenter I wanted should be in that drawer, but I checked there anyway.

I couldn't believe the pictures in those magazines. The gynaecological poses of those women were not unlike my own recent experiences in stirrup chairs. I'd heard about pictures like that and thought I'd be deeply

disgusted if I ever saw them, but I wasn't. I was offended in a way, but there was something fascinating about them too. What were these women offering? Surely it wasn't just the fantasy of their flesh.

A strange, shadowy thrill went through me as I thought of how my husband might have masturbated to the sight of those open legs. What thoughts were going through his head? What did the territory between those thighs mean? What treasure did he hope to plunder and would it still gleam and sparkle for him as his sperm lay, swimming, on his stomach. I thought not. For in the weeks that followed I sometimes masturbated myself to the images of my husband's lonely passion.

The thoughts of his excitement excited me. The power and primitiveness of it. The lack of tenderness. The need. But the thrill from those self-pleasurings never lasted long. After the mystery, that moment that takes you somewhere longing cannot name, came the longing itself. The moment when I knew his excitement wasn't mine. Surrender – dominance – neither felt quite right. I wanted both at the same time, and much more too. Love is what I was looking for, I suppose. It always has been.

It seems to me that though other people can undermine your faith in love, it's one's own cynicism that causes the deepest hurt. It's when you begin to wonder whether you yourself can love that the golden gauze is lifted. When you wonder whether you're capable of surviving the pain, if it comes. That strange pain that, for prolonged periods, leaves you feeling like you've just got off the boat train from Holyhead. Slightly nauseous and in another country. Tired and still swaying from the trip.

'Be not cynical about love, Jasmine,' Aunt Bobs used to say, "…For in the face of all aridity and disenchantment it is as perennial as the grass…You are a

child of the Universe, no less than the trees and the stars; you have a right to be here."'

I used to think Aunt Bobs had a marvellous way with words, until I discovered they were other people's. In fact the ones about love were from Desiderata. 'You're just a thief Aunt Bobs!' I stormed and Mum slapped my wrists.

'Don't be rude Jasmine,' my mother said. 'Life's difficult enough without you being rude.' But Aunt Bobs confronted my wrath with equanimity. '"I have drunk water from wells I did not dig," as I've read somewhere,' she said.

I stayed with Aunts Bobs for two months when I was eleven. The reason for this was never quite explained, but I think my mother may have been going through some crisis. She cried a lot and said things like, 'Will it ever, ever stop raining?' Then she went to stay in England with some relatives and I went to Aunt Bobs and Uncle Sammy.

Their four children had left home so I was very pampered. It was the summer holidays and I scampered around the fields and paddled in the river. I loved the feel of that river. The mud squelched through my toes and the fish sometimes bumped their noses against my legs. I built small dams and discovered the existence of creatures like water boatmen and caddis-flies. Once I was convinced I'd seen a baby crocodile, but it turned out to be a newt. That summer, running through those fields, was probably the happiest time in my life.

One of my Aunt's friends was a potter. He taught me how to use the potter's wheel and one day I made the blue bowl. The bowls that preceded it and succeeded it were misshapen, but that blue bowl was perfect. A gift from somewhere. I chose the glaze myself. It was the same

colour we all wished the sky would turn, especially my mother.

Before I left Aunt Bobs I offered the blue bowl to her. 'You have it Aunt. I want you to,' I'd said.

'No, no dear. You keep it. You made it yourself,' Aunt Bobs replied. 'A thing of beauty is a joy for ever.'

The last time I visited Aunt Bobs, many years later, the blue bowl was broken. I spent the morning mending it. It had broken into five large pieces. There was a chip or two missing, but the rest stuck snugly together. It could still hold water. It could still hold flowers.

I'd thrown the blue bowl at my first, and perhaps only, great love, Jamie. Well not at him so much, but at the floor. It was a silly thing to do but I was only eighteen. I didn't know that water, cathartic but not staining, was what sensible women threw *in extremis*.

The bus to the country seemed to take for ever the afternoon of that last visit. It was quite warm outside, but I still kept on my jumper. I bought some roses from a van beside the graveyard. They were £2 for four. Aunt Bobs grew them better.

The bowl was all right. The chips at the front had showed up a bit until I filled them in with a blue marker. And the roses, the pink roses Aunt Bobs liked, looked just as I'd hoped as I placed them on the grave.

I'd only been to the grave once before, with Jamie and my parents at the funeral. It seemed very strange and still there that day I stood alone.

'Jamie's gone to America.' I knelt on the ground as I said the words. The earth was heavy and soft, still settling. I tidied up some soil that had fallen off the grave. Aunt was always tidy. I wished I'd had a quote prepared. Aunt Bobs would have liked that. But the only quote that came to mind that day was 'Love is the thing with feathers' and it

didn't seem quite right. So I just said, 'I loved you, Aunt Bobs. I loved you and I always will.'

It was beginning to rain so I stood up and surveyed the grave for one last time. The funny thing was – when I looked at it from a distance – I couldn't tell the blue bowl had ever been broken at all.

Maybe that's what happens with some marriages. Great big cracks form down the middle, only you can't see them. Then one day something happens and everything splits open. It may seem like one big thing has done it – but it's been a lot of little things as well.

Like Bruce's pornographic magazines.

I never told Bruce that I'd gazed at those magazines myself, strangely fascinated. But one day, after a row, I mentioned that I'd discovered them, secreted in his drawer.

'I really don't know what you see in those women. They're laid out like slabs of meat,' I said. 'It really is extremely degrading.'

'You're right.' Bruce looked like a little boy. Guilty. Lost. Found out.

'Still, I suppose if they give you pleasure…' I left the sentence unfinished as I squeezed and tore the lettuce I was washing, examining it for slugs and snails.

That afternoon Bruce tidied our garden shed. He gathered old papers and cardboard boxes into a heap, along with some twigs and fallen leaves. He came in and got the magazines. He put them onto the pile and added a firelighter. Then he stood watching as the bonfire burned.

I wish I'd spoken to him then. I wish I'd gone out and told him that my own fantasies were not always politically correct. I wish I'd seduced him. Maybe even got out those old suspenders. I wish we'd laughed. I think people should laugh about sex more, I really do.

I wish I could ask Charlie for advice about my marriage, about all these little snapshots that keep coming back to me. Polaroid pictures that I didn't know I'd taken but which now swim in front of me.

They're not the kind of pictures I'd choose to take. I take happy pictures. My albums bulge with smiling faces at birthdays, holidays and weddings. Sunday afternoon ennui, rows, loneliness and funerals are not in there. Maybe they should be.

That day I found the hair grip, that day I waited in a daze for Bruce's return, I got out my albums and tore up many of those photos. Not into little pieces – just in two – right down the middle. Those smiling faces seemed to taunt me. It was as if it had all been a lie. But if other pictures had been there too – perhaps of Bruce standing by that bonfire – then maybe I could have left them alone. Let them go.

I wish I could let go of things more easily. But it seems to me now to let go of things you must have them in the first place. You can't leave them waiting in your head like film negatives to be processed. You have to accept them all – even the ones that are blurred and unsmiling. The ones where the flash didn't work or Uncle Sammy stumbled and left out all our heads. That's the album that would have helped me. That's the album I need now.

Charlie and I are growing apart. I miss him, even when I'm with him. It's just not the same any more. Ever since that night we almost made love there's been a tension between us. Maybe it's because I haven't been able to talk about what happened. Every time it looks like we might discuss it, I just clam up. We don't hug each other in the comfortable old way either. In fact we avoid touching each other at all.

Maybe Charlie thinks friends can have sex but I'm not sure they can. Not without it changing the friendship

anyway. Then again, maybe he wants more than friendship, but I really don't know if I could cope with that. So, it just seems easier to try and ignore it all. This is probably what's pissing Charlie off. He likes people to be straight with him. He doesn't like this beating about the bush at all.

I don't think Charlie has any idea how much all this brings up for me. I don't think he knows how frightened I am. It's easier for a man to be casual about sex. But if I make love with Charlie I have a feeling I won't feel casual about it at all.

The thing is, if I make love with Charlie I have a feeling that would be it – even if neither of us really wanted it. We'd be stuck together – metaphorically of course – like a habit or something. And I've been stuck with some man or another for most of my adult life.

I never, for example, went into town early and slipped into a cinema on my own. One of the early shows where you don't pay full price. I never went into a café alone and had a coffee and a chocolate donut and read or looked around. Now I often see women like myself, young and old, scribbling in notepads, dreaming, reading a book that must be good company because it makes them smile. Smiling at me too when they look up and see me.

I like choosing clothes because I like them – not because they'll suit some business do of Bruce's. I can't afford too many clothes these days but I tend to go for something comfortable in colours that I like. Colours are important to me. Bruce patrolled my colours for years – telling me this clashed with that. 'Simplify your wardrobe, Jasmine,' he'd say. 'Don't try to wear too many colours at once.' Now I wear what I please.

Baths are another pleasure. It's nice to have one just for the sake of it – not partly because someone may be licking or sniffing you later. I just love lying there caressed by the water, surrounded by strange, exotic scents.

Bruce and I used to take baths together in the early days. We'd soap each other down – rubbing each other's backs – getting at the hard to reach places with a cheerful zeal usually only found in detergent commercials. But soon our scrubbings turned into caresses as Bruce slipped his hand between my legs. He paid great attention to my breasts too – covering them with suds and foam until they resembled a small alpine landscape. He liked having his toes washed, one by one. Fred would get excited then – that was our pet name for Bruce's penis. I loved the way Fred grew in my hands – the pinkness and presumption of him. The determination too.

Those baths often ended abruptly with both of us scampering into the bedroom – me already moist and Fred already juicing. Fred was my friend then. An exuberant little creature that gave us both much pleasure. I don't know why, as the years passed, he stopped being so playful. Sometimes he even seemed a rather sullen presence who pondered his future while languishing amidst the generous folds of my husband's boxer shorts. Disappointed perhaps – certainly moody.

A bit like Charlie's being now.

Charlie is getting more and more distant and something has to give. I think I may move to a flat. Thankfully, I don't have to discuss this relocation with Bruce because he's away on location with *Avril,* who is now demanding all his time. Even if I announced that I was running away with the entire Chippendale troupe I don't think it would quite register with him at the moment.

When I told Charlie that I'd probably be moving out, a tight look came over his face.

'You do what you think is best,' he said, while struggling to open a milk carton. He then exclaimed 'Fuck!' as some of the milk spilled onto the table.

We've been very polite to each other lately, Charlie and I. Too polite. We're usually so at ease in each other's company, but now we're more guarded. He shouts at Rosie sometimes. He never used to. And he doesn't like her coming into the house any more. I've tried to explain to him about my needing some time to myself. I've also said that I have an enormous affection for him.

'How enormous?' he asked. 'Are we talking inches or yards here?'

'Oh, don't kid around, Charlie, you know what I mean.'

'No I don't. And I don't think you do either,' he said. And then he left the room.

Do you know what I wish sometimes? I wish I could just press the pause button on my life. Just stop it for a little while and take a rest. Fast forward and rewind would be useful at times too.

But maybe re-record would be the best of all.

Chapter 13

I'M NO LONGER MR McClaren's temporary secretary – his usual one came back from her holiday. But I am still working for the same company. It manufactures women's hygiene products, but you'd never have known it from Mr McClaren's letters. Amidst his frequent references to the Riviera not once did he mention the sanitary towel with the revolutionary flap.

This sanitary towel is now taking up a great deal of my time. I'm a product demonstrator for it, though thankfully I don't have to actually put the thing on. I just stand by the shelves where it's stored in the supermarket, thrusting coupons into the hands of passers-by.

'Fifty per cent off Superdry this week,' I say. 'Special introductory offer.'

Thank goodness no one has asked me to go into great detail about the flap. I'm not quite sure I understand it, but there is a diagram at the back of the box that I can refer to if necessary. The flap prevents leakage, apparently. You can open it out during the first heavy days, but leave it alone if extra absorbancy is not required.

Arnie, my yoga and meditation teacher, gets all fired up on the subject of menstrual cramps. As he demonstrates the various exercises that can relieve them he always says, 'Never forget your primeval force – your groundedness – your wisdom. Woman is the earth. Woman is strong.'

The men in the class do these exercises too. They're that type.

I have, of course, bumped into some people I know in this supermarket. I dreaded this at first, but now I've got used to it.

'Jasmine!' they say. 'What are you doing here?'

And I tell them that I'm demonstrating Superdry, the new sanitary towel with the revolutionary flap. I refer to the diagram at the back of the box. I go on a bit about leakages and extra absorbancy and then I thrust a coupon into their hand.

This of course is not the answer they wanted. They stare at me for a while and then they usually say 'I heard about you and…and…' as though actually mentioning Bruce by name might cause offence.

'Me and Bruce?' I suggest.

'Yes. Yes.' You can see they're really intrigued. Hoping for some nice juicy little bit of gossip.

'Bruce is off filming in Galway at the moment,' I usually reply. 'The film's called *Avril: A Woman's Story*. It's about espionage and love.'

They usually move off sometime soon after that, these people I hardly know who want to know so much. Who even stand around and wait for a while, hardly believing that they're not going to hear more. And as I watch them walk away there is one small consolation – they usually have a packet of Superdry amongst their shopping.

I wish I was offering people bits of pizza instead of sanitary towel coupons. No one crowds around me like they crowd around that woman near the delicatessen. There aren't too many men in this section either. When one passes I have to remember not to thrust a coupon under his nose.

I'm wearing a white dress and a gold-coloured badge with 'Superdry' on it. At least I don't have to wear a little cap. Standing for hours on end is very tiring. Sometimes I take a quick stroll up to the Mr Proper section to ease the aches.

Smiling all day is fatiguing too. I have to smile at everybody, even at the women who brush impatiently past me, almost snarling. The trolleys they're pushing don't help of course. A lot of those trolleys sort of scuttle along sideways. Everywhere I turn as I stand in this aisle I see women and men wrestling with them – tussling over which direction they should take as though remonstrating with a bored horse from a riding stable. And you can tell which shoppers are really pissed off because they keep shoving their trolley into people.

'Sorry – sorry,' they say, but you can see they don't really mean it.

Many of the women in this supermarket behave as if they're double parked. It's the double life that probably does it – working and then having to go home and take over most of that too. I admire them, but it doesn't seem fair. Sometimes I feel like standing on a soap-box and giving little lectures to the men who breezily saunter by the household cleaning section. Occasionally, just occasionally, I notice a man pondering whether to purchase the lemon or pine scented kitchen cleaner, while his wife consults her Blackberry.

One thing that would really make this job easier is ear-plugs – but then I suppose the same thing could be said about much of life. The music in this supermarket is really fraying my nerves. On the very rare occasion when they play something half-decent this raspy voice always cuts in and roars for Jim Boyle or somebody to go straight to men's toiletries. You'd think there was some sort of emergency with the aftershave.

It's a secular shrine, this supermarket. It's very large and shiny new and in the middle of suburbia. It's the kind of place where you find loads of peach. Peach toilet paper, peach bath towels, peach napkins, peach room freshener.

The funny thing is they don't actually sell the real thing in the fruit department.

'I can't see the point of peach,' Bruce used to announce sometimes. He had a thing about that colour. When we had a row I think he secretly feared that I might seek revenge through Dulux.

There's a little café beside this supermarket and it mainly seems to sell lasagne. Lasagne is everywhere these days – like peach. I don't go to that cafe. I go to the one further away where you don't have to look happy. I have egg and chips and let my jowl droop. It's a very no-nonsense place. Scowling is perfectly acceptable – in fact almost *de rigueur*. They always have the radio on, but not too loud. It's usually some pop station where everyone has either an American or Australian accent. Sounding like you come from a place that could, just possibly, have year-round sunshine is quite lucrative apparently. But no one in this café is fooled. They know that even when Dublin bay is called the 'Bay Area' in weather forecasts, the rain will still piss down if it wants to.

It was pissing down as I waited at the bus stop this evening. It's amazing the conversations you can have about buses when you're waiting for them for prolonged periods of time. They begin to sound like strange creatures out of a wildlife documentary whose habitat and migration patterns are still a mystery.

When I got home, Charlie was out. He left two used mugs on the kitchen table. As I was clearing them away I noticed something.

One of the mugs had pink lipstick on its side.

106

Chapter 14

THERE'S A STRANGE WOMAN in Charlie's bed. I saw her there when I went by. The door was open. She was wearing a T-shirt and a big smile. I fled like a child. My stomach felt like it had been punched. I went back to my bedroom – winded – sore and dazed. I know I'm being stupid. Charlie's a free agent and can do what he likes. It's just I didn't think he'd do something like this. Not without telling me anyway.

It's Saturday morning. I've got the day off so I can't go in to work. But I don't want to stay here and watch them mooning over each other. Maybe I should just go out and walk around for a while. I feel like Chicken Licken did in one of Katie's childhood books. What made Chicken Licken so irresistibly entertaining to my four-year-old daughter was his firm belief that the sky was falling down.

Charlie's house feels cold and furtive suddenly. I walk into the kitchen. If I'm quick I can have some breakfast before they do. I don't feel like eating. I feel a bit woozy actually, but it's important to remember to eat. I've learned that lately. Only suddenly the woman comes in and says 'Hi there!' as if I should be pleased to see her. She wants to know where the Barleycup is kept. She's not wearing a bra under her T-shirt. She pads around languorously, her long cotton skirt swaying gently. She's barefooted. Barefooted and brazen it seems to me.

'You must be Jasmine,' she says as I wonder what to do with the toast I've just made. I wish I hadn't. That toast implies that I'm just about to eat, but I don't think I can eat it now. What I'd really like to do is throw it at her sweet, calm face. I've seen that face somewhere before. It

107

was the face in the nude photos that fell out of the box when I was clearing Sarah's room. It's older now, but still very pretty, and tanned.

'Yes, I am Jasmine,' I reply. I say it firmly, as though the matter requires assertion.

'And I'm Naomi.' She's got an Australian accent. She holds out her hand.

I shake it quickly and then I turn to my toast. I spread sunflower margarine and marmalade on it and then stare at it – as though I've just added the finishing touches to an abstract painting. That's what this morning's become – one of those strange canvases covered with wheelmarks and blobs and daubs and dashes. It must make sense to someone. It must make sense to Charlie.

I know he's been receiving phone calls from a woman with an Australian accent – this woman. I know she's been here before and used a mug – she's wearing that light pink lipstick now too. I suppose I should have guessed something like this might happen. I'm amazed that I'm so surprised.

I've got that cold, damp feeling that comes when you can't cry. Naomi is studying me curiously. Waiting for me to speak.

'Do you work in radio?' I say at last.

'No. Why do you ask?'

I remember all the chirpy voices determined to turn Dublin bay into the Bay Area.

'Your accent sounds Australian. A lot of Australians work in radio here.'

'Oh, do they?'

'Yes they do.'

'Actually I'm a singer.'

Oh dear God, she's going to turn out to be famous too.

'Really? What's your full name?'

108

'Naomi Spencer.'

I'm relieved to realise I've never heard of her.

'You probably haven't heard of me. I don't perform much over here.'

I don't reply. Normally, when a performer I've never heard of says his or her name I say 'Ah yes'. It's a nice, neutral response that implies that the name might just possibly ring a distant bell. I've found it very helpful at my own dinner parties. But this time I say nothing.

'And what do you do?' Naomi is stirring her Barleycup, to which she adds some soya milk.

I really can't bring myself to mention the sanitary towel with the revolutionary flap.

'A bit of this and that,' I say. 'I freelance mainly.'

One of the nice things I've learned since I left Bruce is that when someone asks you something you don't have to go into detail. I used to. I suppose I hoped that by unravelling, like wool, the circuitous pathways that formed my life before them, they would somehow provide a sort of retrospective map. 'This is what you did,' they might say. 'And this is why.'

But after I left Bruce I received so much conflicting advice and admonitions from friends and relatives that I learned how to retreat into the discretion of my own silence. I used to fear silence. I read somewhere that one's own silence is something one can never live up to. Now I don't care. What other people make of it is really up to them.

'Would you like some more toast?' asks Naomi. She's making some for herself now. I suppose I should have made it for her. Where's Charlie? That's what I want to know.

'Where's Charlie?' I ask.

'He's gone out to the studios for half an hour. He'll be back soon.'

Suddenly I know I must leave this house before he arrives back. I don't want to see him. If I see him I might hit him and I don't think he'd be too pleased. I'm suddenly feeling incredibly angry. I should get a tennis racket and thump my bed with it. I read somewhere that Princess Diana found this very therapeutic at times. Or I could use Charlie's saxophone. Bash it against the wall until it fell into smithereens. I feel a flame of satisfaction at the thought.

I get up, leaving my toast untouched. 'I must go,' I say.

'Oh, that's a pity. I thought we might have a nice chat,' she says. 'Charlie's told me so much about you. I'm sorry you didn't know I was staying. It was all rather last minute.'

'I'm sure it was,' I think. 'These things often are.' But what I say is 'Are you staying long?' It comes out like an accusation.

'No,' she says. 'I'll probably go this afternoon.'

'Well, bye then. We'll probably meet again.' I exit stage right, as Bruce might say. Then I have a moment of remorse. It's not her fault – how was she to know? I peer back into the kitchen.

'There's some freshly squeezed orange juice in the fridge,' I announce.

'Oh, thank you.' She beams with relief. 'I'll get some.'

Charlie opens the front door just as I'm about to leave. I look down and try to push my way past him.

'Hello, Jasmine,' he says cautiously. He's studying me. He looks concerned.

'Hello, Charlie,' I reply and, since he won't move out of the way, I give him a sharp kick on his right ankle.

'Ow!' he bellows.

'What's happened? Are you all right?' Naomi calls from the kitchen.

110

I slam the door and head on down the driveway. The sunshine seems almost perverse given my leaden mood.

I travel the mile into Bray like a sleep-walker. 'Well at least that's settled,' I think. 'At least Charlie's out of the picture now. Not that he was ever really in it.' There is a tiny sense of relief, but I still feel like I've just got off that boat train from Holyhead.

'Why on earth am I feeling like this?' I agonise dejectedly. 'I was the one who kept saying it was great we had this wonderful friendship. But it isn't wonderful any more. And it isn't just a friendship either. How has this stuff snuck up on me? And just when I was being so careful.' I kick a stone on the road morosely. It doesn't move very far.

In Bray I buy two newspapers and catch a bus. I go to the top deck and look through the 'Flats for Rent' – marking the promising ones with a blue biro. There's still some conservatory money in my account, along with what's left of my recent earnings. I've got to find something half decent. A bedsit in Rathmines really would be the last straw. Bruce will just have to help if necessary. If I don't go back to him we're really going to have to get a divorce and make some financial agreement. The thought of solicitors makes me wince.

'How on earth has it all come to this?' I think. 'How have I come to be sitting here, thinking these thoughts?'

Bruce frequently remarked upon my tendency to stand back from my life and look at it with a kind of vague curiosity. He said I distanced myself from the world – from him – as it suited me. He said I sometimes swam along with the river of life and then, suddenly, decided to cling to a branch for a while. But watching the water as it swirled by me only made me more frightened, he said. He said I would be better off back in there with everyone else.

111

I'm beginning to notice a pattern to this disconnection and I think the common denominator is probably pain. I had the first glimmers of it when my mother gave away my bicycle. Just gave it away because somebody else wanted it and it was a bit too small. I felt like she was giving me away too. As though she'd grown tired of my childhood. I haven't thought about that bicycle for years. Once it was gone I forgot it. Pretended I never wanted it anyway. Just like Jamie. When he went I was distraught for a while – he was my first love. Then I decided it was all for the best. But Jamie muddled up my arithmetic for ever. I'd thought one and one made two, but ever since they've just made one and one.

The perverse thing is I fell in love with Jamie because I thought he'd help me open up. I was seventeen. I felt like I owned a big house but only lived in some of the rooms. But when Jamie looked at me that day, with piercing blue eyes that didn't look away – that forced me to look back – I felt like he saw all of me. The whole building. We were in a cafe. I went there most days. It was beside the college where I was doing a commercial course.

I didn't see him for some weeks after that. Then one day I saw him again. Caught him looking at me in a way that made me quiver. He was staring at me across the sea of faces. He was holding a sandwich in mid-air. As his teeth paused over the parsley a chill ran down my spine. What did he want from me?

And then he smiled.

It was a nice smile. An inward smile. A witty city smile at the world. And as his eyes lit up I knew this man meant business. This man who walked through my rooms and wouldn't let me hide. This man who watched, and liked what he saw.

We were kindred spirits – I knew that suddenly. There was a touch of hidden sadness to him. Of unplumbed depths. I would stroll through his unlit rooms too – flicking switches – laughing kindly. We would fall madly and beautifully in love in a wonderfully mysterious way.

But not just yet.

Truth to tell the thought of all this passion made me slightly phobic. To have so many hopes – dreams – riding on just one person. A person who, let's face it, I didn't know in the conventional sense, made me walk into that café like a wanted woman. I didn't look up or sideways as I ate my macaroni cheese or the same fish dish with a hundred names. It was one of the cafe's little tricks. One of life's little tricks too. Love – how on earth did one know if one had found it? But he was different. I wanted to believe that. I wanted to believe he really was Seafood Mornay and not just the same flaked haddock disguised in lumpy sauce. I longed for him so much that just seeing him in the distance made me want to run in the opposite direction.

Things came to a head at Anne's party. I saw him across the room talking to her. How did Anne know him? No one had said he was coming. And he'd seen me. 'Oh God!' I thought, 'I'll have to run away.' Run across the moors and the marshes, even though my parents' house was only down the road.

I was reading rather a lot of Charlotte Brontë at the time.

'Maybe he'll run after me,' I thought. 'Maybe he'll grapple with me warmly, passionately, his firm manly thighs pressed against mine. Maybe he'll say "Still, still my beauty. Surrender my darling. Let go into my arms."'

But I didn't run away. I stayed at the other side of the room. And they snuck up on me from behind.

'Jasmine, there's someone I'd like you to meet,' Anne said as she tapped me on my shoulder. I swung around. 'Jamie – Jasmine – Jasmine – Jamie,' she said. Then she smiled innocently and disappeared. I learned later that Jamie had seen Anne with me in the café and asked for an introduction.

Silence followed that introduction. A silence that was so electric, so full of the unspoken, I was sure people would soon turn and stare. I looked up, and for a mesmerising moment met Jamie's sea blue eyes. I swam into them, as if dragged by a current, and then pulled myself away. I was out of my depth. The whirring in my head felt like a helicopter. If I didn't act soon I would be lost. I opened my mouth, and then I closed it. When I opened it again I said 'I'm sorry, but I have to go.'

A smoochy song was playing as I pushed my way past the couples. 'Hey wait!' Jamie called out – and I started to run. 'Hey – wait!' He was yelling now. What should I do? Where should I go? With a sigh of relief I saw the open bathroom door.

'I'm right of course,' I thought as I sat in my skirt on the toilet seat. 'Absolutely right. A woman can only take a fantasy so far, and then the fever has to fade – burn itself out. He's clearly unbalanced – shouting after me like that. He's a desperate man.'

As I sat on that toilet it seemed clear that part of me came from the wrong side of town. It was full of strange talk and loud lipstick. But I couldn't go around throbbing and palpitating like Lady Chatterley. If I did that I'd never master Gregg shorthand.

My dilemma was making me hot and sticky. I removed Anne's body spray from a shelf and squirted 'Dynamique' under my arms. A woman had to wise up – I saw that now. Otherwise she'd have 'ants in her pants and an itchin'

round her heart'…like Aunt Bobs used to say. It was almost certainly a quote and probably American. Aunt Bobs developed a certain fondness for jazz in her later years.

I stood up and flushed the toilet. I ran the taps and spat and gargled for good measure. I'd been in there five minutes. People were knocking at the door.

'He must be gone now,' I thought, staring at a bottle of Badedas. He was right outside the loo.

'Hey wait! Wait a minute!' he called out. I ran upstairs for my coat.

There were a mass of coats on Anne's bed. I dived into them searching for my Afghan – the coat that my mother said smelt like a yak had slept on it in a dank Himalayan shed. He came in. My knees felt like jelly. I wanted to plunge past him and down the stairs – but I wasn't sure I'd make it. I wanted to dive under the bed until he was gone. But he probably wouldn't go.

He moved closer and held something out to me.

'What's that?' I asked edgily.

He smiled. 'It's your handbag,' he said. 'You left your handbag downstairs.'

At first my giggling was just nervous. A release of tension. Then it turned to laughter, along with his own. We spluttered and hiccupped with mirth – and in my case embarrassment. And when we stopped I wasn't frightened of him any more. That's how we started – me and Jamie. I feel foolish remembering it now.

And I feel foolish wishing I was one of the young girls who are getting off this bus, giggling, full of Saturday. I watch them heading home up avenues, clutching their early morning purchases. The bus is travelling through a leafy part of town.

I want to be young again – to be cradled in my father's arms. I want him to say 'There, there. You didn't know any better.' I want to have inexperience as my excuse.

115

People have been creatures I've coped with for so long now I can barely bring myself to hope that it will ever be any different. Most of the time I don't know what they're up to. Even with Susan I sometimes feel I'm negotiating some maze that has no entrance and no exit…just a strange muddled place with huge holes I must not step into. Holes covered with grass so I cannot see them. I can only feel the earth give way and then the fall. And as I do I hear carefree laughter in the distance.

'I'd hate to be a royal,' a woman is announcing to a friend in the seat in front of me. She makes it sound as if being a royal were once, somehow, an option. 'I simply couldn't stand all that prying and publicity.'

'Are you all right Jazz?'

Only one person calls me Jazz. I look up and see the bright concerned face of Richard MacReamoin, former adult literacy student. He has two gold earrings in his right earlobe and a long blond ponytail.

'Oh, hi, Richard. I'm – I'm fine – I was just day-dreaming.'

'You're hunched up there like a learner driver. What's up?'

'Oh, nothing much. Anyway now you can cheer me up.'

He sits down beside me. 'Why do you need to be cheered up?'

'It's a rather long story.'

'Well, just give me the headlines.'

And I do.

'Wow!' Richard says as I finish. 'You've been through a lot.'

'Yes, I suppose I have.' I suddenly feel more cheerful.

Then Richard hands me a slab of chocolate. As I munch it I remember I haven't had any breakfast and it is now almost lunch time.

'I'm working at Burger King at the moment. I've decided to study graphic design at night classes,' Richard reveals.

'Hey, that's great news. I still have that card you drew for me. It's really good.'

'Was that the one of the pig flying over the rainbow?'

'Yes.'

''Cos you like pigs. Right?'

'Right.'

Richard tells me how he went to the library last Saturday and took out a book on Gauguin.

'Just left stockbroking and fucked off to Tahiti. Great, isn't it?'

'I'm sure his wife was a bit surprised.'

Richard starts on about oils and watercolours versus acrylics then and as I listen I wish Dad was here with us. Dad taught adult literacy too. He was a born teacher who believed in his pupils long before they believed in themselves. Dad would enjoy this.

Maybe he is enjoying it.

'You're day-dreaming again.' Richard is looking at me.

'Sorry, Richard. I was thinking about my Dad. He died last year.'

'I'm sorry. I didn't know.' He squeezes my shoulder gently. 'Were you close?'

'Yes. He was a bit odd, like me. For example he used to keep bees because he was frightened of them. He thought it was character forming, or something.'

'Very Protestant.'

'As a kid I used to have to check that he had his bee-keeping gear on right. It was white and rather theatrical.

117

And there was this strange hat with a kind of veil that made him look like an astronaut. I had to check that there were no holes where a bee might get in. He had a smoke box too.'

'A what?'

'A little box that puffed out smoke. Bees don't like smoke.'

'I didn't know that.'

I'm beginning to giggle. The memory of my father's intrepid trek across the lawn to the hives attired in his weird white suit and clutching his smoke box always does this to me.

'The funny thing is' – I'm gasping with laughter now and Richard is laughing at me laughing. 'The funny thing is no matter how many times I checked that suit a bee always got in. A little while after he reached the hives he'd nearly always come streaking and shrieking back across the lawn waving his arms.'

'Did you ever get any honey?'

'Oh yes. Loads.'

'That's cool. He sounds nice.'

'He was.'

Richard has to get off at the next stop. We've swapped phone numbers in case he hears of a flat. Just before he gets up he leans over and kisses my cheek.

'You should do some more teaching. You were great.'

'Thanks. Maybe I will when I've sorted things out a bit.'

He squeezes my hand. 'Thanks Jazz. You helped me a lot.' He gets up to leave.

'Maybe see you in Tahiti sometime,' I smile after him.

He's so different now from the insecure, defensive young man I met all those years ago. Just a little help, a little trust, that's all he needed.

The bus is getting close to town now. I'm ravenous. I'm going to go into a café and have fried egg and tomato and baked beans and piles of chips. I'm not going to let despair land splat in my mind this afternoon – like tomato sauce after a misjudged thump.

It seems to me the best thing I can do this afternoon is try to swim with the current.

Just swim along and not think much at all.

Chapter 15

I'D FORGOTTEN GIN CAN make your face numb, but my face feels rather numb now. I've somehow become attached to the Atlanta Delegation who are attending an international conference on industrial waste. One of them – a woman called April – approached me when I was sending a text message. She wanted to know where she and some of her fellow delegates could hear live traditional music in Dublin.

I'm frequently approached by strangers. If I stand for any length of time in a public place someone is sure to tell me that their son's girlfriend has become pregnant or that their dog has strayed. Only this afternoon I had a long conversation with a woman in a café who seemed to think I could help get her daughter into PR. A distressed young man even grabbed my hand once on the Bakerloo Line. As he did this he told me that it was his birthday, only everyone seemed to have forgotten this fact. Given my own sensitivity on the subject of birthdays, I did not pull my hand away. I knew that birthdays were only part of his problem but I didn't dare broach all the others.

The sweat gathered between our palms as the train sped through Finchley Road, Swiss Cottage and St John's Wood. I decided the terminus of my empathy would be Baker Street. I got off at Baker Street. Only he did too. As he followed me along the platform I wondered what on earth he wanted from me. Whereas he had seemed sad before, suddenly he seemed sinister. I ran up the escalator and into the street. I hailed a taxi and slumped into it with relief.

Back at the hotel Bruce informed me that I had made a serious error of judgement. He said London was not a place

in which to hold a stranger's hand. He said he didn't believe it was the man's birthday anyway. He said the man had probably made that bit up because he knew a sucker when he saw one.

In comparison to that man the Atlanta Delegation seem a very carefree bunch. In fact it would be fair to say I need them much more than they need me. I need an excuse to delay my return to Charlie's house and the Atlanta Delegation have provided it. Since I saw that strange woman in Charlie's bed this morning I've felt I have no home.

When April asked me about where to hear live traditional music, I said I'd show her and her friends the way to a particular pub. I said I was about to head in that direction anyway. Actually I wasn't about to head in that direction. I had no direction in mind.

When we reached the pub the Atlanta Delegation asked me to join them. And so here I am four gin and tonics later, disorientated and talking with a slight *Gone With the Wind* drawl. It's almost impossible to hear what anyone is saying because of the crowd and traditional music. This is just as well because for the last ten minutes I've been telling a man called William – I know this from his badge – about my visualised life in the Mediterranean. He nods every so often. Occasionally he cranes forward and I have to bellow words such as 'Alpes Maritimes' into his ear.

I'm sitting on a tall stool. A bearded German man beside me is standing. He's cradling his half-pint of Guinness reverentially as he listens to the fiddles and bodhrán. It is clear that he feels himself to be part of some mystical experience. He's poised and waiting for it to happen. It probably will too.

Tonight I wish I was from Stuttgart or Atlanta and visiting this place for the first time. I wish I was legitimately foreign and didn't just feel that way.

I also feel knackered. I made many phone calls today and saw numerous flats. The cheap ones were full of lino and the fetid lingerings of grilled lamb chops. 'And this is the kitchen,' the owners usually said with bravado – pointing towards a forlorn corner of the sitting room in which a cooker and sink seemed to cower. I don't know why I bothered to look at them, because the despondency of the hallways said quite enough.

The brighter, nicer places tended to be flats I'd have to share because I couldn't afford them on my own. Some already had people in them who assessed my suitability and said they'd ring back. I don't think they will ring back. I'm much older than most of them, though one girl – Bella – seemed quite taken with me. She had style, did Bella. She was completely dressed in black and her sitting-room was an unusual shade of pink. 'Vaginal pink dearie,' she said, when I commented upon the décor. 'I've got a bottle of wine open somewhere – let's have some.'

I found Bella's quirky self-assurance quite bracing, but I doubt if I could hack it as her and Nigel's flat-mate. Nigel lives there too. The flat was quite big, so we could all have got away from each other. But one would have had to live several houses away to escape the sound from Nigel's hi-fi. He was playing it in his room as Bella and I spoke. The thud from the bass sounded like a herd of wild beasts lumbering over an African plain. Even with ear-plugs the vibrations would have been unsettling.

'Do you like parties?' Bella asked me.

'Sometimes. Why?'

'We have loads of parties here. Great parties.'

'Yes, I'm sure you do,' I replied as I looked round the large, almost old-fashioned sitting-room. Even the luxuriant rubber plant was growing at a slightly tipsy angle – probably the result of one vodka too many.

'Give us a call if you're interested. It would be nice to have someone sensible about the place,' Bella said as I left.

'I'm not sure I am that sensible,' I replied.

'Well then, so much the better.' And as she gave me an indulgent smile I knew what Bella and I had in common was a belief in our intrinsic oddness.

As I walked back to town – Bella's flat was in a 'central location' – I wondered why I found flat-hunting so scary. And then I realised it was because it raised the mysterious issue of my sense of myself. It reminded me once again that life holds many cracks that one can slip into. With just one little slip in resolve, for example, I could find myself in a dreary room somewhere with only the smell of a long-gone lamb chop for company. After a while it might begin to seem quite natural to traipse through some despondent hallway, possibly clutching a Burger King take-away because the murk of the ancient cooker proved too much to face. Go on long enough like that and you have a whole life. As the years went by I'm pretty sure I'd buy a budgerigar.

The rent on that sad solo refuge would be a little more than the cost of sharing Bella's bright but acoustically challenging vaginal pink flat. The flat where a whole new career as a party animal beckoned and any budgerigar would probably be let out of its cage. Let out of its cage to fly and crap happily round the large rooms. Until one day it found an open window and discovered that the cold winter streets of central Dublin are no place for a budgie to be.

The chaotic fug of this Dublin pub is no place for me to be right now. Bruce and I used to come here occasionally in happier days. We'd find a cosy corner and sit and hold hands. The calm of our contentment seemed like a shield against a noisy, turbulent world. We were a couple. I was a couple. The night now seems as abrasive as a non-rusted Brillo pad in comparison.

The traditional musicians are taking a break and someone has put on Eleanor McEvoy. As she starts singing 'A Woman's Heart,' I realise what I need. I need someone to take me away from all this. I've had this feeling many times before and in many places, but never with the same degree of urgency. I know that in *The Cinderella Complex* Colette Dowling wrote '…the deep wish to be taken care of by others is the chief force holding women down today,' but I don't give a shit. It seems to me everyone wants to be taken care of at times, especially husbands. I've ironed quite enough shirts to know that. Pride is no contender against desperation. I know what I must do.

I get up and push my way through the crowd. I lurch desperately in the direction of the door where it's quieter and take out my mobile. I dial the number. I wait as it rings. It rings and rings and rings, but no one answers.

Bruce isn't there.

He should be there. It seems to me, standing, drunk and desolate in that pub, that he may well have absented himself on purpose. It seems to me that he somehow knew I'd find myself *in extremis* at 10.30 p.m. and ask him to collect me. Ask him to rescue me and take me home. So he put on his coat and went out. It's quite obvious that's what he's done.

I phone Susan. 'Hello,' she says, in a very chirpy voice.

'Hello,' I reply. I have to almost scream above the din.

'Is that you, Jasmine?' Her voice now sounds a bit dull and disappointed.

'Yes it is,' I holler, then I pause, trying to ride the waves of rejection and self-pity. I sway slightly as I do so. 'Even Susan doesn't want to hear from me,' I think miserably. 'No one cares. Not really.'

'Sorry if I sounded a bit off.' Susan has sensed an explanation is in order. 'It's just that Liam said he might call.'

'Liam?' For a moment I have no idea who she's talking about.

'Come on, Jasmine, you know Liam. I met him when we were looking for Hilda – the hunt ball woman at the home.'

'Oh yes – of course.' I wish I didn't have to shout. It seems to be increasing my sense of hysteria.

'Where are you, Jasmine? Are you in a pub or something? You sound like you've been drinking.'

'Well, I'd better not keep you if you're expecting a call.' In moments of extreme vulnerability I oscillate between brightness and blabbing.

'What's wrong, Jasmine?'

'Oh, it doesn't matter. It's nothing.' I've started to sob.

'Yes it does. Come on, tell me.'

'But what about Liam's call?' My neediness is somehow fuelling my scrupulosity.

'Oh shut up about Liam. What on earth is going on?'

With an enormous sense of relief I blurt out the whole story about Charlie's woman and flat-hunting and the Atlanta Delegation. Susan tells me to calm down. She says her flat-mate may be moving out and if this happens I can move in instead.

'You should go home now, Jasmine. You're drunk,' she says.

'I can't go home. I have no home!' I wail. 'I think I'll join the Atlanta Delegation for a while. I'll get myself a little badge.'

'Just stay there and I'll come and collect you,' she says firmly. 'And don't run off with any men over for rugby internationals.'

'I didn't know there was a match on.'

'There isn't. It was a joke, stupid. Now stay there until I come.'

When I get back to the Atlanta Delegation, William gives my hand a welcoming squeeze. He bellows that a line dance has started in another room of the pub and wonders if I'd like to join in. The only thing I know about line dancing is that people who do it shout 'Ye Ha!' a lot. I fear it may drive me over the brink, but before I know it I'm caught up and spat out into a sea of Stetsons, like a bit of driftwood in a tidal swell.

'Oh Lord, please help me to remain upright,' I pray. 'Please let me not be driven to throwing myself, howling, onto the floor.'

Redemption can come in many strange forms. Never, not for one moment, did I suspect that one lost December evening it would take the form of line dancing. My fatigue somehow lifts. I'm so busy kicking my feet in the air and trying to learn the steps that I've no time to remember that fifteen minutes ago the craic almost made me crack up. The gin makes me stumble a bit now and then, but nobody minds.

'Take your pardner and swing her round,' shouts our amiable master of ceremonies.

'This isn't proper line dancing,' a woman beside me shouts into my ear. 'This is more a barn dance. Line dancing is much more disciplined.' I can see she's rather disappointed but I'm not at all sure I would have been up to the real thing.

The music is western and jolly. I feel as though I should be in a haybarn in Montana with a piece of straw dangling from my mouth. Someone hands me a Stetson and I wave it around.

'Ye Ha!' I scream. 'Ye Ha! Ye Ha! Ye Ha!'

Anywhere else it might sound hysterical, but here it's almost obligatory.

We're all flying around the room, dripping with sweat and as high as the high chaparral. I used to love westerns when I was a girl. Especially *The Virginian* and the way he came galloping towards our sofa at the start of each programme. Actually it wasn't The Virginian I fancied so much but his sidekick Trampas.

Trampas sometimes danced with a girl in a gingham dress near the end of the programme when the cattle rustlers had been caught. I'm that girl in the gingham dress now. Life feels so simple. How did I ever get the impression it was complicated? You don't even have to get the steps right. Nobody here minds.

We're all holding hands now. There's another line of people holding hands opposite us. We surge towards them and then back, lifting each other's arms up into the air. The next time I move forwards the person opposite me shouts 'Ye Ha!' into my face. I smile at him.

And then I realise it's Charlie.

I get such a shock that I stop dancing, only someone yanks me back into the line.

When the music stops I'm puffing and panting, sweaty and red-faced. I collapse onto a chair and Charlie sits beside me.

'Ready to go home yet?' he asks.

'No. I have to wait for Susan.'

'Susan's not coming. Her car's got a puncture. She phoned me.'

'Oh.'

127

'So, do you want to dance a bit more or should we leave?'

'Is that woman still staying with you?'

'No. She's gone.'

I get up and reach for my coat and bag. I say goodbye to the Atlanta Delegation and then I follow Charlie obediently to his van. I feel light-headed from the alcohol and dancing, but my legs have turned to lead.

'Are you all right?' Charlie looks concerned as I walk very slowly towards the van.

'I'm okay – I'm just a bit tired after all those G and Ts.'

'Yeah – tonic water can do that to you sometimes.'

I know there are things I should say. I know I'm supposed to be angry. But as soon as the van starts to move I head towards the open plain of a deep and dreamless sleep.

Chapter 16

CHRISTMAS IS OVER. I know this because they've stopped playing 'I Wish It Could Be Christmas Every Day' in the supermarket where I'm demonstrating a new brand of ice cream. That song is one of the reasons I'm very glad it's not Christmas every day. There's an unyielding, almost hysterical ring to it.

I dreaded Christmas this year. I approached it as though it was a military operation. Tinfoil, washing up liquid, paper napkins and lightbulbs had been stockpiled in a large cupboard for weeks beforehand – along with the more obscure forms of food such as brandy butter and cranberry sauce that the season seems to require.

The whole business of Christmas dinner was particularly problematic. But *Avril* helped us out there. Bruce was working right up to Christmas Eve so I suggested it might be more practical for him to join Katie and myself at Charlie's place on Christmas Day. Amazingly Bruce agreed to this, but then Charlie was away visiting his sister in County Meath. Bruce doesn't like Charlie. In the interests of PR I told him about the woman I'd seen in Charlie's bed.

'They slept together and everything,' I said, trying not to betray the slightest jealousy. 'She seemed very nice.'

Before Christmas dinner Bruce phoned his parents and I found myself wishing my mother-in-law 'Happy Christmas' on the phone – though at the time this well-worn phrase seemed like a contradiction in terms.

'I'm so pleased you're all back together again,' my mother-in-law said, as though stating this might somehow bring the fact about. I feared that she might go on and on about Bruce and myself like she usually does, but Harvey's

Bristol Cream seemed to have lightened her zeal. If she had gone on and on I had a plan. I was going to hang up while I myself was in mid-sentence. People don't usually suspect anything if you do this. That's what the woman I was sharing an office with while working for Mr McClaren said anyway.

I know it's fashionable to hate one's mother-in-law, but I don't hate mine. I approach her with considerable caution, but that's not quite the same thing. One of her more endearingly eccentric features is her firm belief that Bruce should become a horticulturalist and stop 'mucking about' in the more inscrutable soil of television. She herself is an avid gardener and tried to groom Bruce into being one as well. He had his own little vegetable patch as a boy. The luxuriance of his kale, she once told me, 'had to be seen to be believed'. She still can't understand why he put crazy paving all over our front garden.

In the unlikely event of Bruce ever winning an Oscar, I'm sure it would never match the glory of that kale in his mother's eyes. He pretends to laugh this fact off, but I know it causes him some despondence. I think that's why he was so sensitive when I didn't share his enthusiasm for *Avril: A Woman's Story*.

For the sake of harmony, and in order to avoid more murky topics, I quizzed him about the film during most of Christmas dinner. Katie didn't say much, she just sat there watching and listening to us hopefully. It was all being done for her of course, this show of solidarity. Or was it?

In a funny way I needed Bruce around too. I needed some way of keeping a small sense of continuity. An opportunity to say 'You pour the brandy on the Christmas pud now Bruce, and Katie – get ready with the match.' I required to hear us all say 'Wow!' as the brandy flamed. I enjoyed having a cheesecake topped

with satsuma pieces ready in the fridge because I knew, as a family, we like the spectacle of Christmas pudding but not the taste. I knew we'd all have a little dollop of it, but most of it would go back into the fridge…unless Dad was there.

Dad adored Christmas pudding. Because of Dad my Christmas pudding never, ever, went to waste. If he didn't eat it with us I always saved it for him. Looking at that pudding as it sat, almost untouched, on its plate, I nearly burst into tears. Then Katie had an idea. She said she thought Rosie might like some Christmas pudding, and she was right. Rosie's snout quivered as she munched it. Her eyes were bright with pleasure and she tackled the brandy butter with particular zest. Occasionally she paused, as though savouring the new sensations in her taste-buds. She looked most festive with a large red ribbon round her neck. The ribbon was Katie's idea too.

Katie wanted to bring Rosie into the house, but I said no. I said Bruce had quite enough to adjust to already without having a bright-eyed pig eagerly watching television beside him.

After the Christmas dinner the thought that truly terrified me was that the television mightn't be working. Television has, as in most households, always been an important part of our Christmas Day. Its crucial contribution seems to be the way it allows people to sit together without talking. Thank goodness the television did work – even though I wasn't quite so grateful for this fact after I'd sat through a one-and-a-half-hour recorded concert featuring Katie's pop hero, Brian Allen.

'Peel off those panties, peel them down,' Brian crooned in that predictable way of his. At least I didn't say 'Why is he wriggling around like that? Does he want to go to the

131

lavatory?' Some adult usually made this comment when one of my teenage idols appeared on the screen.

When Brian started singing, Bruce very sensibly fell asleep. He hasn't had much rest lately. I tried to read a book on Gauguin given to me by Richard MacReamoin, my former adult literacy student. I also managed to polish off half a box of chocolates.

Bruce stayed with us at Charlie's place on Christmas night. He was so tired I really couldn't turf him out. The thing is once he'd got settled in the spare bedroom he brightened up considerably and said he wanted to talk. He didn't actually. I realised this when he tried to put his hand between my legs. I gave him a goodnight kiss on the cheek and left. When I walked back to my bedroom I noticed the door of Katie's room was slightly open. She was peering through the crack.

As I lay alone in my single bed that night I ruminated on the wisdom of my current rigorous sexual standards. It seemed to me that if I adhered to them I might never, ever, have sex again – with another person anyway. I miss sex. I didn't think I'd miss it so much. When it was around it often seemed bland and predictable – like something on a list of domestic chores: load washing machine, iron shirts, sew on missing button, have sex, defrost mince. That sort of thing.

The morning after Christmas Bruce, attired in Charlie's dressing-gown, brought me breakfast in bed. He hasn't done this in years.

'It took me quite a while to find some recognisable foodstuffs,' he smiled. 'Those rice cakes look like they're made from packaging material.' I gave him a quick hug to thank him and, at that very moment, Charlie walked by the open door of my room. He must have just got back.

132

Though I'm still staying with Charlie things between us are very different now. I have, for one thing, insisted on paying him more rent. He explained to me about the woman in his bed. The woman's married and lives in Devon, apparently. She and Charlie lived together for some years a long time ago. They didn't have sex the night she stayed, he said. They just cuddled for old time's sake and because she was sad. She was sad because some record company executive said she was too old to appear in a micro-mini with a feather boa across her tits on the cover of her new CD. The record company want her to cultivate a more mature and sultry image and this has made her grieve for her lost youth.

This sounds marginally plausible to me, but I've allowed a large element of doubt to linger. Since the fake diamond hair grip incident I know how innocent men can sound when they're lying about where they've put their penis.

'So you see, there was really nothing to it. We're just friends,' Charlie said.

'Ye Ha,' I replied, because a more considered response couldn't have adequately conveyed the depths of my new cynicism.

'Is that all you've got to say on the subject?' he persisted.

'Frankly, Charlie, you could have both bonked yourselves through the bedsprings for all I care – though I'm sure her husband might have another view on the matter,' I replied. 'I just need somewhere to stay until Susan's flat-mate moves out. What you do is up to you.'

Actually if it's true – that stuff about the feather boa and the micro-mini – I do have a certain sympathy with the woman. I call her the woman because I keep

forgetting her name. I've been grieving for my lost youth for a while myself.

When I was younger men often looked at me twice. It wasn't something I was really aware of until Bruce pointed it out. I'd presumed the second glances, when I saw them, were probably prompted by some shameful error in grooming. I'd rush to the mirror afterwards to check. Then Bruce told me men looked at me that way because I was an attractive woman. He was amazed that I had somehow remained innocent of this fact. Actually I'm not sure I was innocent of that fact. I think it was something I knew but chose not to register.

You see the thing is I wanted to be loved for my soul. While I was glad that I didn't look like the back of a bus, it was the radiance of my inner-being, my essence, that I wanted men to connect with. In pursuit of this goal I wore big shapeless jumpers which gave me no discernible figure. 'My God, you have lost weight!' friends would exclaim any time I wore a T-shirt.

It seemed to me that any man who saw the true woman beneath my sack-like armoury must be a cut above the rest. All my boyfriends, including Bruce, were put to the test. I learned later that Bruce knew I must be fairly slim because I had a 'nice tight bum'.

'Attractiveness is not just a physical thing, Jasmine,' he lectured. 'An attractive woman is much more than just a pretty face or a good figure. Make the most of yourself. Enjoy who you are.' Bruce always seemed to have a much clearer view of who I was than I did.

So I discarded the sack look and got used to admiring glances. I don't get many admiring glances now. Not unless I'm really dressed up and have made an effort. Strange men do still smile at me occasionally. They don't actually guffaw into my face. It's more a conspiratorial little smirk. I don't

know why they do this, but I don't think it's meant to be offensive.

The other day I put this second glance stuff to the test at a bus stop when a man who'd joined the queue looked at me. It was evening and the bus stop was by a shop window. I could see his reflection in the glass and I watched it to see if he looked at me again. He didn't. I had obviously not made the slightest impression on him.

When I was eighteen this would not have bothered me one whit – but now I'm forty it does bother me somewhat. I'm not so confident about being loved for my inner-being as I used to be. It seems to me my inner-being may need a little help – a little marketing.

'Love yourself,' that's what all my self-help books say. I suppose they're right, though I wish they wouldn't go on and on about it. One of them, called *You Can Heal Your Life,* says affirmations like 'I love and approve of myself,' can help. You're supposed to say that affirmation over and over again, to yourself or out loud. I say it to myself sometimes when I'm out walking. After a while my mind occasionally strays to more mundane matters and I realise, for example, that I'm repeating 'Collect coat from dry cleaners. Collect coat from dry cleaners,' instead.

I do think I like myself a bit more these days. I don't bully myself so much about my perceived deficiencies. It seems to me encouragement is far more helpful than continuous scolding, and this applies to oneself as much as to others.

I also find I'm getting to know Bruce better. We meet for lunch occasionally. Now that he's no longer so entangled in the web of my expectations I have a clearer picture of who he is. It seems to me he's not a bad man, but he's not a particularly good one either. It seems to me he's lonely, but not in a way I can help him with. He's lonely for himself. For

all the bits of himself he chooses not to see – the parts he just shuts out.

He's become terribly earnest over the years. There's a whole ream of interests he's decided he hasn't time to pursue. For example he used to paint very well. His canvases were always rather large and abstract. There was no discernible theme, but his use of colour was excellent and most evocative. He got completely lost in those colours – daubing them quickly as though to some inner map. After one of his painting sessions there was a deep calm on his face. I haven't seen that deep calm on his face for a very long time.

The only new interest Bruce has taken up in recent years is jogging. He occasionally jogged in the past, but around his fortieth birthday it became an almost nightly event. There was something obsessive, I thought, about the way he strode up to the bedroom each evening, hung up his clothes, cleaned his ears and put on a tracksuit. A liberal dusting of anti-fungal foot powder onto feet was later added to the ritual. When I learned about him and Cait I suspected that he'd just used jogging as an excuse to be with her. He insists that this was not the case. I'm not sure I believe him.

Chapter 17

AVRIL: A WOMAN'S STORY is almost in the can and now Bruce has been asked to direct a TV film about a young Irish emigrant to New York. He was full of apologies as he told me this. He said he'd been neglecting me lately. That we needed to talk more. I didn't tell him that leaving me alone for a while was just what I needed. I think he finds it comforting to believe that his marriage is simply one more thing he currently doesn't have time for. To believe that once he can slot it in his schedule again it will resume its normal course.

I am truly pleased that Bruce is getting the chance to do the work he wants to do. His eyes were as bright as a boy's as he spoke about possible locations in Brooklyn. He wants me to come over and stay with him in New York when he's based there. Not for the whole time because he'll be so busy. Just for a week or so. And, you know…I just might.

We squeezed in one appointment with a marriage counsellor before he flew to America to work out some pre-production details. I was not at all looking forward to it. I thought my rage might assume volcanic proportions in such an indulgent setting, and though I knew this might be therapeutic, I also knew it would be extremely painful.

My feelings towards Bruce are very volatile. For long periods I feel I've almost grown to like him again, and then some memory or remark can convince me that he's a complete and utter shit. At moments like this I really can't bear to be in the same room with him. And yet that, of course, is what marriage counselling required me to do.

The blaming started almost immediately. 'He forgot my fortieth birthday,' I blubbed, reaching for a Kleenex from the

large box on the coffee table. 'And – then we were supposed to go to Galway to make up for it, only we couldn't because of *Avril*

'Avril?' the counsellor repeated, obviously feeling she was on to something important.

'Yes. And he kept asking people round to dinner without consulting me and – and he fucked his mistress in our bed.'

The counsellor, a Mrs Swan, nodded encouragingly.

'And – and when he had a shower he always draped the wet towel over the bath, even though I'd told him hundreds of times it would only dry if put on the shower rail.'

Mrs Swan nodded again. 'And what did that behaviour mean to you, Jasmine?' she asked gently.

I looked at her fiercely. 'That he doesn't love me. That he doesn't care at all about my feelings.'

This confession induced a paroxysm of sobbing. Bruce watched wretchedly. Then he reached for my hand but I snatched it away. Mrs Swan did not intervene. She sat and waited. After a while the sobs subsided.

'He just sees me as a servant,' I whimpered, twisting the paper handkerchief between my fingers. 'Lots of times when I needed to talk with him about something he just sat there and said nothing. He wasn't – he isn't,' I groped around for some appropriate word from my self-help psychology books, 'he isn't emotionally available.'

Mrs Swan turned to Bruce. 'And how do you feel when you hear Jasmine say these things Bruce? Is there something you'd like to say to her?'

Bruce squirmed uncomfortably. 'I – I suppose I'd like to say I do love her and I'm very sorry I didn't show it.'

'And is there anything else you'd like to say?'

'Well I think that is pretty much the way I feel.' Bruce's voice sounded hollow, and sad.

Silence followed this statement. A silence that went on for some time until Bruce added, 'I'd also like her to know I don't see her as a servant. I see her as an intelligent, attractive woman. I should have said that to her.'

'And why didn't you say that to her, Bruce?' asked Mrs Swan.

'I suppose I thought she knew it. I just assumed she knew it.'

'And are there things you wish Jasmine had said to you?'

Bruce looked down at his hands and appeared most reluctant to answer this question. Eventually he said, in a small voice, 'I suppose I wish she'd said she loved me.'

I looked at him in astonishment, but Mrs Swan's expression, as she gazed at him, remained studiously calm and non-judgemental.

'Excuse me,' I interjected self-righteously. 'I did say I loved him. I frequently said I loved him.' I paused for these brownie points to register fully. 'It's typical of him to try to put the blame onto me.'

'I'm not trying to blame you for anything, Jasmine.' Bruce had assumed his 'reasonable' voice. 'I'm just stating a fact. Yes, early in our marriage you used to say you loved me – but you haven't done so for a long time now.'

I almost catapulted vertically from my seat in rage. 'So, you think I should have been professing my love for you even though I knew you were fucking someone else!' I looked towards Mrs Swan.

'This is typical,' I told her. 'Just typical.'

'No, I don't mean just recently,' Bruce said wearily. 'I mean long before all that happened. And you haven't enjoyed sex with me for years. You've made that pretty plain.'

Bruce was sounding rather angry himself. As Mrs Swan shifted her glance forwards and backwards from him to me she began to look like someone with a prime seat at centre court. I could almost hear her mentally register 'Deuce'. I'd thought this was going to be such an easy match, and now it looked like it could go to a tie-break.

'And what exactly makes you believe I haven't enjoyed sex with you?' I lobbed. 'Go on – explain.'

'Well I don't know if I want to go into details just now.' Bruce looked uneasily at Mrs Swan and back at me. 'It was something I just knew. I could see it on your face.'

'Go on. I don't mind,' I said, as I clenched the armrest of my chair.

Bruce took a deep breath. 'Well, there are numerous examples I could give.' He hesitated before delivering his top spin backhand. 'For example that time when, in the middle of love-making, you got a faraway look on your face. I thought it might be some fantasy that we could share – that might make sex more exciting for you. I asked you what you were thinking and you said you'd just realised we should have pine shelving in the conservatory.'

'It just occurred to me,' I protested. 'These things can occur to you at odd times.'

'Well it's not the kind of thing I thought about when I made love with you,' Bruce sighed. 'It really would have been one of the furthest things from my mind.'

I shifted uneasily in my chair. 'The thing about you, Bruce, is that you don't realise sex is tied in with everyday emotions. I mean, if I felt angry with you about something it might make me more distant with you in bed. I have a book with a whole chapter devoted to that very subject.'

At this point we took a break, and though we did not reach for lemon barley water or throw towels over our heads and

stare at the floor, I for one certainly felt like doing so. We just sort of slumped exhausted in our chairs.

'So – would either of you like to tell me a little more about Avril?' Mrs Swan asked cautiously.

'She's a farmer. She falls in love with a man accused of espionage while collecting seaweed,' I replied wearily.

This was clearly not the answer Mrs Swan expected.

'Avril's a character in a television drama I've just made. Sorry. I should have explained that,' Bruce said.

'Oh,' said Mrs Swan. 'It's just that I thought…When you phoned you'd said…'

'The name of the woman you're referring to is Cait,' I interrupted in a steely voice. 'Cait Carmody.'

This was my cue to rant and rave about Cait Carmody while snuffling and sobbing into my Kleenex. I'd snuffled and sobbed about her so many times before it began to seem like lines I'd learned for an Australian soap opera. I even punched my armrest with considerable vigour at least four times.

'You're very angry, aren't you Jasmine?' Mrs Swan said at last.

'Yes I am.'

'And is there anything you'd like to say to Bruce now?'

'No. I'd just like to hit him.'

'And how do you feel when you hear that Bruce?'

Bruce squirmed uncomfortably again. 'I understand why Jasmine feels that way. But – but it also makes me a bit nervous.'

And it was then that the little smile came to my lips. The little smile that Bruce noticed because he smiled back.

'And when did you first begin to feel you might be drifting apart?' Mrs Swan asked. She was looking at us in

a rather puzzled way, prompted no doubt by our changed facial expressions.

'I'm really not quite sure,' said Bruce.

'Neither am I,' I corroborated.

Suddenly we were behaving as though we'd been summoned to the headmistress's office and were trying to obscure the gravity of some misdemeanour.

Mrs Swan waited patiently, so I eventually said, 'It's been happening for quite a while, but I suppose it came to a head around the time our daughter, Katie, left for college.'

'And why do you think that was, Jasmine?'

'I suppose she was a focus for us really. Once she'd left there was a vacuum.'

'And did you feel this too, Bruce?'

'Yes. I suppose I did.'

And then Bruce started to cry. He did it very quietly, almost as if he hoped we wouldn't notice. He was desperately trying to regain his composure, but the tears kept running down his cheeks. Mrs Swan pulled a couple of paper tissues from the box and handed them to him.

'Why are you crying?' she asked gently.

'I don't know,' Bruce whispered forlornly.

'Is it something to do with Katie?'

'Maybe.' He blew his nose. 'I think – I think it's the whole thing really.'

'What whole thing?'

'Everything – everything we've been saying. I feel something ending…and I don't know how to stop it.'

As he said these words tears came to my eyes too and my heart ached for him and for myself. We both cried quietly – neither of us wanting to upstage the other. Suddenly it wasn't a matter of point scoring any more. It had gone far beyond that.

Bruce talked about his affair then. When it started he had been very depressed, he said. He'd been depressed about his work because it looked like he mightn't get funding for *Avril*. And he was depressed because I seemed to care more about factory-farmed animals than him. And there were other things too. Things that were harder to name but drifted together to form a general feeling of pointlessness, of time wasted.

I was the one who talked about feelings in our marriage, he said. When I talked about feelings I often got angry and seemed to blame him for everything. He said that when he started to have all these feelings himself he didn't know where to turn. He tried to talk to me about them once or twice, but we ended up having a row instead. Then one evening he confided in Cait. Cait listened and he was grateful. And then, as the weeks passed and they both shared more of their thoughts, he began to feel something more than gratitude. He felt an excitement. A complicity. He felt like he'd woken up out of a kind of stupor.

When they made love, as they eventually did, he said it had been such a relief to feel her acceptance and enjoyment. He knew that the affair wasn't going to last. There wasn't love in it really, but there was a tenderness, a passion. And for a while he needed those things so much he would have risked almost anything for them. We had those things in our marriage once, he said. He wanted them back.

He wanted them back because he was no longer prepared to be in a relationship without them.

I listened to these details with a fiery fascination. I'd never heard Bruce being so open in his life. In fact I didn't realise he was capable of it. I'd been waiting for an explanation and here he was trying to offer one. And even though I frequently felt like interrupting and

shouting 'Nonsense!' I didn't because, beneath my resentment, I could see it wasn't nonsense. It did all piece together in a way.

I felt something small and scared stir inside me. Forgiveness? Maybe. Certainly a kind of hope. I'd seen glimmers of another Bruce – almost a stranger. He seemed to be offering something different. Something deeper. Part of me wanted to fling it back in his face and watch him wince. But another part was grateful, and a bit guilty too. Because it wasn't all his fault. It wasn't. Maybe this period in our marriage wasn't just the sandstorm it seemed – gritty and uncomfortable – obscuring only a desert anyway. Maybe it could lead to something else entirely.

Or was this just another mirage?

We were both exhausted when we left that room. I felt far too drained to manifest any serious attempt at rage. So many cats had been let out of the bag they were almost swarming at our feet. I thought another feline might be easier to mention in the circumstances.

'Katie thinks she may be a lesbian,' I said.

'I know,' said Bruce.

'How long have you known?' I asked.

'For quite some time.'

We trudged forlornly towards Bruce's car. He was about to give me a lift home. Then I started to smile.

'What are you smiling at?' Bruce asked.

'Just the look on that poor woman's face when I said Avril was a farmer who collected seaweed.'

'Yes. She did look extremely bewildered, didn't she…especially when you mentioned the bit about espionage.'

And then we both burst into laughter.

We laughed so much that tears came to our eyes.

Chapter 18

SOMEONE ON THE RADIO is talking about a survey of British housewives. If offered a choice between a free £25 shopping voucher and sex with their husbands many of them would, apparently, choose the voucher. I can see their point. After all, sex with their husbands will probably be on offer again, but the free £25 voucher may not be. Still, this does not placate the men who have phoned into the radio programme. They sound decidedly miffed.

I'm listening to the radio in my kitchen. Not Charlie's kitchen. My kitchen. Bruce is still working in America and I told him I'd pop in and keep an eye on the place from time to time. It's not safe to leave a house empty these days. That's what Bruce says anyway.

Once I got here there didn't seem any reason why I shouldn't stay – just for a couple of nights. Now I've been here for two weeks. I went back to Charlie's the other day to collect the rest of my stuff, it didn't seem fair to leave it scattered around his spare room, and anyway some of the clothes needed to be dry-cleaned.

Charlie didn't help me carry my bags to the taxi. He was in the sitting room and had his headphones on – probably listening to some recording he'd just done. He didn't seem to want to talk at all, but I really couldn't leave without saying something.

I tapped him on the shoulder. He looked at me and said, 'I'll be with you in a second.' He sounded very business-like.

He wasn't with me in a second actually. It was more like thirty. I was just about to say 'I've got a taxi waiting, Charlie'

when he took his headphones off and swung around to face me. He was on a swivel-chair.

'So you're off,' he said impassively.

'Yes. Yes I am.' I could feel my lower lip quivering a bit. I looked down at my shoes.

'Have you said goodbye to Rosie?'

'Yup.'

'She'll miss you.'

'I'll miss her.' I was making a big effort not to cry. My voice sounded clipped and small.

'Let me know how things go.'

'Of course I will.' I hadn't meant the departure to seem so final. I'd hoped I could come back to Charlie's if I needed to.

'I'm really, really grateful, Charlie.' I didn't want to look in his eyes but somehow I had to. They looked so sad. Like my own probably. Why on earth was I doing this?

'I – mmmm – I've got a taxi waiting.'

'Well then, you'd better go.'

'Yes, yes. I'd better go.' Was this to be it then?

'You've been so good to me, Charlie.'

Charlie gave a philosophical shrug. 'Well, that's what friends are for.'

I must have looked like a small kid standing there, bewildered, waiting. Charlie stood up and patted my shoulder.

'Come on, I'll see you out.' We walked slowly to the front door.

'Can I have a hug?' I hadn't planned to say it but I had to. Part of me was already in his arms – bathed in that light, right feeling I get when he's near. I so much wanted him to understand. I so much wanted our goodbye to be good. I couldn't bear us not being friends – Charlie and me.

But then he looked at me so tenderly that I got scared. Terrified really. I knew he was seeing through me, seeing parts of me I didn't even see myself. I knew he knew something that I didn't want to – and I didn't like it at all.

As he put his arms around me I froze. Ordered myself not to feel. Our hug became awkward and formal. We pulled away quickly from each other, embarrassed. I knew Charlie was hurt – very hurt. I didn't have to look at his face, I could feel it – misty and baffled between us. Sharpening into something angry too.

'So long then,' he said tightly, as I got into the car. Then he swung the door closed with unnecessary force.

'So long, Charlie.' I was looking up at him apologetically but he wouldn't meet my eyes.

The taxi driver started up the engine then. As we crunched our way down the gravel drive I turned round to wave, but Charlie had already closed the front door. Then I slumped miserably back into my seat hoping the taxi driver wasn't one of the chatty cheery ones.

Actually he was of the sullen, pissed-off variety which came as something of a relief. He asked me where I was going, but not why. Just as well because I'm not sure I could have told him.

That goodbye haunted me for days after I got back here. Part of me still seemed to be skulking around Charlie's driveway hoping for a retake. I kept wanting to phone him, but I really didn't know what I'd say. I didn't want to mislead him because the truth is, I think I do want to give my marriage another try. I mean, you don't just walk away from twenty years without a backward glance – even if you sometimes feel like it. And there's Katie to think of too.

After an initial blast of angst and misery I'm getting used to being home. Even before the bad goodbye it was getting a

bit tense at Charlie's, and anyway this is my house. I should never have had to leave it in the first place. If I'd stuck to my guns I'm sure I could have got Bruce to leave instead. I was in such turmoil at the time I just wasn't thinking straight.

The neighbours have been most welcoming, but they're also curious. I haven't given them too many details. I don't want them to think it's patched up between Bruce and me, though it seems it may be. Of course our marriage won't be the same as it was, but I don't want it to be the same as it was. I think we may be more open with each other – more truthful.

Mrs Anderson across the street frequently knocks on my door to ask if I've seen her tom-cat, Tibby.

'He keeps straying. I don't know what he's up to,' she says. And as she lingers on the doorstep I know she's hoping for information about my own recent wanderings. 'Tibby,' she tells me, 'hasn't been the same since a female cat he was very fond of teamed up with a Burmese.'

I can't get used to how quiet it is here. Of course I was often alone in this house in the past, but the knowledge that Bruce and Katie were going to return soon surrounded me. The rooms feel different now that there's only me in them. The emptiness seems to get bigger at night. I'm not in the house all the time myself. I go out to work sometimes – for a day or two here and there when the secretarial agency rings or when I'm needed to demonstrate some product in a supermarket. When I return from these outings the house feels quite different. It feels like a refuge instead of a space. A space I expand into to fill my own vacuum.

How busily my house and I have conspired to fill that vacuum over the years. Now I've my familiar things around me I see how hard we'd been working and it seems to me she's okay – the woman – myself – who chose this wallpaper, these carpets and fabrics, these ornaments. This life.

She did choose this life, though at the time it seemed something that just happened. That's where we differ, she and I. I see the choice. The decision. I see it could all have been quite different. I no longer have the sanctuary of blaming Bruce for hijacking me and making my life so often seem like foreign tarmac glimpsed fearfully from a grounded airplane. But if I have, at times, been my own terrorist, can I also be my own liberator? That's what I need to know. Maybe being my own confessor is a start.

The happiest memories I have of this house are connected with Katie. I remember how she used to rush in from school and run upstairs to her room, two steps at a time. She'd put on her jeans and a sweatshirt and then one or two of her friends used to call around and they'd all giggle a lot in her room. I liked their giggles. I'd often stop what I was doing just to listen to them.

Of course they sometimes played music too loud or hogged the phone, and then I'd have to take a stand. And through it all there was a sense of really making a difference. Of being needed.

All through my life I've had this sense of people needing things from me.

'Do you ever ask yourself what you need from them?' Susan said when I told her this.

'I suppose I must,' I replied. 'But their needs always seem to be more urgent – more obvious somehow.'

'You'd better wise up on that one, or you'll get their needs and your own mixed up,' she said as she reached down and scratched Rosie's back. We were in Charlie's back garden. 'I mean look at Rosie,' she continued. 'She doesn't agonise about any of this stuff – do you dear?' Rosie closed her eyes blissfully as Susan scratched her. 'If we stood between her and a bucket of turnips I don't think she'd be in any mood to negotiate.'

I'm not quite sure how this stuff about my needs and other people's started. Maybe it was with my mother and my fervent wish to cheer her up. To make up in some way for some lost dream she seemed to be mourning. Sometimes it worked, sometimes it didn't, but I felt impelled to try. I didn't just do it for her – I did it for myself too. Even when I was sad I tried to make her feel better. I think what I was trying to prove, to believe, was that it was possible to be happy.

I don't ask myself too much about happiness these days. I do believe something though, and it's that I'm doing okay. I'm doing the best I can.

This morning I went to the cupboard where I keep Katie's old toys and emptied its contents into a black plastic rubbish bag. I'd consulted Katie about this and she said the only toy she wanted me to keep was Teddy. I'm glad she said this because I'm not sure I could have got rid of Teddy anyway. He's on a shelf in my – our – bedroom. When Bruce and I made love Bruce sometimes got up and turned Teddy's face to the wall. He said Teddy was looking at him. I don't know how Bruce got the impression that Teddy is a prude.

After I'd put Katie's toys in the bag I went to my bookshelves and picked out the books belonging to dead relatives that I will never read. I kept the ones I thought I might read, but none of the others. They went into the bag too.

By this stage I was feeling jittery. I made myself a cup of tea and stared out the kitchen window into the garden. 'What am I going to do?' I found myself saying. 'What am I going to do?'

My mother sometimes asked me that question. It was usually connected with something ostensibly mundane – such as whether to cook chicken casserole for dinner. But even at ten I sensed there was more to it than that. I knew she was disappointed by something, but I didn't know what

she'd expected, what she wanted in its place. Maybe she didn't either. She just knew she didn't have it. She was so busy feeling this I'm not sure she had much time to see what she did have. And what she no longer needed.

After I put the books in the bag I went to my wardrobe and grimly plucked certain items from their hangers. I didn't have to think about it – I just knew I'd never wear them again. I also knew if I'd paused this certainty would disappear so I added them quickly to the bag, along with some ornaments I've never liked. Then I had some lunch and now I'm ready to bring the bag to the Oxfam shop. I've fastened the bag to a luggage trolley and, as I get onto the bus, I'm aware of curious, almost wary glances.

I approach the Oxfam shop with a fearful resolve. I take a deep breath outside the door, then I go in and put the bag down.

'These are some things I no longer need,' I say to the elderly lady behind the counter. 'I hope they may be of some use to you.'

Then I flee guiltily. It's supposed to be a clean get-away but, some time later, I realise I've left my luggage trolley behind so I have to go back and reclaim it before it's price tagged.

I feel surprisingly light-hearted as I walk to my bus stop. I'd feared the abandoned items would call piteously to me, reproving me for disloyalty. But they don't. Maybe this is something they also wanted. Maybe they feel like a change too.

Then I notice a Morris Minor for sale outside a garage. I like Morris Minors. There's something friendly about them. They don't want to speedchase or show off. They don't want to snarl or honk. They just want to get from one place to another. They know the world is not exactly Toy Town, but they're only as streetwise as they need to be.

They are a type of car I think I just might possibly be able to drive.

I'm frightened of driving. I've had some driving lessons and they have only strengthened my belief that driving cars is something other people do. The last time I had a driving lesson I did an excellent three-point turn.

'Well done, that was perfect,' said my instructor. Then he grabbed the steering wheel. Having mastered one of the most difficult manoeuvres of driving I was heading off down the wrong side of the street.

'I spent some months in California once,' I said, blushing with shame. 'They drive on the other side there.'

I could see he was not impressed by this excuse. In fact he was visibly shaken. I'd been sailing along dual carriageways with him for weeks. He couldn't believe I'd made such a basic and dangerous error. Neither could I. I haven't driven since that lesson. It just doesn't seem fair to other road users.

Susan says I need more practice. She says driving lessons are fine, but one also needs to drive on a daily basis and for that one needs one's own car. If I drive often enough it will become second nature, she says. Maybe she's right.

I'm still gazing at that Morris Minor when a man comes out of the garage.

'Hello, Jasmine,' he says.

'Hello,' I reply absent-mindedly. For a moment it seems quite natural that a stranger should know my name. I'm falling in love, you see. The emotion is unexpected and not entirely comfortable – as is so often the case. I'm falling in love with Bunty. That's the name I've decided would suit the car – my car. I want her. And she needs me. A bit of paintwork, a bit of re-upholstering, would give her back her dignity. She's middle-aged, like myself. But that doesn't

matter. She'd show me the ropes, I'm sure of it. We'd make a good team, Bunty and me.

'Hello, Jasmine,' the man says again.

I look up. It's Jamie. My first great love. I feel the earth lurch. Other people talk about the earth moving during sex, but I find that it can sometimes happen long afterwards. Even when full penetration has not occurred – as is the case with Jamie and me.

'Oh shit,' I say.

'Thanks. It's good to see you too.' He smiles cautiously.

He's plumper than I remember, and he's lost some of his hair. But he still has a jaunty look about him, an engaging warmth. That warmth surrounded me once. Sheltered me. I'd stepped straight into it from the cocoon of girlhood and it had seemed to me, then, that it would always be there.

I prepare myself for his eyes by staring at his mouth. It's still a nice mouth. It still curls in a wry, worldly way. That mouth once used to French kiss and suck me into its urgent sweetness. That mouth searched out my secret places while I blushed with innocence and longing. I was uncharted territory and Jamie was my first explorer. I believe he may even have left a little flag.

'Hello, Jamie,' I say at last. 'What are you doing here?'

'I own this place.'

'That's nice. You always did like cars.'

I look into his eyes. They look a little sad, but there's an affection in them too. The last time those eyes saw me I was crying. I was crying because Jamie was going to America to start a new life.

'We're both so young,' he'd said. 'We should go out with other people. Travel. Maybe in a couple of years I'll feel differently. But that's the way I feel now.'

153

I wish I'd felt that way too instead of just wanting someone – Bruce as it turned out – to take Jamie's place. I couldn't stand the feeling that comes when love goes. For months I went around in a daze of disbelief. Love was supposed to last, wasn't it? That's why everyone wanted it. I couldn't believe that someone might have it, and then choose not to keep it. I didn't think one had a choice in the matter – but Jamie obviously did.

'I love you, Jasmine,' he'd said as I cried. 'But I need to get away from all this for a while.'

'From all what?' I'd asked angrily. 'From me, I suppose.'

'No, not you,' he'd sighed wearily. 'From this island. From the person I am when I'm here. There's a whole world out there, Jasmine. Haven't you ever felt it? Don't you get tired of the smallness of this place? Haven't you ever wanted to be a stranger someplace where no one gives a fuck?'

'No,' I replied truthfully. 'No I haven't.'

'Well I have,' he'd said. 'That's the way I feel.'

So Jamie went off to his other country and left me a stranger, for a while, in my own. What he'd said to me made absolutely no sense, until I went to California with Susan that summer. I was supposed to meet Jamie in San Francisco, but by then he'd met someone else.

I didn't fall in love with another man that summer, but I did get some sense of why Jamie had left. It snuck up on me in strange ways. Like that time our friend Doug was driving Susan and myself along the freeway to San Francisco. The Bay to the right was smooth and calm and before us was a jet plane which seemed to almost touch a flyover as it headed for the airport. Cars were streaming to and from the city, which we could already see in the distance. Life seemed to be moving all around me in a

154

vast, confident way. And as I sat in that car I felt confident too. I felt it was all right to be part of all this.

I began to see why people loved driving along freeways, along highways. Some of them had such great names for a start. 'The Pacific Coast Highway' – that was a great name. Doug drove us along part of it one day. We went south, through Monterey and a small town called Carmel to a nature reserve called Point Lobos. It had seals and cypress trees and sea otters and we found a beautiful little cove with white sand called China Beach.

'Look,' Doug had said. 'There are two seals making love. Isn't it beautiful?'

Susan and I had watched, rather embarrassed. The seals making love didn't seem that beautiful to us. But what Doug had just said was. We'd so often heard sex described as sinful or dutiful. Maybe it could be something else too. Something innocent. Something entirely natural. Like the seals and the sea before us. The Pacific Ocean seemed to have an inky, sinuous movement to it I'd never seen in a sea before. And everywhere, following us, above us, was the big, blue sky.

I didn't like that big blue sky when I first arrived in California. It seemed to me very still and vast above the flatness of much of the landscape. I felt almost drawn up into it at times. At least in San Francisco there were hills and clouds, but once one got beyond the city the land and the sky seemed to merge. When there were hills they were golden dry. They looked like sleeping lions. It just didn't seem right at first. I yearned for meadows – for a sense of containment – something cosy. And then, after a while, I didn't mind the big sky any more. I didn't mind that the land felt as endless as the sea. I liked the vastness. It mirrored some sense of space that was growing inside me.

I could see why people had always been drawn out west – to the wild west. It was still wild in many ways. It still called for a band of steel inside. It was such a jumble of people's longings. If someone wanted and could afford a French chateau, they'd build one – perhaps beside a scaled-down German schloss. Difference – variety – was everywhere. Now I understood the listlessness I sometimes saw on people's faces. There's just so much information one can process at one time.

'A strong gust of wind would blow a lot of this down,' joked Doug as we drove past the Mexican taco bars and Japanese sushi restaurants. And I knew what he meant. One thing I didn't feel in California was a sense of permanence. It wasn't what people went there for.

And of course the San Andreas Fault didn't help.

I think I might have stayed on in California if it hadn't been for the earthquake. It happened shortly before Susan and I left. It wasn't a very big one – but it did wake me up in the middle of the night with my bed knocking vigorously against the wall. At first I wondered if I were having feverish sex without my knowledge – then I heard the water sloshing around in a neighbour's pool and realised what was going on.

'Earthquake!' I screamed at Susan who was in a bed beside me. By the time she sat bolt upright the ground had regained its composure, but neither of us did for the rest of our stay.

I'm not sure if I can keep my composure now as Jamie stares at me in his knowledgeable way. He knows me very well, does Jamie. He probably always will. He clearly wants me to talk, but I have no idea what to say. At least I've got some make-up on and am wearing my best coat. I decide I won't bring up the past. There's just been so much of it. To really cover the whole thing we'd need to book a

conference room in a hotel and stay there for at least a week.

'I rather like this car,' I say eventually.

'The Morris Minor?'

'Yes.'

'Well, I'm sure we can work out something.'

And we do. Jamie offers it to me at cost price, and I take it. €750 – that's all he's charging. I know if I hesitate I'll think of a hundred reasons why I shouldn't do this, so I write out the cheque there and then from the joint account I share with Bruce. I haven't used that account in months.

'Can I come back and collect it next week?' I ask.

'Sure,' he replies. He says the word in an American accent.

'Why did you leave America?' I ask.

'I – we – wanted to bring the kids up here.'

'Yeah. A lot of people come back for that.'

'Did you come back for that?' He's looking at me curiously.

'No. I never left.'

He wants to meet me for a drink sometime, but I say I'm not sure. I'll let him know, I say. Then I thank him for giving me such a good deal on the car.

As I walk away I feel the heaviness of his eyes following me, wanting me to turn back. Part of me wants to turn back too. Turn back time. I know now what he wanted me to know back then. I understand.

But it's too late.

I don't feel full of anguish. I'd always thought I'd feel that way if I met him again, but I don't. I realise I don't miss him any more. But I do miss missing him. I do feel sad.

Unutterably sad, and unutterably relieved, that even love is something you can get over.

Chapter 19

THIS MORNING I GAVE my pine kitchen cupboards a good scrub. Bruce kept the place reasonably tidy, but husbands often don't think of those kinds of details. As I did it I felt a kind of elation. This was surprising as I don't normally enjoy domestic chores. Any slight sense of satisfaction I ever got from them was usually clouded by the realisation that sometime soon I would have to do the whole bloody thing again.

The floor tiles in the kitchen needed a good scrub too. You could see someone had pushed a mop over them in a half-hearted manner, but the gap between the cooker and the washing machine was filthy. It was full of bits of spaghetti and blobs of bolognese. I was tempted to just leave them there because they'll somehow find their way back anyway. But I got down on my hands and knees and got them out. I wish a J Cloth could do the same thing with the other blobs and greasy patches in my life – but I suppose a clean space between the cooker and washing machine is a start.

I took the plastic cloth off the kitchen table and gave it a good scrub too. I used to teach my adult literacy students at that table. Bits of jam or mayonnaise always got onto their copy books however much I wiped it. The other two rooms downstairs were out of bounds for my teaching. Bruce didn't like people to use his study, and Katie always seemed to have MTV or *Neighbours* on in the sitting-room, so there was no point bringing my pupils in there. Anyway, the kitchen was nice and cosy and tea and biscuits were close to hand. My classes tended to be very informal.

I painted the kitchen myself. It's a nice light yellow that gives the impression the sun just might be shining. I chose a cheerful colour because I sometimes felt deep despondency in that room, especially as I took out the ironing board. I eventually trained Bruce to iron his own shirts. This was not brought about through discussion of gender roles or equality, I simply stopped ironing them myself.

I remember the morning he discovered my change of heart about ironing very clearly. I was in the kitchen making porridge for breakfast – I liked to send Katie off to school in winter with a hot meal inside her.

'What have you done with my ironed shirts, Jasmine?' Bruce called out from the bedroom. 'There don't seem to be any hanging up in the wardrobe.' He related this with the blithe confidence of a small boy asking his mother to locate his lunch-box.

'Your shirts are in the kitchen,' I yelled back.

Bruce descended the stairs two steps at a time, checking his watch as he did so. He was due at a meeting that morning.

'I think I'll wear the denim blue one,' he said as dashed into the room. He's a fastidious, if casual, dresser.

'Here it is.' I delved into the basket of clean laundry.

Bruce stared at the shirt in horror. 'But it isn't ironed,' he said.

'I know,' I replied and started to set the table.

'But you always iron my shirts.' He made it sound as immutable as the Law of Gravity.

'All rules have their exceptions, including this one,' I replied, glad to have remembered something from philosophy night-classes.

'Have you ironed any of the others?' he demanded, in a state now.

'No,' I said, and plugged in the kettle.

He stared at me, dumbstruck. 'What am I going to do?' he wailed.

'I suppose you'll just have to iron it yourself,' I replied. 'I'm in the middle of making breakfast.'

I don't know why he was so surprised. I'd told him on numerous occasions how much I disliked ironing his shirts. I was also attending an extramural course on women's studies at the time, and was seething with indignation at the hidden heroines of history.

Bruce stared at me again as though I'd grown two heads. Then he snapped, 'Where's the ironing board?' I knew he expected me to find it and set it up for him, but I simply pointed airily in the direction of a cupboard.

There was much clattering and fuming as he took it out, parading his incompetence with it in an expert manner. He set it up in the middle of the room to cause maximum inconvenience. But since I didn't comment on this he soon got down to work, fretting and checking his watch while he did so.

'I'll be late for my meeting,' he muttered. 'I wish you'd warned me.'

'I have asked you to iron your own shirts on many occasions,' I answered. 'Us women have to take a stand sometimes.'

Bruce, who occasionally tries to delude himself into believing he's a New Man, did not reply.

I would have taken a stand about the rest of the housework too, if I'd been in a full-time job myself. But it was a small victory that day I watched Bruce at the ironing board. I knew the sisters at my women's studies class would be proud when I told them.

When Bruce comes back from New York I'm going to insist we make an agreement about housework. We're going to have to share it more equally – especially since I may

well be working or studying full-time myself. I never had to bargain about housework with Charlie. If anything he did more of it than I did. It was simply not an issue.

Oh, Charlie – I miss you, but I can't be with you. I hope you understand. Things are messy enough as it is. I keep trying not to think of you, but I do. Often. They're like an ache, these thoughts of you. I don't know what to do with them. I keep trying to tidy you away – but you just won't stay in your cupboard. I can go for days pretending you're not that important – that you're just a friend. Then you suddenly lunge at me from one of my furthest corners – somewhere I hardly know myself. How did you get in there? I'm always so glad to find you, and then so scared. You make me feel like I've been grabbing *hors d'oeuvres* – hoping they'll make a meal. And they don't, do they Charlie? We both know that. But I've got to find some way through all this. I've got to see what can be salvaged. So please stay in your cupboard, Charlie. It really is best for both of us.

I keep coming across things I'd almost forgotten about in the cupboards of my kitchen. The missing cassette from 'Teach Yourself French', for example, was hiding in a casserole dish. And that Kaffe Fassett designer jumper I'd started to knit so enthusiastically had found its way into the box where we keep the tablemats. I liked the idea of that jumper – it was to be a hedonistic swirl of colour. Now I think I may turn it into a tea cosy.

I never knew Bruce liked Greek yogurt. There were at least four half-empty cartons in the fridge – the fridge that I am currently defrosting. Some old fried rice in a take-away tin was in there too. Apart from the mess beside the cooker and ground coffee and some muesli, I don't see much evidence of attempts at self-nourishment. I suppose he must have eaten out a lot. I think he did

quite a bit of drinking though. The drinks cabinet is full of almost empty bottles.

At some stage Bruce must have gone to a supermarket and decided to buy some non-digestible items in bulk. He wanted to get them over in one fell swoop, or 'swell foop' as Katie would say. There are at least four large multi-packs of toilet paper in the bathroom, and a number of packets of detergent on the washing machine. He bought some fabric conditioner too – and several bottles of stain remover. He also appears to have grown very keen on something that makes the toilet water Mediterranean blue when you flush it.

The house seems to have turned into a kind of base camp. A place Bruce returned to for shelter, but not much else. There's a functional, bachelor feel about the place. The vases are empty and washed, waiting for flowers. The distressed pine dining-table is covered with books and files. It seems to me my presence in this house must have made some difference through the years if I can actually sense my own absence. I often thought that the house itself set the tone and I was just responding to its commands.

'Thou shalt have freesias on the hall-table,' it said – and so I bought them.

'Thou shalt keep up the standards of suburban living and wash the net curtains at least once a month,' it advised. And so I did.

Everyone else was doing it, weren't they? All my neighbours adhered to the standards they'd subscribed to when they saw the show-house on this award-winning estate and decided to live here.

Actually, I didn't want to live here. I wanted us to buy a cottage in County Wicklow with enough land so I could breed Connemara ponies. I'd had a pony for a while, as a

girl. I got my first sense of freedom galloping through the fields near my parents' home. The fields that are now covered with semi-detached houses, not unlike my own. My mother used to worry about me falling off my pony – which I occasionally did. I didn't worry about it though. Worrying about falling off was something adults did, and I was much happier without it. I liked that little girl. She never understood the strange exigencies adults place on their lives.

Bruce has no time for all this inner-child stuff that's become so fashionable. He says people just use it as an excuse not to grow up. He said if he gave into his inner child he'd spend all day reading the *Beano* and setting off bangers under neighbours' cars, and where would that get us?

Susan says the inner child is very important. She says we have all the ages we've been within us, and each of them has a message for us. She has numerous books and tapes on the subject. She says we are all a community of selves. If this is true, if we are all a community of selves, I think I may need a UN peace-keeping force to deal with my particular enclave. Never in my life have I felt so many conflicting feelings. For example one part of me wants to stay with Bruce, another part doesn't. One part of me wants to believe in love again, another tells me to man the barricades.

If it weren't for the internal ombudswoman, who's somehow sprung up to deal with all these dissenting voices, I'm not sure how I would manage. I think I've modelled her on Mrs Swan, the marriage counsellor. She listens to all complaints against the current administration in a calm manner which implies that, at some point, the appropriate course of action will become clear.

I hope to God she's right.

Susan gave me a book called *Women Who Run With the Wolves* the other day. I haven't read it yet, but I think it's about getting in touch with your 'wild side'. By way of thanks, and to remind us both that a sense of humour may be one of the most important senses we have, I bought her *Women Who Run With the Poodles*. I haven't read it either but I liked the cartoon cover of a woman being dragged dramatically along by her pampered pets, who were all on leashes. All this earnestness, however worthy, does seem to need some antidote. I wish Rosie could write a book. I'm sure she'd get the balance just right.

The first letter I opened on my return here was from the *Reader's Digest*. They informed me that I had been singled out from thousands of people as the possible winner of an enormous prize. When I first got one of those letters I whooped and danced with excitement. This time I just shoved it behind a bunch of others on the mantelpiece. Ebullient letters from the *Reader's Digest* have frequently featured in my marriage.

I was enormously pleased to see Dad's chair again. As I sat on it and surveyed the reclaimed territory of my sitting-room, I noticed the crack in the wall. It's grown a good deal larger since I've been away, in fact it's almost up to the ceiling. There's a purposeful look about it now that I don't like. It's definitely up to something.

I never thought the drawers in my sitting-room cabinet would contain much the same items as my parents' did – but they do. The items are so small it doesn't seem worth fretting about whether or not to keep them – but en masse they take up quite a lot of space. Chalk, for example, seems to be much in evidence. As are stray pipe cleaners, golf tees, ancient horse chestnuts, broken birthday candles, marbles and knitting needles.

But every so often, amongst the dust and the buttons one comes across something one thought one had lost. Which is why, I suppose, I have always regarded these drawers with a certain reverence. And now, true to form, among the flotsam and jetsam I have found Annie's photograph.

Annie used to work for my parents when I was a girl. She'd cycle down our driveway on the same bike that took her to local dances. Unless she had a young beau of course, and then she went on his crossbar. While my parents tried to get to grips with the endless paperwork spawned by the garage they were running, Annie and I would dance to the music from the big radio in the kitchen. The big radio with the little glass window on the right hand side that lit up when you switched it on and where, until I was five, I knew the singers lived. Just like I knew all the wonders of the world were crammed into the back of our black and white TV.

Annie taught me how to jive – twirling me around her fingers – both of us laughing as I stumbled and then grew more confident. She taught me how to do the Twist and the Hucklebuck. Over tea and toast she'd tell me the Garda had caught her without a light on her bike – again – and that I was wrong about the singer Brendan Bowyer. Brendan Bowyer was great.

When my parents drove into town on shopping trips I'd help her do the housework, so that in the afternoon we could make a big plate of pancakes and watch the telly. There was only one channel, but it was great. *The Donna Reid Show. The Virginian.* Magic.

And then one day I went into the kitchen and found Annie talking to my mother. The radio was off and they were both looking solemn. Annie had met a man at a dance and was going to marry him and move to England. Annie was leaving. Annie was moving on.

Something had ended, but I was too young to know what, and too old at eight to throw my arms around Annie's cotton skirt and beg her to stay. Instead I went upstairs to find something precious and chose the dried sea horse I'd bought in the Isle of Man. That was my wedding present to Annie.

The day she left I went for a walk by the river. The river was nice – the place where I built rafts and sailed, feet half submerged, along in them. And now I'm grown I know a river is often used as a metaphor for life – always changing – moving over rocks – into depths and shallows. But that day the thought that came to me was that it looked just the same as yesterday and as it would tomorrow. That it was a bit boring really.

And Annie was gone.

And just as I was turning to go home I saw a flash of blue by the bank – a brilliant blue – like something from a paintbox. And I thought it might be a bit of blue plastic fertiliser bag blowing on a twig. But then it flew by me, and I saw it was a bird. A beautiful bird, like something from a book. And I stayed, and stayed, but it didn't come by again. And when I got home I said I'd seen a parrot that must have flown in from Africa, or escaped from a pet shop. That it was beautiful. Blue and orange. And my mother said it must be the kingfisher. The kingfisher that lived by the river all the time.

Sometimes I see myself out of the corner of my eye. The woman I might be. The woman I am becoming. It's strange being lost. You cling to songs and memories like signposts. You feel things leaving, and you don't know what will take their place.

There's a picture of a kingfisher in the sitting-room. Just like there's a picture of a herd of Connemara ponies in the kitchen. The Connemara ponies I never got around to breeding. Being here is bringing all this stuff back. Sometimes

the memories are nice, and sometimes they're so painful I have to go out and buy another pint of milk. And there's something else too. Lately I've had a funny feeling. I have a funny feeling that I'm being watched. Not all the time. Just occasionally, when I'm in the sitting-room. I get this eerie feeling and look up – the way I do when, say, someone is staring at me across a room. I look back at them. I know. But when I go and look out of the window, I don't see anyone looking in at me. It's probably just my imagination. But I'm glad we have a burglar alarm.

I'm using the spare bedroom. I simply couldn't face my marital bed now that I know what's gone on in it. In fact I've only been into that room once since I've been back, and then just to scour it for any traces of more recent philanderings. I didn't find any. The peach pillowcase was on the bed though – the same pillowcase that once harboured the fake diamond hair grip.

I was unprepared for the wave of fury that surged over me when I saw it. It seemed to me that if Bruce had any sensitivity at all he would have burned it. We've piles of other pillowcases in the house, and he doesn't even like peach.

I tore the pillowcase off the bed and used it as a duster for a while.

'You little shit,' I said to it as I stuck it into the more grimy regions behind the lavatory bowl.

'You lying fucking bastard.'

Afterwards I put it in the wash-hand basin and poured bleach all over it, watching with grim satisfaction as the colour seeped away from it and down the drain.

'That'll teach you,' I said. 'That'll teach you all right.'

Then, when the bleach had done its job, I lifted it up with a rubber glove and threw it in the dustbin. I needed the rubber glove to protect my hand, but it felt right in another way too. I didn't want to leave fingerprints. I had just performed the

perfect crime. I'd just murdered Bruce. And he didn't even know it.

I stopped cleaning after that. Once you start cleaning it acquires its own momentum, and I wondered who I was trying to fool. Getting everything perfect in these rooms is not going to make everything perfect in my marriage. I can't get Mr Proper to wipe out all that's happened. I'll just make do for a while. Dust need not be too fearful in my presence.

So now I'm slumped on the sofa reading *Hello* magazine and admiring Richard Branson's jumper and Caribbean island, when the doorbell rings. It's Susan. She's come to collect Bunty with me.

'Susan, you're going to be really pleased about something I did this morning,' I gush as soon as she comes through the door.

'What did you do?'

'I murdered Bruce.'

'Oh my God!' She's put her hand to her mouth.

'No, no, not really. I used a pillowcase.'

'A pillowcase?' She still looks alarmed.

'That peach pillowcase. I used it as a stand-in. I turned it into a duster then I poured bleach all over it and shouted at it and – and threw it in the dustbin. You keep telling me I need to get my anger out. Well – that's a pretty good start isn't it?'

'Well done, Jasmine.' She smiles warily.

'Would you like a cup of tea?'

'No. I've just had one at Liam's place. We're going out to dinner later, so I can't stay too long.'

Susan has set aside her Mills and Boon novel for the moment. She's living it instead. The dishy man with lots of money that she met through Hilda, the hunt ball woman at the home, flies over to see her once a fortnight. Liam is

168

still based in Provence but he also has a posh apartment in Dublin. As far as I can gather they spend most of their time there having steamy sex. Susan hasn't gone into details, but I can tell what she's been up to by the slightly dazed expression on her face. She's wearing that expression now. She also looks rather furtive.

'You're looking a bit furtive, Susan,' I say.

'Am I?' She looks around the sitting-room. 'Is that painting new?' she asks.

For some time now I've sensed there's something Susan is not telling me.

'No, that painting isn't new. Susan, is there something you're not telling me?'

'Look, we'd better go,' she says. 'I told you I can't stay long.'

Then the phone rings. 'It's probably Anne,' I sigh. 'She keeps ringing me up to ask me how I am, and then goes on and on about her husband.'

'Well, just tell her you're going out,' says Susan as I wearily pick up the handset.

'Hello.' I say it quickly, trying to sound rushed.

'Hello,' says a voice, which is definitely not Anne's. I feel a rush of incredible joy, quickly followed by enormous trepidation – I must have been missing him even more than I'd realised. I'd recognise that 'hello' anywhere. It's Charlie. There's an uncomfortable pause while I sit down.

'Hello,' he says again.

'Hello Charlie.'

'How are you Jasmine?'

'Oh, you know – this and that.' As soon as I've said it I realise it doesn't make sense. 'Quite busy,' I add, now trying to sound jolly.

'You seem a bit surprised to hear from me.'

'Do I?'

'Yes. Is Bruce there?'

'No. He's still in New York.'

'Ah.' It's Charlie's turn to pause now. I feel sure the telephone lines must be rattling with all the things we aren't saying.

'So how are things at the studio?'

'Oh, you know – this and that.' I can hear him smile.

'I'm sorry about – you know – the way I said goodbye. I was a bit uptight.' I'm waiting for him to say 'That's okay' but he doesn't say anything. It's as if he's waiting for me to continue, so I add, 'It's good to hear from you Charlie.'

'Is it?'

'Yes it is.'

'I'm glad to hear it. Actually I was wondering if you might come round.'

'What?' I didn't mean it to sound so surprised, so wary, but it does.

'Not to see me – I've got a favour to ask you.' Charlie's voice has lost its warmth. He's suddenly become very business-like. He tells me that he's rescued a horse that was being ill-treated. The horse is stronger now and needs to be exercised.

'You used to ride, didn't you Jasmine?' he asks.

'Yes. A long time ago.' I'm aware that Susan is growing restive. She's jangling her car keys in her pocket.

'Could you come over and ride the horse sometimes – she's called Pinda? I'm keeping her in a neighbour's field, but I don't have time to take her out every day.'

'I'll think about it,' I say. 'I mean I'd like to if – you know – I can.' Susan taps me on the shoulder. She's frantically pointing at her watch.

'I have to go now, Charlie.'

170

'That seems to be a favourite line of yours lately, Jasmine.'

I'm about to explain that Susan is waiting for me but he says a tight-lipped 'Bye' and hangs up. I stare at the phone, shocked, almost aching, but then Susan says briskly, 'Come on. Come on. The garage will be closed if we don't get a move on,' and bustles me out the front door. She can be surprisingly insensitive at times, especially if she's in a hurry.

'Ring him back this evening,' she says when I've told her about the way the phone call ended. 'Charlie's really fond of you, Jasmine. More than fond actually.' She gives me a meaningful glance.

In the past I would have hotly denied this statement, but now I let it pass. I really don't know what's going on between Charlie and me, and I certainly don't feel like arguing about it. I probably won't phone him like Susan's suggested, though I'd love to. I couldn't take it if we had another stupid spat.

As we're driving along, Susan says that her flat-mate will be moving out soon and I can move in if I want to.

'Well, I don't know if I need to now,' I say. 'Bruce and I are getting on much better since we saw that marriage counsellor. You yourself said I should give my marriage a second try.'

'Yes, well, I just thought I'd let you know,' says Susan. She turns on the radio. An American woman is talking about holidays abroad.

'I'd love to go somewhere sunny for a holiday,' I say.

'Well, why don't you?'

'Bruce may not be free. He's very busy these days.'

'You could go yourself. You could go with me.'

'What about Liam?' I ask.

'He wouldn't mind.'

'Are you sure?'

'Yes,' Susan frowns.

We're almost at the garage when I ask Susan to stop the car.

'I have to go to the loo,' I tell her.

'You went to the loo just before we left.'

'Yes, and now I have to go again.'

'Can't you wait until we get to the garage?'

'No.'

She looks at me irritatedly.

'Okay, okay, I'm nervous. I'm nervous about seeing Jamie again. Look, there's a cafe.'

Susan pulls over to the kerb with a sigh and I dart out of the car. My stomach is churning. I sit on the seat for some time pondering my situation.

'What kept you?' asks Susan as I return. She's looking boot-faced and impatient. All this sex seems to have made her a bit aggressive.

'I don't think I'm just nervous about seeing Jamie,' I say as I get back into the car. 'I think I'm nervous about driving Bunty too. Could you drive her for me Susan? Could you?'

'No,' says Susan. 'Have you got your provisional licence with you?'

'Yes – I mean – oh dear, maybe I don't.'

'I think I saw you put it into your bag,' says Susan.

'Well then, why did you ask me?' I'm getting a bit irritated myself.

'I forgot for a moment – okay?' She says it very snappily.

I look at her. 'If all this is too much bother for you Susan, just let me out here. Go back to Liam now and I'll be fine on my own. I don't want you here actually. Not in this mood.'

172

Susan drives on for some time without speaking. As we turn into the garage she says, 'Sorry.' And after she's parked she turns to me and adds, 'I'm so so sorry Jasmine. I really am.' She reaches for my hand and gives it a squeeze.

'Oh, it's not that bad.' It's nice to hear a grovelling apology occasionally, but this one seems rather overdone. 'I was being a bit of a drama queen. You're right, I must drive Bunty sooner or later, so why not now?'

The arrangement is that Susan is going to accompany me home in Bunty, and then I'm going to pay for a taxi to take her back to the garage to collect her car. Jamie is with another customer when we arrive, so we deal with his assistant. Jamie wants us to wait so he can talk to us, but I tell him we're in a hurry and I'll ring him sometime. I stick L plates on Bunty's back and front.

'Should I put some on the sides as well? I've got four,' I babble nervously.

'No,' says Susan.

'Maybe I should put one on my back too – and my forehead. I could wear them all the time. Learner Woman, that's a good one isn't it, Susan?' I giggle semi-hysterically.

'Get into the car,' says Susan.

'I've arranged insurance,' I say as I clamber cautiously into the driving seat. I stare dully at the dashboard and moan, 'Oh God, I've forgotten how to start these things.'

'No you haven't,' says Susan. 'You've had at least forty driving lessons over the years. You know exactly what to do.'

When Susan is in one of these moods there is really no point in arguing with her. 'I love and approve of myself,' I say to the gearbox. 'I am in the rhythm and flow of ever-changing life.'

173

'What?' asks Susan.

'They're just some affirmations,' I reply. Then I put my head on the steering wheel. 'Oh, Susan,' I wail, 'I'm not sure if I can do this!'

'Stop blubbering,' Susan barks. 'Come on, we can't stay here all day.'

Jamie has finished with his client now and is looking at us. He would be looking just now. I turn the key and the engine starts. I put my foot down on the clutch and move to first gear. I'm just about to release the clutch while pressing down on the accelerator when Susan yells, 'Handbrake!' I release the handbrake and Bunty snorts anxiously, hovering between movement and inaction like a horse in a starting stall.

'Well done,' says Susan as Bunty edges nervously towards the road.

'Where do all these cars come from?' I fret as I wait for a gap in the traffic. When I see a gap I panic and press down the accelerator too hard. Bunty stalls.

'I told you. I told you,' I tell Susan, but she remains impassive.

'You're doing fine. Start up again,' she says.

I almost run over a Rottweiler as I pull out. We stall at least four more times on the way home, usually at traffic lights.

'I'm keeping everyone waiting,' I wail as I grapple with the gears. 'I can see a man shaking his fist at me.'

'Fuck him,' says Susan, while at the same time turning round to give him a charming smile. 'This is your car and you've every right to drive it.'

'Yes, you're right,' I say, suddenly emboldened by her words. I take off at the next traffic lights at quite a speed.

'Steady on there, Jasmine,' says Susan. 'It's best not to go from one extreme to the other.'

'Sorry,' I say, but as I grip the wheel with new resolve I am flooded with a strange exhilaration. I realise how pleasant it might be to press Bunty's accelerator closer to the floor. She'd enjoy that. I know she would. Suddenly it seems Bunty and I may not be quite such a sedate team after all.

Bunty and I may run with the wolves.

Chapter 20

I STAYED IN BED all day yesterday after hearing the news about Cait Carmody. Susan called round last night with a Chinese take-away, but I didn't feel like eating. Now it's morning again. I don't feel awake, but I must be. Reality hasn't seemed so problematical in ages – not since those philosophy evening classes and Descartes and his table and the dishy lecturer who became an organic gardener.

I look around and discern that I am in my own spare bedroom. I deduce from the mess of clothes in the corner that I am not particularly tidy. Teddy has fallen out of bed and is crouching, face downwards, as though addressing Mecca. Pictures of Victoria and David Beckham's charity barbecue, as featured in *Hello* magazine, lie on the floor.

Yet beneath this bewilderment, beneath this sense that I have no past and no future, I can sense a personality formed and functioning. I know that if, for example, the phone rang now I'd say, 'No, you didn't wake me. I was just about to have breakfast.'

And that is the strangest thing of all.

'This is how newborn babies feel,' I think. 'Or it's what happens to people when they die. Floating through time and space while the Marks and Spencer jumper and one pair of Dunnes Stores' thermal knickers wait in their laundry basket. While two pound coins, four pennies and a note lie in their purse. The note that reads "I can explain everything. Bruce."'

I don't get up, I rise. I rise and gather my cerise silk kimono round myself – the one Katie found at a Salvation Army jumble sale. I pad barefooted into the bathroom and turn on the immersion. Soon I will be clean and warm, if

nothing else. As I go into the sitting-room I get that feeling again. That feeling that someone is watching me. I go to the window but I don't see anyone.

'Get a grip on yourself, woman,' I say to myself sternly. Then I turn my gaze to Bunty, who's resting serenely in the driveway. She's a very pretty car, is Bunty. She's navy blue. I wouldn't call her elegant, but she does have a certain *je ne sais quoi* – a curvaceous charm.

In the kitchen I try to open a carton of milk and some spills onto the table. I go to the sink and try to fish out a J Cloth that smells the way J Cloths smell when they've been curled up in a stagnant ball underneath the washing up. As I reach for a tea bag I catch a glimpse of myself in the small mirror beside the wine rack. I look a mess. I've gone to seed, that's what I've done. I always knew it might happen. Even small things, such as brushing my teeth, seem to require great effort.

I gave birth again last night. I was in labour for some time. Bruce was there, holding my hand. My face was puce from pushing and I strained and wailed and sweated just like you're supposed to. 'Congratulations Jasmine!' the nurse said when it was over. Then she handed me my newborn in a pink towel.

The towel contained a puppy. A Labrador it looked like. I must have been watching too many toilet paper commercials. And of course the theme of birth is not without its relevance.

Cait Carmody is pregnant.

Susan told me this the other night after I'd driven home in Bunty. She suspected it some months ago when she saw Cait looking serenely plump and coming out of Mothercare. Then, last week, she met a mutual acquaintance who said the baby is due any day now.

Any day now.

It may be Bruce's child apparently. It could also be her new boyfriend's. The man she left Bruce for. The man she's fallen madly in love with. Bruce didn't leave Cait. Cait left him.

Bruce, of course, did not tell me this. He just said the affair was over and that he'd been foolish to start it in the first place. Somehow I assumed he'd made the final break. I can see now that he encouraged me to believe this, without saying it in so many words. So this new bombshell puts an entirely different complexion on things.

My own complexion needs some attention. I go into the bathroom and put on a mud face mask to unclog my pores. I'm glad that you can't laugh or cry with a face mask on. You just have to wait for it to draw out all the grime while it dries. This will force me to be stoical for at least ten minutes.

I go into the sitting-room and put the phone back on the hook. I took it off the hook and switched off my mobile after I'd phoned Bruce in New York to tell him I knew. That's why he sent me the Email saying 'I can explain everything.' And I'm sure he can. The thing is, I'm not interested any more. It's completely left me, this wish to understand him, this wish to somehow patch things up. I feel so betrayed I just want to curl into a little ball and whimper for at least five months. I don't want to have to deal with anything practical – but I know I must. All indecision about my marriage has gone. It's as though I've been picked up and shaken very hard, and all the loose stuff has just fallen away.

My fury this time goes so deep it's burned out its own hysterics. Now it's demanding a toughness I didn't know I was capable of feeling. It's demanding that I stay on in this house and tell Bruce to leave. It's demanding that I call a solicitor to commence my divorce.

My fury is a feisty lady. She wants to kick ass. She's telling me life is happening here, now. It's not waiting while I waste time. And as I sit with her and listen I see she's not just my fury. She's the part of me that's always been there, waiting for the moment when I would listen fully and not just grab half-sentences.

She was there at my wedding, screaming in the background. She was in America, urging me along that open highway. The other night, when I was driving Bunty, she was there too. In fact she's been around quite a lot lately, in one way or another.

Susan says we have to accept the different parts of ourselves to become whole. She says every part, every voice, has its own message. 'Why have black and white,' she says, 'when you can have Technicolor?'

The thing is I quite like black and white sometimes – especially in old romantic movies. The classic ones. They have a kind of gritty truth to them you don't often find in films these days. However much modern heroes and heroines claim to be in love, there's a sense that a recalcitrant pet poodle could, for example, already be causing a reappraisal of mutual commitment as the credits roll. But I never get that feeling with Tracy and Hepburn. There's a conviction to their love, their animosity, that goes much deeper than mere romance.

I decided long ago that I wouldn't leave Bruce just because I no longer felt 'in love' with him. I always knew falling in love might one day lead to falling in something else – and I just hoped it wasn't something one often finds on pavements and has to grimly scrape off one's shoe. Another kind of love is what I expected. A deeper, more restful, cosy kind. One that could accommodate routine and even boredom. A love one could settle back into, like an armchair. A place to dream from. And return to.

179

Because we need our dreams, don't we? We need to believe there's another side of the mountain where none of this applies. A place where our first hopes, our first feelings, are kept pristine and pure. Why else would a book about a man who turns up on a woman's doorstep while photographing bridges have turned into such a bestseller?

He was all man, that photographer in Madison County. He moved like a leopard. It's just as well he didn't act like one, otherwise that woman might have looked up and found him crouching on the top of her wardrobe. The poignant thing was that they didn't end up together. But of course it also meant he didn't have time to lie or long for something else. In some ways that probably helped the romance considerably.

It's not just Bruce's lies that hurt. It's my own lies too. I've been trying to kid myself for quite a while now that I've made these big changes. But I haven't. Not really. I'm frightened. I'm shit scared of asking myself what I really want. Until recently even posing that question seemed an impossible luxury. I knew what everybody else wanted and that filled up my time.

Day-dreaming was my only form of subversion. And the marvellous thing about Mell Nichols was that he understood this completely. Even though he was, he is, a multi-million dollar Hollywood star, in my fantasies he was capable of enormous empathy. Our steamy sex in stalled hotel lifts was an act of defiance against life's more leaden regions. As he peeled off my clothes he peeled off my resignation. I was a wild thing with him. Not quite a leopard, but certainly in that sphere.

But they're not enough any more – these fantasies about Mell Nichols or my visualised Mediterranean. Life – real life – involves a series of decisions and I'd better get started on mine. The thing is I'm not quite sure how to go about it.

It's like that time I went into a sports-shoe shop in California. There were hundreds of sports shoes displayed on the wall, and they all looked the same to me. The assistant said, defensively, that they were all very different. They were all very different and very scientifically designed and she could find the one that exactly matched my needs, if I knew them. Would I be using the shoes on grass, clay, or tarmac? Did I have strong ankles? Would I wear them as a fashion accessory? Would I walk in them to work? Would I be jogging in them? Did I require extra cushioning at the instep and deodorised insoles?

I didn't know. As I stood there it occurred to me I hadn't thought much about the shoes at all. I looked around and saw some white leather tennis ones on the floor. Someone else must have just tried them on.

'I'll take those,' I said, because I knew if I stood there much longer I'd burst into tears.

My watch keeps going off. The watch Bruce gave me for Christmas. It's one of those digital jobs that measure many types of time. I don't use its more sophisticated features. I just use it for the hours in a day. The problem is every time an hour passes now it gives off a little bleep. It went off in the newsagents some days ago and everyone froze for a second, as though I'd farted. I think I must have set the alarm when I pressed the button that tells you the date. I don't know why I pressed that button because I knew the date anyway. I've tried bashing it against the wall, but it still won't shut up. I have the instructions somewhere, so I suppose I'll just have to read them. In the meantime I've left it under a cushion in the sitting-room.

Today the sleeve of my jumper keeps catching on the handle of the kitchen door. It's a disconcerting feeling. It's as though someone is grabbing me and hauling me backwards.

181

'Oh for God's sake!' I roar at the handle every time it happens. 'Give me a break, will you!'

My neighbour, Mrs Anderson, has been over to tell me her cat, Tibby, has gone missing again.

'I have no idea where he is,' I told her frostily – I'd been in the bath when the doorbell rang. 'He's a tom-cat after all and they do tend to stray...have you thought of having him neutered?'

Mrs Anderson did not react favourably to this suggestion and stomped back across the road.

I've just put a Van Morrison song on the hi-fi. It's one of his later CDs. 'I forgot that love existed' he sings.

I've turned up the volume. This song is one of Charlie's favourites. I so much want to go to Charlie and have him hold me. But I can't. I'm too terrified. If he turned out to be a liar too I just couldn't deal with it. I want to keep him on the other side of the mountain, pristine and pure.

Susan must have told our mutual friends that I need some cheering up because the phone keeps ringing.

'Are you all right, Jasmine?' they ask. 'Would you like to go to a film?'

'Not just at the moment,' I tell them. Then they usually ask if they can call round 'for a chat'. I've been saying that I can't meet them because I need to go to the hairdresser's – which is in fact true. I do need to go to the hairdresser's. The thing is I haven't actually gone.

'Let's meet sometime next week,' I say – because next week feels like another world at the moment. I hope to God I'm feeling better then because this house is going to be like Piccadilly Circus.

I wish I felt like talking to people, but I'm just not up to it. The perfect companion for me now would be Rosie. We could sit together and watch soaps and grunt at each

other occasionally. She wouldn't need any explanations. Rosie can sense shifts in mood, but she doesn't pry.

Since Rosie is not around, I've taken to talking to Teddy. 'My husband's a liar and my daughter thinks she may be a lesbian,' I tell him.

Teddy looks at me sympathetically, but says nothing.

'My marriage is over and I'm too scared to get involved with anyone else – even though there's another man who's probably perfect for me.'

Teddy looks at me sympathetically but says nothing.

'I need to go to the hairdresser's and get the crack in the sitting-room wall mended, but I don't seem to care.'

Teddy remains non-judgemental.

'I've got to work out what to do with my life before it's too late, and my watch keeps bleeping,' I wail.

Teddy gives me his calm, reassuring stare.

I don't mind that Teddy says nothing – especially not 'Our session is over – that will be 80 Euros please.'

After my latest talk with Teddy, I go to my father's favourite chair and sit on it. 'Oh, Dad – what am I going to do?' I ask. Then I find myself getting up and going to the phone. I dial Charlie's number, then I hang up and stare at the crack in the sitting-room wall. I dial Charlie's number again. My palms start to sweat as I wait for him to answer. But Charlie's not there. He's got his answering machine on. The message says he'll be at the studio until late this evening.

I've got to get out of this house. I decide I'll drive over to Charlie's anyway and ride that horse he told me about. I have a key to his place so I can go in and get the saddle and bridle he's borrowed. And I still have a pair of riding boots and a hard hat from that time I thought I might train to be a riding instructor. It'll do me good to get out and feel

the wind in my hair. I need to blow away the cobwebs and clear my head.

Bruce is due back this evening.

Bunty is now adorned with five L plates. The journey from Glenageary to Bray is not without its moments of panic. Sometimes I feel like pulling out my mobile and summoning a taxi. I don't. But once I've turned into Charlie's driveway and parked, I sit for a while, quaking.

After I've visited Rosie in her pen and given her a carrot and a hug, I go to the field to catch Pinda. I've got a plastic bowl with me and shake it so Pinda can hear that it's full of oats. She raises her chestnut coloured head immediately from the grass she's grazing. Then she whimpers and advances slowly towards me. As she gets nearer she extends her head cautiously towards the bowl and my hand. Thankfully she doesn't sprint away as I put the bridle on her head. She's too busy chomping the oats and studying me curiously.

I can see the welts on her face and back. They're just bumps now. They've almost healed. She's filled out well too. Apparently when she arrived she was just skin and bone. She was lame and had an eye infection too. You'd never guess that now.

'That's enough oats for the moment,' I say moving the bowl away from her. She butts me gently. 'I don't want you to get colic. You can have more oats later. I'm taking you out for a ride, Pinda. Is that okay? I'll groom you a bit first and give you a chance to digest all that grass.'

Her ears move as I speak – forwards and backwards – following my intonation. I can tell from her big brown eyes that she has a kind nature. You can tell a lot from a horse's eyes – just as much as from a person's. I can see she wants to trust me, but she's a bit wary too. I offer her a carrot on the flat of my palm and stroke her gently – giving her time to get used to me.

Back in Charlie's rambling garden I groom Pinda, then I put a folded rug on her back before saddling up. Some of those welts might still be tender. Rosie looks on with great interest. I bring Pinda over to her pen. Rosie cowers and backs away at first and then, impelled as usual by curiosity and good humour, moves forward to snuffle a greeting.

As Pinda and I trot along the windy country roads I think of what Susan said the other day – after she'd broken the news about Cait Carmody's pregnancy. She said we should go on an 'alternative holiday' together. There's this place in Ibiza she's heard about and she thinks it sounds just the thing for us both. Everybody hugs each other a lot, apparently. I'm not sure I like the sound of it.

But after a while I'm not thinking of anything very much. I'm just going with the rhythm of Pinda's movements and staring at the hills and fields. As we pass some open grassland I wonder if Pinda's strong enough to go for a gallop. Then I decide not to push it. My skin is tingling from the wind and I can see Pinda is enjoying herself. Her ears are pricked forwards and she's lifting her feet high. She's watching everything with cautious interest. Sometimes she gets a bit spooked by a plastic bag in a hedge or a barking dog. When she does this I pat her neck and talk to her gently, and she calms down. It's not like when I was a girl riding my pony. Back then I was drunk on life, and freedom, and everything else that hadn't yet been tested. My pony wasn't scared then, and neither was I.

This is a different kind of elation. This is a decision.

I find myself fervently hoping that Charlie will have returned when we get back, but as Pinda walks up the driveway I see his van isn't there.

It seems I'm going to have to do this thing alone.

I never knew one could be this alone.

On the way home I buy some food. Easy food. Nothing fancy. Then I dart into a hairdresser's. It's small and slightly shabby. It's not the posh place I usually go to. The place where Fabienne, that's my stylist's name, yanks my locks around as if they were bits of limp lettuce.

'Just make it a bit tidier,' I tell a girl who looks younger than Katie. 'Just trim it a bit, or something.'

'Going out somewhere tonight?' she asks.

'No I'm not. Are you?'

'No,' she replies, and then she stops talking.

As soon as I get home the phone starts ringing. It's Bruce. He's driving from the airport. He's on a mobile phone. I ask him if he's eaten but then the phone crackles and he shouts, 'Jasmine – I can't hear you. The line's almost gone – we're breaking up.'

'Yes we certainly are,' I say. And put down the receiver.

Chapter 21

I'M IN IBIZA. IT'S May and the weather is perfect – not too warm and not too cold. Susan is with me. We're taking part in an 'alternative holiday'.

I wanted Katie to come with us but she said she didn't want to 'cramp my style'.

'You're not supposed to cramp my style. I'm supposed to cramp yours,' I told her. She just laughed.

Katie's become more secretive recently. I keep trying to find out if she's got a boyfriend, but she keeps steering the conversation onto homeless dogs. Along with her studies she's doing some voluntary work for a dog's home. Last time I visited her in Galway she brought me there and introduced me to her many boisterous charges. These included a sweet quartet of mongrels she'd called Marmaduke, Mandy, Patch and Pearl. When I asked her about them the other day she said they'd all been put down.

'That's awful, Katie. I'm so sorry to hear it,' I said.

'Nobody wanted them,' she replied grittily. 'We did our best. We found homes for some of the others.'

'That's good, darling,' I said, 'but you must be feeling sad all the same.'

'I dunno. I don't seem to have time to think about it.'

'It may be helpful to think about it a bit, dear,' I ventured. 'Not too much. Just a little. It's best not to pretend nothing's happened. I've done that a lot at different times — but it does catch up with you in the end. And then it feels like it's all happened at once.'

She didn't say anything and I began to fear I'd handed down my tendency towards denial. She'd berate me for it

one day, I felt sure. She'd remind me of when my grandmother died. She was five at the time and wanted to know where her great-grandma had gone. I didn't know what to say. My numb response to this spiritual dilemma was two Yorkie bars and a visit to the wax museum.

But thankfully Katie didn't bring up that particular maternal *faux pas* there and then.

'Have you seen Dad's flat?' she asked.

'No. But it's just down the road. He sometimes pops by actually. It all feels rather strange.'

'Do they know yet?' Her voice sounded tight. Restrained.

'Know what?'

'Whether Dad is the father of Cait Carmody's baby?'

I took a deep breath. 'Not yet. They'll probably do a blood test when he's older. He's too young for them to do it now.'

'Have you seen him – the baby?'

'No.'

'Has Dad?'

'I don't know. You'd better ask him.'

'I'd like to see him if – if it turns out he's my half-brother.'

'Of course you will darling.' And then I added fiercely, 'I'll make sure you do.'

As soon as I put down the receiver I felt guilty. I'm very good at that. I could run evening classes on the subject. Katie's upset. I wish I could tell her I was just fibbing. That Bruce and I are back together – that the nasty bits were all a kind of dream. They got away with that in *Dallas* sometimes. Just like they got away with making people believe that a hugely rich extended family all chose to live together, despite the endless rows at

breakfast. I feel a keener sympathy for Sue Ellen these days. I understand more fully her quivering lower lip.

It's probably just as well Katie didn't come with Susan and me on this alternative holiday. Another woman has brought her teenage daughter with her and the girl keeps sneering at the earnestness of the place. I find myself sneering a bit myself, actually. I seem to have grown rather cynical recently. I wish I hadn't. It's not much fun.

They run a number of workshops here, so even though we're on holiday we are, in fact, quite busy. I'm doing windsurfing and 'The Inner Dance – An Exploration'. Susan is doing massage and 'Loving and Letting Go – Finding the Harmony Within'.

Everyone here seems very nice so far, though of course that may be because they feel they have to be. Most of the conversations tend to become rather meaningful. If, for example, you remark on the luxuriance of the geraniums you will probably end up hearing about someone's search for inner peace. This is our first week here and I must admit peace is something I'm beginning to yearn for myself. There are piles of people here in Holo – that's the name of this place. The brochure explains that 'holo' in ancient Greek denotes 'whole'. Everyone here says 'holo' by way of greeting. It wears a bit thin after a while.

I don't know if it's the heat or the cockerels, but I feel a bit dopey. The cockerels kick off at dawn and are soon joined by a donkey. They sound as though they think they're in Carnegie Hall. Certainly they know a thing or two about voice projection.

I've bought some wax ear-plugs. They muffle the sound of the donkeys and the cockerels somewhat, but I can still hear Susan when she shouts 'Oh God!' and

'Josh!' in her sleep. I've asked her who Josh is, but she won't tell me.

Yesterday I skived off my Inner Dance workshop and sat by the bay for a while. It's so beautiful that bay. The Mediterranean really is a very charismatic sea. It's such a wonderful colour for a start, and it contrasts so magnificently with the powder blue sky. The earth that borders the bay is terracotta brown and is covered with olive trees and spiky olive-coloured grass which is growing sun-bleached. The dryness really brings out the smells of the wild mint and rosemary – the grasses and the geraniums.

I sat there bathed in a kind of wonderment as the warm air caressed my skin. Cherished – that's what I felt. Cherished by the sun and by myself who had brought me here. I have brought myself to many places I have not wanted to be in – but this bay was not one of them. This was just gorgeous. Blissful. And a perfect setting for a Mills and Boon novel because there were cicadas too.

Then I heard a kind of sniffing. I stood up to see what form of interesting wildlife could be creating this noise and discovered it was Nathaniel, a large man from Leeds. He was sitting on the other side of a big rock with a wad of paper handkerchiefs in his hand. He was not just sniffing, he was crying. His face was all pink from sunburn and he was wearing a large straw sun-hat.

I've got used to seeing people in tears here in Holo. It's kind of encouraged. Letting it all out – that sort of thing. I suppose I need to do this myself, but I don't feel up to it. So the atmosphere is rather getting on my nerves.

The protocol of the situation *vis-à-vis* Nathaniel was rather subtle. I had to work out whether he looked like he needed empathy or space. Given that he'd sought out a

secluded corner, I decided he wanted to be alone. So I snuck off morosely into the undergrowth.

A lot of people come to Holo to deal with inner stuff and you never know when they're going to let it out. I find myself picking my way through various angsts every time I cross the large whitewashed courtyard, where people sit earnestly discussing Life at various tables. We're all encouraged to meet regularly in little groups and talk about what we're feeling. The thing is, when I'm in one of those little groups, all I really feel is that I want to be somewhere else.

My Inner Dance workshops are held outdoors and are rather intense. 'Dance what is within you,' says Michael, the workshop leader. 'Be what you feel you are. Dig deep into your hidden spaces. Release. Release.' So one minute we're all gaily prancing round to some hypnotic jungle beat. Then, for example, somebody might suddenly crumple up in anguish and start crawling along the ground, possibly wailing while they do so. The last time somebody did this I went for a walk. When I returned Michael came over to me.

'Are you all right, Jasmine?' he asked.

'Yes, of course I am,' I replied defensively.

'It's just I noticed you slip away then. Did this bring something up for you?'

'No. Not at all.' For some reason I'd started to cry.

'It's all right, Jasmine,' Michael said, squeezing my elbow. 'We're all a bit broken.'

'"The world breaks everyone, and afterwards, some are stronger at the broken places,"' Laura, a pretty woman from London, piped up. 'That's a quote from Hemingway.'

'Look, I just went for a walk,' I protested as Nathaniel handed me a tissue.

'Is there anything you'd like to talk about, Jasmine? Or would you just like to be left alone?' Michael persisted empathetically.

'I'd like to be left alone,' I said. Then I felt a surge of courage. 'And I'd like to get away from here. It's weird. We're weird. I don't know what we're doing. I mean, how can this possibly help?'

A number of people looked extremely shocked as I said this, but Michael just listened. 'This is your truth at the moment Jasmine, and I respect it,' he said.

'I don't need you to fucking respect it!' I hollered. 'Shirley Valentine never had to put up with this!' Then I stomped off and left them all gobsmacked. I went off to a taverna down the road. I got talking to a man who hardly spoke any English. This somehow made communication much easier. The local wine also helped. He was rather old – probably seventy – and not at all like Tom Conti. But at least he wasn't manifesting any obvious signs of searching for inner meaning. He was very restful to be around.

'I'm missing a man called Charlie,' I tell him. 'I'm a nostalgic sort of person. I'm sure I'll miss sitting here with you in a couple of weeks. How do you stop missing people, José? I'd really like to know.'

'"Life is Just a Bowl of Cherries,"' he replied.

'Yes, you're absolutely right,' I agreed. It's much too mysterious to take it so seriously.

José spoke mainly in song titles. It seemed to be the only English he knew, along with some of the more frequent words used in the International Shipping Forecast.

'Rockall, Fastnet, Humber, German, Bight' we sang as he escorted me back to the front gates of Holo. We were singing it to the tune of 'Show Me the Way to Go Home'.

I'd missed my vegetarian supper so, after I'd said goodbye to José, I stumbled up the pathway to the small stone chalet I share with Susan.

'I should have gone to Greece on a package holiday like Mum and Shirley Valentine,' I thought. 'At least that way I might have got some sex.'

I've been thinking an awful lot about sex lately, especially now that I'm abroad and not wearing so many clothes. Sex has snuck up on me. It's slinking through my celibacy like a feral cat. It's got a hungry-eyed determination to it now that's quite disturbing. It's sitting on some high wall waiting to pounce.

It's strange, but I almost feel under some sort of obligation to renew my acquaintance with sperm. Newly separated women are supposed to do that on holiday, aren't they? Kick over the traces. Find themselves a toyboy – some exotic hunk who wants to pleasure them in a superbly superficial, uncomplicated way. It happens. I've heard about it. But it won't happen to me. I don't know how to be uncomplicated. Charlie understands that.

I really wish Charlie was here so we could talk – talk like we used to before it got so complicated. I think we'd giggle a lot actually, and struggle desperately not to burst into laughter at inappropriate moments. Not that Charlie would be too cynical about all this. He'd probably think it was sweet in a way. Rather endearing. But not to be taken too seriously. Like most things.

I wish I could be laid back, like him. I collect experiences like some people collect antiques – storing them, restoring them, polishing them – lugging them fearfully to the emotional equivalent of the *Antiques Roadshow* for valuation. 'Your marriage? Ah now – it could make a good *trompe-l'oeil*. But see those flakes there? They'd need to be varnished.'

193

'Where have you been?' Susan demanded that evening as she came into our chalet. She'd been at an impromptu flamenco dancing session in the courtyard.

'I've got to get away from here, Susan,' I replied. 'There's just too much pressure to be authentic. I don't want to be authentic. I want to be a fake. I know how to do that – I've been trained.'

Susan smiled at me.

'You're not taking me seriously, Susan!' My voice rose in desperation. 'I've got to escape for a while.'

Susan continued to calmly unfold her cotton nightdress. Then she lit her aromatherapy burner which she uses to deter mosquitoes.

'This is hardly Alcatraz. You're dramatising things again, Jasmine,' she said sharply. 'Stop it.'

Her 'Loving and Letting Go – Finding the Harmony Within' workshop has made her a bit irritable. In fact Susan is often irritable these days. I'm not sure I like her any more.

'Have you seen my sex?' I demanded.

'Your what?'

'My socks – the blue cotton ones.'

'You didn't say socks, Jasmine. You said sex.' Susan was smirking knowledgeably.

'Of course I didn't. Why on earth would I say that?' I protested, with as much conviction as I could muster.

'Yes you did, Jasmine. I heard you say sex quite clearly.'

'Well, I'll tell you what you shouted last night in your sleep,' I countered. 'You shouted "Josh!" Who is Josh? I've never heard of him.'

The still night heat seemed to be making both of us more and more direct. We just didn't have the energy for obliqueness.

194

'Josh is a man I loved once,' Susan flung the words at me while tossing off her flip-flops. Then she started to slap aftersun onto her arms.

'It seems to me you still love him. You should be sharing this chalet with him instead of me.'

'I can't share this chalet with him,' Susan snapped.

'Why not?'

'Because he's married.'

This silenced me for some time. I watched Susan as if she were a stranger. I studied her cautiously as she scrubbed moisturiser into her face and shook sand off her towel. She performed these small tasks in an abrupt, almost harsh manner. She looked like a woman preparing for a night alone at the bare base camp of some dream.

'You had an affair with him?' My voice sounded small. Fearful.

'Yes.'

'Where is he now?'

'He's with his wife. They live in Africa.'

Susan got into bed then and pulled a blanket over her head. I sat up and twiddled my new ceramic necklace.

'Did his wife find out?' I had to know.

'Yes.'

'Why didn't you tell me about this before?'

'I wanted to tell you – many times,' Susan sighed. 'But you were so upset about Bruce and Cait I didn't think you'd be very sympathetic.' Her voice was somewhat muffled by the blanket.

'So you don't love Liam?'

'Maybe I do. I'm not sure,' Susan sighed. 'Look, can we talk about this some other time? I'm really tired.'

I lay in bed for hours thinking about what Susan had just told me. At around one o'clock she blew her nose.

'Susan, are you awake?' I said. 'I want to ask you something.'

'What?'

'Did you and – and he – the married man – ever make love in his home? In his bed?'

'Of course not. I never even went to his house. It wasn't like that at all.'

'So – so you weren't careless?'

'No. We weren't careless. I'm not like that, Jasmine. You know me.'

But suddenly I wasn't sure I knew her. I wasn't sure I knew anything. Holo was having a strange effect on me. I could almost feel myself fragmenting. Facing things I didn't want to face. And there was all this sex to deal with too.

'There's just no getting away from oneself. Not really,' I thought forlornly. 'Not even in the Mediterranean.'

That night I dreamt Susan and a stranger were making love in the sitting-room of my home while I watched *Emmerdale Farm*. All she was wearing was a huge diamond hair grip, and then Bruce came in attired in an off-the-shoulder silk evening dress. When Bruce opened his mouth to speak he sounded rather like a donkey braying. Very loud flamenco music started up then and he hitched up his dress and started to twirl around shouting 'Ye Ha! Go with the feeling!' And when I looked over at Susan and her lover – who resembled Eoin, the greyhound man – I saw they were covered in slugs and slime and smiling in a very eerie manner.

'What on earth were you dreaming about last night?' Susan asked the next morning. 'You called out "Charlie!" at least four times in your sleep.'

'Really?'

'Yes.'

'I couldn't have.'

'You did.'

'Four times?'

'Yes – and quite loudly too.' Susan studied me knowingly. 'What's going on between you two?'

I turned sharply towards her. 'Nothing.'

'Are you sure?'

'I don't want to talk about it, okay?' I gave her a flinty look. 'Now could you please get up for a moment. My dance workshop's about to start and you're sitting on Nathaniel's tambourine.'

Susan and I had a long chat that afternoon.

'You've grown a bit self-righteous lately, Jasmine,' she said.

'No I haven't!' I exclaimed self-righteously.

'Yes you have. You're like a Benetton shop assistant. You go around folding things up. You want everything to be neat and tidy. Life's not like that.'

I stared at her glumly. 'So what should I do, Susan? Throw all the jumpers in the air and shout "Whoopee!"'

'Of course not. You need to find some middle ground. Some acceptance that life can be a messy business. We all make mistakes sometimes, Jasmine. If we don't forgive others, how can we forgive ourselves?'

We were sitting in the large whitewashed courtyard. Susan's eyes were glistening.

'We're talking about Josh, aren't we?'

'Yes. In a way.' Susan looked down at her sandals.

'I'm sorry if you got hurt.' I meant it.

She smiled at me gratefully.

'Tell me about Josh – if you want to,' I continued. 'Don't be too fair. Wallow in it if you like – I've got some extra tissues. I've already decided he's a complete shit, so you're on safe ground.'

'Oh, Jasmine, if only he were a shit,' Susan mumbled brokenly. 'It would have made it so much easier.'

And so Susan told me about loving this man who wasn't free to love her. I listened and nodded in the appropriate manner and reluctantly felt life getting larger – as much in flux as the molecules you'd see in a table – or in a marriage – if you stared and stared long enough.

And then Susan jumped up and said she'd be late for her massage class.

'By the way, I found your sex,' she said, before she raced off.

'My what?'

'Your blue cotton socks. They were underneath my bed,' Susan laughed mischievously. 'You should have a fling, Jasmine. You've gone too long without socks. You really have.'

Chapter 22

I'VE ESCAPED.

This morning I caught a taxi into a nearby town. I need to get away from Holo for a while and just be a tourist. A person in a brochure.

Susan was still dozing when I left the chalet, so she didn't notice me splashing on her aftershave. Funny how many women prefer men's perfume to their own these days.

Susan's aftershave is an expensive one that does not seek to charm so much, as to assert a certain attitude. At least that's what I make of the ads for it in the Sunday supplements. They feature black and white photos of an angry, unshaven young man in his underpants. He's tearing at a croissant in a bedroom that looks like a disused factory.

So now I and Susan's aftershave are sitting in a nice, posh, hotel foyer. I needed to get out of the heat, and this hotel is cool and comfortingly familiar. The kind of place Bruce and I frequently stayed in on holidays.

Occasionally Bruce had to go off on business and leave me alone. It was a weird feeling, being left alone in those hotels. In the more touristy places I often didn't feel like I was in another country at all, but in a realm of Jacuzzis and chips. A sort of mental stopover where one might have nightmares about not getting a suntan or missing the coach. A place where the tennis courts waited and Sky Television beamed ads across Europe inviting you on a family visit to Sellafield.

I remember how one night, alone in some hotel, I started to switch television channels in an almost compulsive manner. Grazing through the frequencies with a dejected fascination.

Then I chanced upon a hearty German programme about penile length. Since there were a lot of Germans in the hotel I tried to turn down the volume – the walls between the rooms were not particularly thick. But I must have pressed the wrong button on the control because, for half a minute, sounds of simulated orgasm blared from my room. The next morning the fat man from Huddersfield sneaked an interested look at me in the corridor, as he and his wife waddled down to the breakfast buffet.

I'm sneaking looks at my tanned skin. My tan does look good. There's no doubt about it. It makes me feel different. Exotic. Cosmopolitan. Sexy too – but that's pretty much par for the course at the moment. I think this sex stuff will go away if I ignore it. But like a drunk at a party, it will loiter for a while, testing my resolve.

My resolve isn't as firm as it was, actually. It's not really convinced any more by my arguments. I think it's pissed off with me about Charlie. It thinks I made a big mistake there – that I should have shared his bed – his life. 'I don't care what you do any more,' it seems to be saying. 'I'm going for a beer.' This, of course, is rather unnerving. It also has the effect of making me want to act out of character. It occurs to me that if I act out of character for long enough I may become someone else.

Sensible middle-aged women do not, of course, think such thoughts. That's why it's so important to keep myself busy. I must ignore the hypnotic pendulum of my emotions as they swing between propriety and whoredom. I must spend today looking at the sights and shopping. I've bought a guidebook and am determined to be very earnest about it all. I'll be one of those people who finds little shops down alleyways with ethnic bargains. I'll brag about it too.

But I'm not going to start just yet. I'm having some wine and *tapas* first. I'm lingering without intent. I'm foreign. Legitimately in between. Time is slipping by softly and unobtrusively. My watch has ceased to panic and I'm feeling rather smug. Yesterday I managed to breach one of my own boundaries. Yesterday I managed to stand up on my windsurf board.

This was, of course, not something I expected. As I clambered onto the board and attempted to stand up I knew that, at any moment, I would slosh back into the sea in an ungainly fashion. Then, just as I was wrestling with the sail, I looked over at Al, a very handsome blond man on the course. He was bending over for some reason and I couldn't help appreciating the beauty of his bum. So taken was I by Al's posterior that I quite forgot that windsurfing is something I, Jasmine Smith, cannot do. Before I knew it a gust of wind caught my sail and I was skimming along just like you're supposed to. I was incredulous. It was great. I didn't want to stop.

'If only Cait Carmody could see me now,' I thought with deep amazement. 'If only everyone 1 know could see me now.'

Someone is seeing me now – in this hotel foyer. I'm becoming aware that a man straight across from me, on another sofa, is studying me with interest. He's quite handsome, in a worldly sort of way, and probably in his late forties. I smile politely at him and then I pretend to be looking for something in my handbag.

I take out a used envelope, and my Eurovision Song Contest biro, and start making notes about nothing so he will see that I have a life of my own. That while I may enjoy lingering looks from strange men in foreign hotel foyers, I do not depend on them.

Only he's not getting the message. He's come over and is standing in front of me. He's gesturing towards my sofa and saying 'May I?' in a French sounding accent. And because I don't know what to say, I say 'Yes'. Then I stare hard at my envelope as though his relocation has nothing to do with me and people switch sofas in hotels all the time; as though, having traversed oceans and entire continents, their wanderlust must somehow find an outlet.

Only he will not be ignored. He leans forward – lifts my empty glass and says 'You 'ave another – yes?' and I'm just about to say 'No' when a waiter appears. 'A whiskey and a...' The strange man smiles at me helplessly. He has smooth olive skin and mischievous knowing eyes. His hair is quite long – past his ears – and there are tiny daisies on his expensive blue shirt.

'Red wine,' I mutter

'And a red wine for ze lady,' he says.

Well that's that then, isn't it?

As I've said before, being accosted by strangers is not new to me. They tend to want to discuss some problem and I'm a good listener. I don't butt in and tell them what to do, but at some point in the conversation I usually manage to insert the name of a relevant organisation or support group. I've built up a long list of them in my diary.

I look at this man and wonder what his problem might be, only he doesn't seem to have one. It seems he wants to listen to me. It seems his appreciative looks were not just a cover for some more prosaic purpose.

'Oh well – why not!' I find myself thinking. 'It's just a bit of harmless fun.'

After my second glass of wine I unwind a bit, and after my fourth I'm growing friendly. I'm growing friendly and not bothering that my linen skirt is riding up past my golden

knees and my handbag is sprawling wantonly under the table. I've never behaved like this with a strange man in a foreign hotel before. It's quite exhilarating. Of course I'm going to have to leave any minute, but it's nice to be frivolous for a while, to flirt.

Women do this when alone on holidays. I've read about it in glossy magazines. For newly separated women skiing seems to be the ultimate statement – negotiating some snowy peak with glamorous ease. But this foyer friskiness isn't too bad either. No one could call this moping. Women in foreign films behave like this. The kind of films Bruce raves about. I never really understand those women but they have style. An unlikely style. I like their improbability.

'Jasmine.' Serge's lips decant my name like vintage Bordeaux. Even though he's French, his English is perfect. He's in Ibiza on business. 'Jasmine's a lovely name,' he says. 'How did you get it?'

I tell him the story of my mother and the man who gave her the jasmine blossom in Greece. 'So anyway my mother took this as a sign and called me Jasmine…I'm glad he didn't hand her a bougainvillea.'

Serge finds the bougainvillea bit enormously amusing. He's virtually crumpled up with mirth and I'm rocking around a bit myself. Then he reaches towards a vase on the table beside us and picks out a pink rose, which he places behind my ear – brushing a stray hair gently from my face while he does so. And as he leans close to me I realise something. I realise we are both wearing the same aftershave.

'The name Rose would suit you too,' he says seductively. 'A beautiful little rosebud, ready to blossom. Jessica – I have some champagne in my room. Share it with me. Let me open your petals and kiss them – one by one.'

203

'You just called me Jessica!' I'm sitting bolt upright, startled.

'I am so sorry, my dear.' Serge does not look shamefaced. 'You are Rose to me. May I call you my Rose? My Rambling Rose?'

'This hasn't happened for a year,' I say, adjusting my skirt.

'What?' asks Serge, somewhat irked by this change of theme.

'It's over a year since someone's called me Jessica. It used to happen a lot. I'd say it's happened at least twenty times.'

'Really,' Serge says glumly. 'Well, maybe you were a Jessica in another life.'

'That's what my friend Susan says.'

Then Serge takes my hand and starts talking about my petals again, only I'm not listening.

'What is a Jessica?' I wonder. 'What is a Jasmine – or a Rose?'

It must be significant in some way – people's lax attitude towards my name. It feeds into a wider belief about myself and my existence – and that is that people frequently get me wrong. They are frequently so wide of the mark about me that I might as well be Beerbelly Bert from Ohio. And the thing is, I know I'm not entirely blameless in this regard. Along with being a bit of a social chameleon I have, to use AA terminology, co-dependent tendencies. I will guiltily secrete all evidence of my presumed self if a more compelling version comes along.

Or I used to.

I turn, straight-eyed, to the man I have just met.

'Look, Serge, cut the crap about the petals will you? I am not Jessica or Rosebud or Rose. I'm Jasmine Smith, and I'm forty and three-quarters.'

Funny that I used the fraction. I haven't done that since I was a kid. Serge gives me back my hand and runs one of his own through his stylishly greying hair.

'You're a feisty lady. I admire that,' he says, but he looks uncomfortable. 'You have style.'

'So have you,' I say. 'And I'm not sure I like it.'

Serge's face breaks into a broad, conspiratorial smile. I frown at him.

'Do you do this a lot?'

'What?'

'Approach strange women in foreign hotels?'

'Occasionally.'

This is not a romantic answer. I look at him with sudden distaste. He didn't even bother to dress the reply up. Toss a silk scarf over its sharper contours. Give it some accessories. A woman likes verbal accessories and men, duplicitous creatures that they can be, tend to need them.

'He probably has a wife,' I think. 'I'm almost sure he does. He has that look about him.' Suddenly I don't know what to say. It occurs to me that I could bite him – hard.

'Don't get me wrong, Jasmine. I am fussy,' Serge continues. 'This doesn't happen all that often.'

I remove the rose from behind my ear and shove it back into its vase. I straighten up and reach for my handbag. 'You should brush up on your reassurances, Serge,' I say. 'They're not all that convincing.'

'Are you leaving?' Serge looks amazed.

'Yes. Yes I am.'

'Why?'

'You want to have sex with me, don't you?'

Serge gives me a coy smile. 'The idea had crossed my mind.'

I rise from the sofa in as regal a manner as I can muster. 'I'm sorry Serge, you've got me wrong. I'm not that sort

of person. I do not treat sex in such a casual manner. My husband and many of my friends do – but I've chosen not to join them.'

'That's a pity, because I think we could have had some fun, Jasmine. I think you need to have some fun.' Serge rises and reaches for my hand. He kisses it without rancour. I find myself hesitating. He's right, I do need to have some fun, but surely I'm not this desperate. No – no – of course I'm not. My resolve returns and I try to assume the friendly yet feline inscrutability of, say, Charlotte Rampling.

'Thank you Serge, I did enjoy – you know – whatever it is we were doing. I've got an awful lot of shopping to do now, so I'd better go.'

And I do go. I square my shoulders and stride through the door of that hotel. My path is less linear than I would like it to be because I'm slightly tipsy from all the wine. As I step out into the full blast of a Mediterranean afternoon I shade my eyes. I walk along blinking at the world in a bewildered manner and searching in my bag for my sunglasses.

And then I bump straight into Al. Al of the beautiful bottom. Al from my windsurfing class.

'Hello, Jasmine,' he beams. 'Doing a bit of sightseeing?'

'Mmmm – sort of.' I try to smile in a calm, friendly fashion but I fear the wine may have turned it into a leer.

'I was going to go to the beach – want to join me?'

'Mmmm – well.' I stare down at my canvas shoes and feel myself sobering.

'Don't worry if you have other plans. It was only a suggestion.'

The midday heat is baking my skin now. It's uncomfortable. The beach would be cooler. It would be

sensible to go there, and I'm going to be sensible today – I really am.

'Okay,' I say. 'I'll come for a while. I've got some shopping to do later.'

'Great,' says Al. 'It'll be nice to have some company.'

We start to head in the direction of the sea. I walk while Al saunters. I try not to look at him. I'm not used to men being quite so handsome. I feel rather frumpy and old beside him. His skin is a beautiful kind of honey colour, and his thick hair is tousled and sun blond. He's in his early thirties but he looks about twenty. His body is great too – muscled in all the right places, but not offensively so. When he smiles I almost shade my eyes again. It's such a wide, carefree smile. His brown eyes smile too. They're less carefree though. In fact they look a little lost.

The aimlessness of holidays is, of course, one of their attractions. But I'm not sure I like it just now. I'm used to having Bruce beside me, steering me towards some monument or other place of cultural merit. Suddenly the day seems chaotic and I do too. Suddenly a wave of loneliness engulfs me. I'm walking towards a beach with a near stranger. A stranger with a beautiful bum. I have no idea what we are going to talk about – surfing maybe. Al looks that type. I'm going to have to pretend to be happy too. You're supposed to be happy on holidays. This fact has been pressing in on me lately – thickening my thoughts – making me a bit miserable in itself. I consult my holiday script.

'It's wonderful to be away, isn't it?' I say. 'And it's so beautiful here. So warm.'

'Absolutely,' says Al.

'I'm surprised you're in town on your own. You seem to have made so many new – new friends.' I'm remembering all the nubile beauties who hover around Al at Holo.

'Mmmm,' says Al. Maybe it's my imagination, but there seems to be a certain gloom behind his cheery demeanour.

'Have you been to Holo before?'

'Yes, once. With my girlfriend – my former girlfriend.' Al sighs as he says this, then he adds, 'We broke up last month.'

When I turn to look at him his eyes are glistening.

'Do you want to talk about it, Al?'

We've stopped so that Al can examine some postcards at a stand.

'No, not really,' he says as he chooses some. I wait while he pays for them at the counter.

'I've just separated from my husband.'

'Do you want to talk about it?' Al studies my face kindly.

'No.'

We walk on, a trifle morosely now. All the things we don't want to talk about swarming around us like mosquitoes. I've got four mosquito bites on my arm and they're a bit itchy. I scratch them absent-mindedly and then stare at the ocean we've just reached – trying to find some peace in the view.

Al has been to this beach before. He knows a secluded corner. I'm not sure I want to be in a secluded corner with him, but he seems determined to go there. The day seems to be taking on a momentum of its own. Something I don't understand and can't seem to stop. It's very improbable – Al and I walking together along this beach. I feel like a miscast actress in *Baywatch*. Any moment now someone is going to grab me off the set.

My holiday script has made no provision for this scenario, so I decide to fill Al in on some local history that I've gleaned from my guidebook. Al does not appear that interested so

208

I find myself blabbing about Serge, the man in the hotel foyer. Al's silence is fuelling my revelations in a disconcerting manner. I give him far more details than I intended to. Still, I know I'm on safe ground. Al can't possibly be interested in me in the way Serge was and these intimacies do, in a sense, show that I realise this. As I speak I take off my shoes and then I yelp with discomfort. The sand is very hot. I head for the wet sand by the sea which is cooler.

'I'm not used to being single you see, Al,' I say. 'Sex is like a kind of dance – isn't it? But I don't know the choreography. I know a bit about ballet, but not this modern stuff.'

Al smiles wryly, as if I've just said something amusing.

'It's not a joke, Al. I mean it. My friend Susan says I should have a fling, but I don't know how to. I mean, I want to, in a way. But I don't know how I'd react.'

'You won't know until you give it a try.' Al smiles charmingly. Then he picks up a stone and sends it skimming along the water.

I'm beginning to see why strangers sometimes approach me and tell me their life stories. Sometimes it's easier talking to someone you don't know. Someone who will listen to your story without already knowing the plot. Who won't butt in and correct you, as though it wasn't your story at all.

I feel like a comfy pair of carpet slippers – a cosy presence that Al somehow needs. This has the effect of dampening my libido and making me maternal. I don't know what his girlfriend did to him, but it's obvious he's very hurt. Since he doesn't say anything much I blab on in that awful way one does sometimes. Driven by a pleasing indiscretion – showing off my warts.

I find myself telling him about Charlie. 'I wish I could love him, but I don't know if I can love anyone any more

– not in that way,' I tell him. 'Not after what Bruce – my husband did.'

I wait for him to ask what Bruce did, but he doesn't. He's a bit like Teddy in that way. Kind but uncommunicative. I tell him about Bunty.

'It's amazing. I never thought I could drive, but I can. It frightens me a bit, but I've got used to that.'

The secluded spot we're heading for is now, apparently, in view. It's sheltered by rocks and very out of the way. I turn, half-scared, towards the other end of the beach where the holiday-makers are now small dots. I really didn't know we had walked this far.

'We've come an awfully long way, Al,' I say.

'Yes we have. Can I have a hug?'

'A hug?' I stare at him, bewildered.

'Yes, a hug. I need one.'

Somehow I'd forgotten all about Holo, where frequent hugs are almost *de rigueur.*

'Okay,' I say, a trifle grudgingly. But when Al wraps me in his arms I lean against him gratefully.

'Do you buy into all that stuff?' I ask. My voice is muffled by his T-shirt. My face is pressed against his chest, smelling his sweet, young, smell.

'What stuff?' Al is rubbing my back in a friendly fashion.

'That stuff at Holo. Hugs and everyone trying to be so nice to each other all the time.'

'Well, it makes a nice change, doesn't it?' Al is holding me quite tightly and his chest seems to be heaving. It occurs to me that he might be crying. I pull back and look up at his face. He is. This exotic creature that has somehow landed in my day is clinging to me now for comfort. I suppose I shouldn't be too surprised. Susan says I have a comforting face. Susan says I'm

good at comforting others and what I need to do now is learn to comfort myself.

'You poor old thing,' I squeeze Al's elbow. 'I'm sorry that you're sad.'

We spread out our towels then and I take off my skirt and blouse. I've my bikini underneath them. Al's got his swimming trunks under his jeans too. I rub suntan lotion onto Al's back and he rubs it onto mine. Then we lie down and let the sun shine on us. Roast us gently in the cooling sea breeze. Feeling so at ease with him is not what I expected. It's like that night at the line dance when the steps didn't matter any more.

'Al,' I say, turning to him cosily. 'Do you think I should take a chance on that man I mentioned? You know – Charlie. He really is very nice.'

'I don't know, Jasmine,' Al replies. 'You need to follow your own instincts on these things.' Then he sits up and says, 'Would you like a massage?'

'A massage?' I squint up at him warily, shading my eyes from the sun.

'Yes. I've been doing that course. I need some practice.'

I look around. 'Are you sure it's all right to – you know – do it here?'

'Of course it is. Who's going to see us? The nearest people are right down the other end of the beach. They'd need binoculars.'

'I dunno.' I wriggle uncomfortably. There's something about Al that makes candour obligatory. 'I'm not sure massaging me is such a good idea.'

'Why?'

'Well, it's rather intimate – isn't it?'

'Only if you want it to be. Do you want it to be, Jasmine?'

211

I stare down at the sand guiltily. 'I think most women would want it to be intimate with you, Al. Look, I'm not your type – you and I know that. I'm too uptight. Didn't you listen to all the stuff I said earlier?'

'Shhhh,' says Al – reaching for his suntan oil. 'Stop making complications where there are none.'

'But there are complications!' I protest. 'Piles and piles of them.'

'They're only in your head, Jasmine,' Al replies. 'Now lie down on your stomach and relax.'

I follow his instructions grimly. 'I want you to know, Al, that I'm beginning to feel very tense,' I mumble rebelliously.

'Shut up,' Al laughs. And so I do.

Al's practised hands knead my skin pleasurably, as though I am a ball of dough. He's using just the right amount of force and gentleness. The long sweeping movements up my back are especially nice. I feel my rebellion, my tension, easing. I'm growing heavier – sinking into the sand.

'Thank you,' I mumble every so often. I feel extremely humble.

'Shhh,' Al says. 'Just relax.'

I turn over after a while, so he can get at the front bits. His warm hand moves down my belly so innocently that I hardly register that it has reached my crotch. He slips two fingers under my bikini bottoms. I sit up.

'No, no, Al. I can't let you do this,' I say, reddening.

'Why not?' He looks at me. Perplexed. He's used to this kind of thing. I can sense it. But I'm not.

'You can't because – because...' His fingers have found my vagina now. As he slips one of them inside me I lie down again. It's just so nice.

'I can't let him do this,' I think. 'I must stop him now, immediately.' Even though we're shaded by some rocks, the midday heat is intense. It's making my feelings hard to fight.

212

Al's fingers are working – sending tingles all over my body. I squirm with pleasure and shyness.

'Mmmm,' Al says, looking as playful and pleased as a puppy. 'You're all warm and wet. I'd love to kiss you there. Can I?'

'No! No! I hardly know you,' I say through half-moans, as though what he's already doing is somehow the sexual equivalent of small talk. Something that can somehow accommodate ambiguous intent. A small act of wantonness. Nothing serious.

'Is anyone coming?' I'm terrified that some clump of earnest British tourists are going to suddenly appear with their open-toed sandals and their *Reader's Digests*.

Al looks around. 'No, Jasmine. We're quite alone. The only person who is coming is you.'

'I'm not sure if I can – not here. Oh, Al, you should be doing this with someone else. Someone more modern.'

Another frightening image has occurred to me. The image of Al rubbing and rubbing my clitoris for hours and hours, waiting for me to come. Patiently, diligently. Occasionally stifling a yawn. Changing hands maybe because of tired muscles. My face tight and grim. The sun, perhaps, already setting.

'It doesn't matter if you come or not, Jasmine,' Al says. 'Just enjoy yourself.'

'I can't do this,' I think. 'I can't let go here – on a foreign beach – with a stranger. People do this in films. Not me. Not Jasmine Smith. I should be shopping. What's wrong with me? What am I becoming?'

Part of me stands up and surveys the scene.

'You wanton hussy!' she screeches, reaching for a towel, backing away. Distancing herself from this depravity. 'I always knew you came from the wrong side of town. Oh, you've ants in your pants now, Jasmine Smith. But don't

give in to the itchin'. Don't scratch. It will go away if you leave it. Remember what I taught you. Look at how you dealt with Charlie. You don't even know this man. This is highly inappropriate.'

I try to listen but her voice grows fainter. And then sensations cascade carelessly over me – washing her away.

I'm floating like a seal in the ocean – drifting deliciously with the waves. Carried, urgently now, with a swell that surges – cresting – to a sudden sweet release. As the contractions close and open round Al's fingers I look around, shivering slightly. Spat out upon the shore.

'Oh no, what have I done?' I think, fearful of the desert island that this indiscretion, this foolhardiness has surely brought me to. But Al stares into my eyes with a warmth that shows that he has travelled with me. That I am not alone.

'Thank you,' he says, and kisses me. Then he lifts his hands to his face – drawing in my smell.

'Thank you too,' I mutter. Bashful. Disbelieving. But feeling so nice. So nice all over. A woman in a glossy magazine article. One of those brazen features that scream on the cover: 'Casual Sex – The New Way to a Slimmer You'.

Then it occurs to me that it's Al's turn now.

'Do you want me to – you know?'

'Okay.' Al lies down eagerly with almost boyish pleasure. Two kids, that what we're like. Two kids playing – experimenting with sex instead of sandcastles. On holiday. Feckless. Not caring that the tide may wash all traces of what we've done away. I didn't know sex could be like this – so cheerful and casual. It's quite a revelation.

Al has an erection. I cover him with a towel just in case the opened-toed sandal brigade arrive unannounced. I massage his belly and then I move down to his penis.

'You're good at this,' Al smiles mischievously, all traces of his previous moroseness now gone.

'Am I?' I'm absurdly pleased, as though I've passed some sort of test. Bruce's infidelity has made me insecure about my competency in this sphere. But now I feel like I've been handed a small certificate. I massage Al's genitals carefully. After a while he begins to moan and then – pop – like champagne out of a bottle comes sperm. Squirting rhythmically. Gathering – a little pool of swimming seed upon his tummy. Probably perplexed at where it finds itself. Like me.

'Wow!' says Al. 'That was great.'

'Thank you,' I say smugly. 'We do aim to please.'

There's a silence then that could turn unpleasant. A moment when the Jasmine Smith who was going to go shopping could turn with great animosity on the Jasmine Smith who didn't. Could tear into her like a snarling terrier, unforgiving, relentless in her disapproval. I wait for the blaming to start – the howls and yelps of recrimination – but they don't. I can't quite believe it.

'I'm glad we did this,' Al says breezily, wiping himself with a towel.

'So am I,' I say, but less blithely.

Al's sex life has been very different to mine. He's open. He doesn't hide. You can see it in his face, just like you can sometimes see a guarded, closed look on mine. I, Jasmine Smith, have led a very sheltered life. It's made me smaller than I wanted to be. Too easily shocked. But maybe I can change. Not be the Benetton shop assistant any more – tidying things away. Someone who can deal with these strange interludes. A learner woman who knows when to take her foot off the brake. This is what I travelled all these miles here for, isn't it? Hoping for some small epiphany.

'I could only have done this with someone like you, Al,' I say. 'Someone who understands its innocence.'

'I feel the same way.' Al grins disarmingly.

'Even though I'm older?'

'You have a bit of a hang-up about your age, don't you Jasmine?'

'Do I?' I'm digging my toes into the warm sand.

'Yes, I think you do. Do you know what Picasso said about age?' Al is squinting up his eyes and looking at a windsurfer.

'What?'

'He said "To be young – really young – takes a very long time".'

I look at him gratefully. 'That's lovely, Al. You know something – you look so youthful – but you're really rather old and wise inside.'

I'm not noticing his looks so much any more. One soon gets used to beauty. Beauty can even get boring if it's only on the outside. But Al's isn't. It radiates from within him. He's lovely. It occurs to me then that he's just the sort of man I wish Katie would marry. And though it feels highly inappropriate to be thinking these thoughts after what we've just done – another part of me is wondering if I could engineer a meeting between them. I don't want him for myself. I'm not sure I want any man on an on-going basis any more.

'My daughter's hair is the same colour as yours,' I say. 'She's very beautiful.'

'You're very attractive yourself, Jasmine.'

'Oh, come on Al – there's no need to flatter me.'

'I'm not flattering you. It's true.'

'I wish my Katie – that's my daughter's name – could meet you.'

'Why?'

'Well – you're so hunky she might decide not to be a lesbian.'

'Is she a lesbian?'

'She's not quite sure – but it's beginning to look that way.'

'And how do you feel about it?'

'To be frank about it, Al, I'm very disappointed. Of course I've been trying to pretend that I just want what she wants 'cos that's what one's supposed to say, isn't it? I mean, I've read enough *Guardian* articles to know that. But deep down I'm extremely pissed off about it. Extremely.'

'Why?'

'Well, I suppose I hoped one day she'd marry someone like you and have children and we'd – you know – have things to talk about. Have things in common. Mothers tend to feel that way. I mean, my mother wasn't that happily married, but she couldn't wait to see me walking up the aisle. And now here I am, separated from my husband, and still wanting my daughter to do what I did. It's weird.'

'No it isn't weird, Jasmine.' Al looks at me tenderly. 'It's human. But just keep loving her anyway. Love her in the way we all want to be loved.'

'And what way is that?' I turn towards him earnestly.

'The kind of love that comes without conditions.' He picks up a pebble and cups it in his hand. 'Contentment is inside you, Jasmine. It's not out there waiting for people to do what you want them to do. It's not waiting for you to be who you think you should be. It's a decision, in a way.'

I sit there happily, drinking in what Al is saying. The ideas are not new. I have, of course, read them many times in various books. He probably has too. But it's nicer when someone says them. Someone who understands them – who's not just using the words hoping one day to learn the language.

Every so often in my life I have these mystical conversations. For a while everything makes sense, because I know it doesn't have to. And then I find a fake diamond hair grip in my marriage bed, or some other urgent conundrum – and it's as if I've never had these cosmic conversations at all.

Al and I get up and go for a swim. Then we walk along the beach and I look for interesting stones. The thing about interesting stones is that they tend to look better when they're wet – so you have to choose ones that retain their charm when they're dry. This, of course, applies to many things in life – though the deciding factor is usually not as simple as water.

I so hope that what's happened today doesn't turn all dull and sullen later. There's no need for it to – surely. It's for me to decide, isn't it? Why shouldn't I give myself a rest from myself? Isn't that what holidays are for?

I just choose one stone today. I don't want to weigh myself down as I have so often in the past. It's a perky little coral pink one that seems to have the faint outline of a pig. I miss Rosie. She's such a very charming, understanding pig. And not just a pretty face, because she's smart too. She's slowed down lately because she's getting old. But she still has style.

I miss Charlie too. But it seems to me I'll always miss Charlie more than I want to. More than is convenient. Men tend to remind me of him – even Al. I compare them with him and they make me want him all the more. It's something I'll just have to get used to. I'm tired of wanting people. Of needing them. Casual liaisons – maybe that's the answer. Regular holidays and attentive attendance at rugby internationals. Love – the whole hog type – doesn't have to feature. When I get home I think I'll buy a dog.

After our walk Al and I go to a restaurant by the beach and have a delicious seafood meal. Then we go into town and shop for presents. When we get too hot and need a rest we sit at outdoor cafes and have mineral water. I

spend a lot of time staring at things. Colours seem so much more vivid in the strong sunlight. Doors the colour of lemon groves. Woven rugs hung up for sale. The hills in the distance. The whitewashed houses. Everything. I feel much more vivid too. More alive. It's so nice not to have to visualise the Mediterranean. It's so nice to just be here.

The bus we take back to Holo is so hot I feel I'm baking. As I wipe sweat and grime from my skin, Al asks me about my career.

'I don't have a speciality,' I answer. 'I've done a lot of this and that – especially housework.' Then I tell him a bit about my years with Bruce.

Al is a social worker, which he finds fulfilling but very demanding. He feels like a change. He feels like he needs to work out his own needs more, and not just other people's. His words discomfort me.

'You didn't – you didn't take me on today as – as a sort of client, did you? Someone needy?'

'Oh for God's sake, Jasmine,' he looks a little offended. 'Of course I didn't. I'm not that altruistic. It felt right – you know it did. We both needed cheering up. These things happen.'

He tousles my hair then, as if I am a kid. And I do feel like a kid for a moment. Very young. An open definition. What has happened between us is not something to magnify. To cling to. It has to be seen for what it is. Not something to lug along, as I so often do, to the emotional *Antiques Roadshow*.

'Your little holiday fling – now where did you get it? Ah yes – in Ibiza. Well of course they are most attractive. And very in demand. But to be honest with you, dear, there's an awful lot of them about. They don't tend to fetch that much at auction.'

219

'I suppose one of the good things about my marriage ending is that I'll have to learn to live alone,' I tell Al. 'A woman should learn to be independent. To kick ass.'

'Kick ass?' Al looks perplexed.

'Well not kick ass exactly. But not kiss it so much either. That man in the hotel foyer – he told me that I'm a feisty lady. I do need some time alone.'

'From what you've told me about your marriage,' says Al, who's staring out the window at the olive groves and mulberry trees, 'it sounds like you've lived alone for a long time already.'

Then he reaches into a paper bag he's carrying and hands me a peach. I stare at it, somewhat perturbed. I've rather gone off peaches since the peach pillowcase incident. I take it from him and bite it warily. It's nice and ripe. The juice runs down my chin.

When I get back to Holo I half expect Susan to shade her eyes from my radiance. She's dozing on her bed in our chalet. An open copy of *The Man Who Made Husbands Jealous*, by Jilly Cooper, is lying beside her. She stirs and yawns as I enter.

'Hello Susan!' I beam unconditionally. 'How are you?'

'All right, thanks. Did you have a good day?'

'Yes. Great.' I try not to look too smug.

'Have you finished your packing?' Susan is studying me quizzically.

'Almost.'

I show off the presents I've purchased, and she admires them with gratifying enthusiasm. Then I tell her about Al and she looks pleased, but slightly envious.

'Good for you, Jasmine,' she says indulgently. 'You're learning, you really are.'

I sit on my bed. I reach into my bag and take out a bundle of postcards and my Eurovision Song Contest biro. I've left it very late in my holiday to write them. I stare at them for some time, chewing the top of my pen as I ponder.

'I'm having an enjoyable time here,' I eventually scribble. 'The people in Holo are open and friendly, and the workshops, though weird at times, are quite interesting. The weather has been great and I already have a nice tan. I've even learned to windsurf!! I went to a nearby town today and…' – I pause as I study this partial sentence – 'and had a delicious seafood meal in a restaurant by the beach.'

The amazing thing is – as I read back over what I've written – I realise it's pretty much the truth. I wish I'd realised this earlier.

I'm leaving here tomorrow.

Chapter 23

A LETTER FROM ÉOIN, the greyhound man, awaits me on my return home. Charlie has forwarded it.

'Dear Jasmine,' it reads. The writing is small and precise. 'How are you? I was disappointed that you didn't contact me last time I wrote to you – but looking back perhaps it's just as well. I am now married and Jacinta and I are expecting our first child. I'm sure you'll be glad to know this. I also want you to know that I do respect your honesty about being married. Many women would have given in to temptation and not mentioned it at all. I hope Jacinta shows the same level of loyalty to me if she ever finds herself in a similar situation. I don't seem to have as much time for the greyhounds these days as I used to.

'Anyway, I'd better get this in the post. I did very much enjoy our evening together. I'm occasionally up in Dublin. Do give me a call if you'd like to meet again for a chat. Best wishes, Eoin.'

Eoin has not put his home address on the letter – only his work phone number – which he's underlined. I'm not going to phone him. I don't think he'll mind. I think Eoin needs me as someone who could, but hasn't yet, called. I understand that. Maybe we're not so different after all.

This will be my last summer in this house. Bruce and I are going to sell it. That crack in the sitting-room wall is serious.

It's caused by subsidence. The house needs major structural repair work and builders tramping around for at least a month. I'll move out when they move in this autumn. As soon as it's repaired Bruce and I will put it on the market. It's too big for one person. On the proceeds

Bruce and I should, hopefully, be able to afford smaller places of our own.

A friend of Susan's is going to sell her apartment later this year, and I think I may buy it. Though it's quite small it does have a sea view. And it has two bedrooms, so Katie can stay when she wants to.

It's not in a posh part of town so it's not too expensive. But it is modern and in one of those no-nonsense red-brick buildings where everything's laid on. Comfort does become more important as you get older, especially if you're alone. It's a sensible place, and a good investment, apparently. It's also quite bright and cheery because the large windows let in lots of light. You can keep pets there too – so I'll be able to get my dog.

I did consider buying a cottage in the wilds – but I don't think it would be a good idea for me to be too cut off at the moment, I already feel pretty cut off as it is. If I don't like the apartment I can move out – rent it to someone. I might even go to the Mediterranean for a while. In fact there's absolutely nothing to stop me going to the Mediterranean right now. I wish I found this more comforting.

I'm getting used to being alone. It's okay, but I do wish that when I went into the bathroom I sometimes found the loo seat up. I wonder if I'll ever find the loo seat up again on a routine basis. It seems unlikely.

I keep wondering if I should bring Charlie the present I got him in Ibiza. It's a really nice pottery mug with a saxophone painted on it and lots of musical notes. I've never seen a mug with a saxophone on it before – I almost leapt with joy when I saw it. 'This will be perfect for Charlie,' I thought. 'Just perfect.'

The thing now is, how on earth am I going to get it to him? Posting it is out of the question. Even if carefully wrapped it could get broken – and that might appear uncomfortably

appropriate given the state of our friendship. No, it has to reach him intact. I could, of course, drop it off at the reception desk of his studio, or leave it on his doorstep – but I'm sure he'd find my furtiveness a bit odd – a message in itself. I really wish I didn't feel so uncomfortable about seeing him again.

I used the mug myself today. When I'd finished with it I let it clatter into the sink and then washed it rather roughly. I suppose I was hoping the thing would break, or at least chip, but it didn't. It's pretty robust. It's suddenly become a huge thing in my life – this bloody mug. It's got completely out of proportion. I've got to get rid of it in an appropriate manner. I'm going to drive over to Charlie's with it – now – this evening. I know he's home because I phoned him and when he answered I hung up.

Though I managed to pass my test, I'm still a bit tense about driving. However I am more proficient and can mull over what I'm going to say to Charlie, even while changing gears. I'm going to tell him I've really adjusted to being on my own. That I'm having a wonderful time. Then he'll ask me about my tan and I'll tell him about my holiday. My wonderful 'alternative holiday'. I'll mention the windsurfing – I mustn't forget the windsurfing. And though we won't actually discuss it, it will be quite obvious to him that I am doing the right thing.

He'll smile at me fondly and he'll say…he'll say…well it'll be something friendly anyway. And he'll like his present. No – he'll love his present. And he'll ask me where I bought it and I'll tell him about the little shop – but not about how happy I was. How incredibly happy I was when I saw the mug with the saxophone on its side.

I put on the radio and scan the wavelengths for something cheerful. 'Girls Just Wanna Have Fun' – tum ti ti tum. I tap my fingers on the steering wheel. It's so much easier living alone in many ways. Just answerable to yourself. It's

not lonely – not really. Still, I must get around to getting a dog. I'll go to the dogs' home. Ideally I'd like a puppy – a terrier – something that will stay small. I won't mind if it sleeps on my bed. I'd quite like it to really. Still I hope it won't be too yappy. Small dogs can be very yappy sometimes.

Charlie and I have driven along this road so often. Sometimes we'd stop in that lay-by beside the bay. It's got a wonderful view. I'm near that lay-by now. Maybe I'll park there for a while. Good – there's a space. I'll turn off the radio and have a little rest. I won't get out of the car, like Charlie and I used to. I won't walk along the beach, my shoes crunching the pebbles, laughing. I won't try to find a flat stone that I can send skimming over the waves. Charlie liked watching me do that, I know he did. He'd stand there just looking. It was nice. I wonder if he knew I watched him too – when he was engrossed in something far away, or telling me the names of different kinds of seaweed. I loved the way his hair flopped over his forehead as he bent forward to study them.

I love…no, no! – I mustn't do this. Why on earth did I stop here? It was a very silly thing to do. And now it's getting late and I don't like driving when it's dark. I feel so lost and alone suddenly. I stare at the sea, but even it looks sad. I turn on the radio, hoping for something perky and superficial. But 'Something So Right' by Paul Simon comes on instead.

Part of that song is about the Great Wall that surrounds China – and the wall one can easily build to surround oneself too…

I wish that song hadn't come on 'cos – 'cos it's making me cry. Big warm tears are pouring down my face – they feel like they are coming from my heart. Because – Oh, Charlie – I've got a wall around me. I don't like it either, but I've

built it, stone by stone. I need it, you see. It's got me through.

I don't want to be defensive. Fearful. But I am. I am for good reason and I can't wish it away. I didn't use to be like this, Charlie. I used to be so open. I trusted people. I would have trusted you. I wish I'd met you then. I really do. I wish I had the courage to tell you all this to your face. I've pushed you away – haven't I?

The sea is getting choppy now. A sudden harsh wind is billowing the waves. I start up the car. I wish I could stop crying. I wish I'd never bought that stupid mug. I'm going to have to post it – two Jiffy bags and some newspaper might do the job. I'll put 'extremely fragile' on the package and see what happens. So what if it gets broken. Things do sometimes, it seems.

The photos from my holiday came out really well. I've shown Katie the ones of Al. She agrees he's handsome, but she doesn't seem too interested.

Things are changing so fast I often feel a bit dazed. Something's been set in motion and there's no point remonstrating with it. Al says that arguing with change is like arguing with life – we had a long talk on the plane coming home. I was going on about all the things I'd felt I'd lost lately and he said, if I thought about it, I'd already lost myself many times. I'd already changed from a baby to a toddler to a girl to an adolescent to a woman. These were all losses in their way. And now all these ages were inside me and made up something different.

We've promised to keep in touch – Al and I. We've promised to write each other long, truthful letters. No bullshit. I wonder if we will.

Last night Susan came round with a big chocolate cake. As we were guzzling it, she said she'd decided to go back

to work in Africa. She said being in Ibiza had made her realise how much she missed regular sunshine. I asked her if this decision had anything to do with Josh – the married man she'd had an affair with – but she said it didn't. Then I asked her if it had anything to do with Liam – and she said it did. Liam the rich, handsome man with a home on the Mediterranean and a flat in Dublin. The gorgeous man she met through Hilda – the hunt ball woman at the home.

'I don't want you to go to Africa, Susan. I need you nearby – within the EU,' I told her.

'No you don't,' she replied. 'And anyway, you have Charlie.'

'Why do you always bring him up?' I asked as I chomped feistily. 'I'm alone. Alone like you.' Susan pulled a dismissive face, showing she did not believe this for one moment. She can be very stubborn at times.

I really do wish I could do something about Susan and Liam. He does love her. It's obvious. He's taken time to understand her. The thing is, I don't think she understands herself. I must say she has hidden this fact very well over the years. I was convinced she had it all worked out.

'You don't have to go to Africa. You could live with Liam in Provence. It would be sunny there,' I lectured. 'And I could come and stay with you both. I'd love that. You know I would.'

'I simply can't do it, Jasmine,' she said. 'I'm too scared.'

'That's my line,' I protested. 'You're the one who's supposed to be so well-adjusted.'

Susan frowned, then she leaned forward earnestly. 'You're frightened of men in case they hurt you. I'm frightened of what I become when I'm – you know – involved with one of them.'

'What do you mean?' I cut another slab of cake.

227

'I get so needy – so vulnerable. All these bits of me I don't know what to do with start spilling out – demanding to be dealt with.'

'That's not so unusual, is it?' I tried to assume the non-judgemental tone of Mrs Swan, the marriage counsellor.

'I just can't believe anyone would love me if they really knew me.' Susan's voice sounded small. Dejected.

'I love you,' I said. 'As a friend. I do, really.'

'But that's different,' Susan wailed.

'Why is it different?'

'Come on Jasmine, don't act stupid. It's different 'cos we don't have sex.'

'Yes Susan, I am aware that we don't have sex. It has not escaped my notice.' I wished Susan would go back to being her old, fake, well-adjusted self. I almost resented this new authenticity.

'And that makes things simpler because, the thing about sex is…' Susan hesitated and looked at the crack in my sitting-room wall. 'The thing about sex is – it's sneaky.'

'Sneaky?'

'Yes. Sex is basically about bonding, Jasmine. It's a kind of glue – for women anyway.'

'A kind of subversive Loctite?' I giggled.

Susan did not smile. 'No – a bit less adhesive than that – Pritt perhaps.'

I stared glumly at my Turkish puzzle ring. I wasn't sure I liked this analogy. It seemed to be bringing sex into the realm of office supplies.

'I think sex can be very beautiful – with the right person,' I announced, somewhat defensively. 'I think – I know – it can be a very spiritual experience.'

'Yes. Yes,' Susan said impatiently. 'But even when it isn't, it wants to be. Afterwards. Even if the guy's a creep,

you still want him to phone. Sex affects women like that. It's pathetic.'

'Well then, maybe women should stop sleeping with creeps.' I announced this grandly, like a proclamation.

'Oh, Jasmine, you're such an innocent. Sometimes you only find out a guy's a creep after you've slept with him. They're always nice beforehand.'

The conversation was beginning to depress me. When Susan gets a bee in her bonnet she generalises in a most demoralising way.

'Surely if you know someone well before you have sex with them, then all this is less likely to happen,' I ventured. 'I mean, surely if there's something there already, then sex may make it more. Sex may bring you closer together.'

'Yes, but there's no guarantee.' Susan announced this flatly, as though it somehow settled the matter.

'Of course there's no guarantee, Susan. We're not talking about dishwashers here. You have to take the risk. You've taken the risk with Liam and he phones you, doesn't he? He loves you. What are you going on about?'

'I haven't really taken the risk with Liam.'

'What do you mean?'

'I haven't shown him the nasty bits yet. We just meet once a fortnight. He hasn't seen me like this. Whimpering. Whingeing.'

'I'm sure he'd get used to it.' I tried to sound brisk and reassuring. 'I mean, there must be bits of him that he's hiding too.'

'I can't believe anyone would love me if they really knew me.' Susan repeated. She was cradling her mug of tea. Her face looked very wistful.

'Oh no, we're not back to that again,' I sighed.

'What you don't seem to understand, Jasmine...' Susan peered at me strangely, as though she was wearing bifocals.

As though half of me was in focus and the rest blurred. 'What you don't seem to understand is that I feel a fraud.'

'Oh, is that all!' I smiled with relief. 'What you don't understand, Susan, is that feeling a fraud is as common as muck.'

'Really?'

'Yes. I feel a fraud sometimes, and so does Charlie and – wait for it – so does Cait Carmody.'

'Cait Carmody?'

'Yes. Charlie works with her in the studio sometimes – when she's recording voiceovers. One day, when she was rehearsing an ad about fabric conditioner, she stopped in mid-sentence and said, "Charlie – I feel a complete fraud."'

'Well, maybe she doesn't use it.'

'What?'

'Fabric conditioner.' Susan glared at me as if I were dense.

'For God's sake, Susan, she wasn't talking about fabric conditioner!' I snapped. 'She was talking about herself. About acting. She's insecure.'

Susan absorbed this information in a rather neutral manner.

'That's all you are, Susan. You're just insecure.' I waited for her to look comforted, grateful. But she remained morose.

'The thing about Liam is – he could really hurt me. You know, if I let myself get involved and then he lost interest.'

'But that mightn't happen, Susan.'

'Yes, but it could. It's happened before. I suppose that's why I sometimes feel it's better – you know – to go for the ones I don't mind losing.'

'I don't know, Susan,' I muttered. 'It sounds a bit bleak to me.'

230

I wished we could get off this subject. I was beginning to find it most uncomfortable. How could I lecture Susan about Liam, when I was so mixed up about Charlie? I began to hope that one of us, at least, would begin to show more courage in these matters. Hack some sort of pathway through the love jungle that the other could follow. But somehow this seemed less and less likely. We were getting old, Susan and I. Old and cautious.

'What Liam doesn't know is, if I let myself love him, I'd become a bit like an amoeba,' Susan announced disconcertingly. 'A sort of big blob of longing and loathing. I'd change.'

I had to admit Susan was not painting a very pretty picture. Susan in love was beginning to sound like 'The Creature from the Swamp'.

'Do you know what I think, Susan?' I said. 'I think we both need therapy. Piles and piles of it. Like people in New York.'

'But that's expensive,' Susan looked up at me, half-hopeful.

'Yes, but you haven't tried Teddy,' I smiled. 'Teddy doesn't charge.'

That evening, as Susan was driving away, I looked at the weeds that were growing at the front of our house – springing up between the cracks in the crazy paving. Bruce used to get at them with weed-killer early on, but I left them because I couldn't be bothered. And now I'm glad I didn't interfere because – because some of them have grown little flowers. I like those little flowers very much.

I haven't done much gardening lately – or housework. I've been busy with other things. I've taken on more literacy students and I'm learning how to do aromatherapy massage. Professional massage – not the kind of intimate stuff Al and I got up to on the beach. A lot of people need

231

massage these days, apparently, and you can make quite a good income from it. I've learned this because I've started to have the occasional aromatherapy massage myself. As I lie there, prone and trusting, a strange sympathy suffuses me. For myself. For everyone.

It's funny that I'm studying aromatherapy massage and not Avril. *Avril: The Aromatherapist,* that's what I suggested Bruce should call his film. I said that at that dinner party where he and Cait Carmody kissed in the kitchen. It seems like centuries ago, and not just one year.

Avril: A Woman's Story was televised the other night. I suppose part of me hoped that, considering all we'd been through, Bruce might revamp the storyline slightly. That he might make Avril a little more sassy. A little less dutiful. But Avril, in the main, remained faithful to her original script. The only new characteristic she seemed to have developed was an aversion towards ironing.

Katie and Sarah come to stay here occasionally. Sarah does not use the spare bedroom. My daughter is a lesbian. This has now been confirmed. It would take too long to describe the myriad emotions I felt on this announcement. As I watch them holding hands on the sofa, I feel like I'm in a film and the script's got mixed up. 'No! No!' I want to shout to the director. 'She doesn't have a serious relationship for ages yet, and when she does it's with a fantastically supportive man who isn't in the least bit jealous when she wins the Nobel Prize. She travels all over the world and does all the things I wish I'd done. Eventually she even has two kids – a boy and girl. This bit on the sofa isn't right at all.'

But it is right. It's right for Katie. And who knows – maybe she will travel the world and win the Nobel Prize. 'Nothing has prepared me for this,' I think as I watch them go up to Katie's bedroom, together. But she's happy, and that's all Bruce and I

said we wanted for her. I have to remind myself frequently of this fact.

I understand my mother better now as I sit, as she so often did, munching toast morosely at the kitchen table. It takes time to adjust to things not being like you thought they'd be. It seems to have taken me most of my adult life. But lately I've been realising that wanting things to be different all the time has stopped me from seeing, appreciating, things as they are.

I've been looking at some of the old family photos I saved from the black plastic bags and searching them for clues. Studying the expressions closely I realise my mother may have been happier than I, or indeed she, thought.

She wasn't contented of course. She wasn't ecstatic or over the moon. She was under the moon and it puzzled her. It lured her back and forth between misery and acceptance, like the tides. She wasn't her own witness. She didn't stand back sometimes, from her own still centre, and smile. Or maybe she did – just occasionally. How can one know these things? How can one judge?

'Look, Mum – the moon has a face. It's smiling – it's laughing at us,' I remember saying to her when I was ten.

'Yes, Jasmine, so it is,' she said. 'I wish it would share the joke.'

I thought this was a joke in itself when she said it. I laughed and laughed with the moon, and then I stopped. My mother was crying. I'd made her cry – that's what I'd done. And how could she love me if I made her cry? I didn't look at the moon for a long time after that. I suppose you could say I sulked.

When I got older Mum sometimes used to take me to movies in a nearby town. We'd settle into the velvet red seats contentedly, secure in the knowledge that, for an hour-and-a-half at least, life would have some sort of discernible plot. The films tended to be mushy and none

too memorable. But the ads were great. I especially liked the one for Martini…'the most beautiful taste in the world'. Martini, as far as I could make out, tasted like a huge happy multi-coloured hot air balloon. A balloon that bore its laughing passengers over mountain peaks, drifting deliciously in the benign breeze.

This contrasted pleasantly with my other favourite ad – the one for Badedas which was more home-based yet also held the promise of travel. It was Susan's favourite too.

The ad featured a woman draped decorously in a bath towel. The woman was staring out a window. She wasn't staring out a window in the way I so often do now – half-sullenly – perhaps wondering if it's about to rain. No, this woman was staring expectantly because she'd just had a Badedas bath. Her anticipatory state was a consequence of this. 'Things happen after a Badedas bath,' the ad told us, adding beguilingly…'perhaps it's something to do with the horse chestnuts'.

And sure enough there was a horse outside – a nice white horse with a handsome man beside it. The power of Badedas seemed an incontrovertible fact as my mother and I sat in that cinema.

It was a mistake, perhaps, to buy Badedas myself and test this hypothesis, but I was that kind of teenager. After my bath I'd hang around the bathroom draped in my towel and wait – gazing hopefully out onto the lawn. I did this a number of times with decreasing expectation. Actually something did happen eventually, when I'd ceased to believe in Badedas at all. A bat flew out of the airing cupboard.

Along with many people, I held the mistaken belief that a bat would be almost impossible to dislodge from my hair. I screamed for my mother, who rushed in enthusiastically because she had a fondness for this particular nocturnal mammal. She liked them because their innocent intentions were so often

misunderstood. As I flapped around the bathroom, screeching at her to save my hair from the black creature's clutches, she told me to calm down.

'See – see, Jasmine,' she said. 'It doesn't mean you any harm. Look at its little face. It's as frightened of you as you are of it.'

My mother smiled at me then. A big, broad beaming smile, almost as big as the moon's. This was, for her, a happy moment. My mother loved me. I can see that now.

Did Bruce ever love me? I know he thought he did. We were both too young when we met at that dance. Susan dragged me to it to help me get over Jamie. It turned out Bruce was getting over someone as well. We spent the whole evening talking about these people who no longer loved us. Bewilderment was our bond. It still is in a way. I don't want to hate him any more. I've decided that.

The weeks are going by so fast I almost forgot my forty-first birthday. I've been going out quite a bit – with new friends I've made at my massage course or with Anne and Susan. We go for long walks or to the cinema. Sometimes we just sit and chat and then suddenly decide to go to a restaurant and have a meal. We laugh a lot at nothing very much. I suppose you could say we have fun.

Sometimes I watch myself, out with my friends, single, unattached. 'I can do this,' I think, with some amazement. 'This is all right – this is okay.'

Bruce is getting rather intimate with Alice, his production co-ordinator. They're not living together or anything like that, but they do date. I'm pleased for him in a way. I've always liked Alice, and Bruce needs a relationship more than I do. I used to think he was so emotionally self-sufficient, but he isn't. He said he pretended to be because he thought that's what I expected. We really don't seem to have talked together

very well. It amazes me how little we have learned about each other through the years.

Our marriage would have made a great documentary. One of those ones where camera crews camp in people's houses at periodic intervals and rob them of all dignity. Cait's pregnancy would have had the director salivating. The ratings would have been up there with *I'm A Celebrity, Get Me Out Of Here.*

Cait's baby isn't Bruce's. They did the test the other day. I must say I'm very relieved. It would have got rather complicated – you know – Katie visiting her half-brother and probably getting pally with her father's ex-mistress. Blood ties do force a certain tolerance. I would probably have ended up inviting them all to dinner.

Alice has encouraged Bruce to start painting again. He painted a picture for me for my forty-first birthday. He arrived with it in a fluster of embarrassment and left it, parcelled up in yellow paper, on the kitchen table.

'Can I open it now?' I asked.

'No. No. Wait,' he pleaded. 'I'll know if you don't like it, even if you say you do.' Then he fled like a frightened child.

The painting was of a woman staring up at a huge sky full of stars. The sky I saw that long ago evening in California when I thought what an amazing, magical place the universe was. I told Bruce about that sky, but I didn't think he'd remember it. I don't remember it too well myself now.

I sat for ages staring at that painting. It must have taken Bruce hours to do it. I knew he was trying to say something through it, something that he couldn't say in words. That he cared more than I realised, maybe. That he knew me better than I'd guessed.

'If only he'd done this last year,' I thought. 'The year of the big 40. The birthday he forgot.'

I considered waiting for a while before phoning to thank him. I considered letting him stew in his insecurity. But I found I couldn't. I found I didn't want to. I wanted to free myself from all this resentment I've been feeling. I knew that soon it would start eating away at other things too, if I let it. Resentment is like that, I've discovered. It doesn't know when to stop.

But if I didn't forgive Bruce, could I forgive myself? Forgive myself for not being who I wanted to be. Forgive myself for the fears, the frailties I've been reproving myself about for so long.

You see I once really did believe life could be as magical as that huge Californian sky. I really did. Now I know it isn't. Now I know life is something you try to get through the best way you can. You have to get to know your limitations.

Oh, I can have wonderful, mystical conversations on foreign beaches, but the feeling – the sense of freedom – doesn't last. I have my moments, and I enjoy them, but essentially I'm rather plain. Rather ordinary. It doesn't bother me so much now.

There is something I really wish, though. I wish I could treat love the way my father treated his bees. He saw bee-keeping as a challenge. An assignment. However often he streaked, stung and shrieking, across our lawn, he still trudged intrepidly back towards the hives, after a dab of antihistamine. And he got his honey in the end. He did. It's easy to forget that because the lawn bit was so dramatic.

Still, there's a lot to be said for living alone. I'm even growing to like it in a way. Maybe that's why socks keep

237

going missing. They know we're not supposed to live in pairs.

Susan's just phoned. She bumped into Charlie in town this morning. I should go round and see Charlie, she says. But she won't explain why.

'I don't know if I want to see him,' I reply.

'Just go. You have to – it's very important,' she says urgently.

'Susan – what's…?' But she's hung up. When I try to ring her back the phone's engaged.

I'm really worried now. I hope to God Charlie's all right. What on earth does he need to see me for? Bunty and I race through the twilight towards Bray.

I'm a bundle of nerves by the time I reach Charlie's house. The lights are on and his van is parked outside, so I know he's home. What on earth am I going to say to him? I haven't seen him in ages. My mind is awash with possible predicaments that could have prompted this urgent journey. By the time I reach the front door I'm almost in tears.

There's no answer when I ring the doorbell, but I decide to go in anyway. I rummage around frantically in my bag for Charlie's spare set of keys, but I don't have them with me. Then, for some reason, I decide to go into the garden. And, as I do so, I see Charlie's silhouette. He's standing by the oak tree – a shovel in his hand. He's digging. Every so often he stops and stares into the distance.

'Hello Charlie,' I call out with great relief. He looks round, startled. Then he looks away.

'Doing some gardening?' I say, determined to be friendly. 'Susan said you needed to see me. Why do you need to see me?'

'She phoned you, did she?' His jaw is clenching and unclenching. He looks like he's going to cry. I've never seen Charlie look this way before.

'What is it Charlie?' I approach him gingerly. Fearful now.

Charlie adds the last sods to the patch of earth he's been digging. When he turns towards me I see his eyes are tender and sorrowful.

'He wants to spare me something,' I think. 'What is it he wants to spare me?'

The moon is shining now, casting a strange silvery glow over the garden. The night seems very still. Very quiet. I look around. Rosie's pen is empty.

'Where's Rosie?'

Charlie doesn't answer.

'Where's Rosie?' my voice is raised now. Suspicious. 'Tell me where she is. Where is she?'

He just stands there, looking at me. There are tears in his eyes.

'No – not Rosie,' I feel numb. Disbelieving. 'No – no – not her too. It's not true – is it Charlie?' I'm imploring him now.

Charlie turns away from me and looks down at the soft sods of earth.

I stifle a sob and stare at the empty pen. 'How did it happen?'

'I just came out this morning and found her lying in her pen. The vet said it was probably old age. She was quite old.'

'How old?'

'About twelve.'

'Is that a good age for a pig, Charlie?'

'Yes – it's a ripe old age for a pig.' He tries to smile. He moves towards me, but I back away.

'We'll miss her – won't we, Charlie?' My voice sounds small.

'Yes, we will, Jasmine. Yes, we will.'

'I'm sure lots of people would think it's silly – the way we're going on about her. But she was special. She was unusual.'

'She was our role model.' Charlie smiles again, but I can't smile back at him. We stand there numbly for a while. Too sad to speak. I wonder what Rosie would have done in the circumstances. Scratched herself probably. Rosie liked a good scratch.

Suddenly I feel cold. I'm shivering. Something inside me is curling into a tight ball of pain. I don't know how to do this any more. I don't know how to stand here. To stand this. I know I have to leave. I can't stay here feeling so sad. It's unbearable. I need someone to hold and comfort me. Someone who loves and understands me. Someone I can trust. But how do you trust – how do you? I just don't know.

'Charlie, I'm sorry but I have to go.' I say it softly, between half-sobs.

'Why do you have to go?' The question is gentle, tender.

'Because if I stay here any longer, I think I'll crack open and I don't think you, or anyone else, will be able to put me together.' I look up at him, stricken. 'Charlie, I'm not the person you think you love. You've no idea how frightened I am.'

'I think I do.' He's moving slowly towards me, he's touching my cheek. 'Because I'm frightened too.'

'You are?'

'Of course. I'm frightened you're going to just turn away from me, from us, again. I don't think I could bear it.'

He's standing very still. He's looking at me with such a mixture of pain and hope, I just don't know what to say. And then I know I don't want to say anything. I'm tired. I'm so tired of fighting this. If only I could read the white spaces between his words – if only. But I can't. And suddenly I can't stand this space between us – this black space – so full of doubt and fear. It's become something fearful in itself.

I move towards him, tears coursing down my cheeks, and he wraps me in his arms.

It feels so right, having Charlie's arms around me. He's holding me so close, as if I'm someone precious. There's a sweetness to it, an innocence I always knew would be there. His warmth is warming me deep, deep inside. The pain is easing. We need this, me and Charlie. We fit.

'How have you been?' Charlie studies my face.

'Oh, you know – sort of okay, I suppose. I've been learning how to be alone. It's important to learn that – isn't it Charlie?'

'I suppose so.'

'Rosie didn't mind being alone – did she? I mean, she didn't have any other pigs around.'

'But she had us – she had me.'

'Yes, I suppose you're right. She was quite sociable. She did like company.'

'She certainly did,' Charlie smiles. 'By the way, thank you for that mug you sent me. It's lovely.'

'Oh, – so it arrived.'

'Yes it did. It's great.'

'It wasn't broken?'

'No. No. Not at all.'

'Charlie,' I finger one of the buttons on his shirt. 'Charlie, do you know *Swiss Family Robinson*?'

241

'Yes.'

'Well – they got shipwrecked on an island – didn't they? Washed up with nothing but their broken craft. That's what my marriage has felt like for ages. Like I was on an island. All alone.'

Charlie rubs my back comfortingly.

'But then – you know – *Swiss Family Robinson* – they found they could make a shelter from the broken pieces of their ship, didn't they? Something new. Something different. They didn't cling on to the past, and I mustn't either. You know what I think I've been doing this past year?'

'What?'

'I've been sorting through the debris, Charlie. Just sorting. Searching. It hasn't been easy.'

Charlie opens his mouth to say something – then he hesitates.

'What were you going to say, Charlie?'

'I – I was going to say I've seen you occasionally – at your sitting-room window. You looked a little wistful. I was worried.'

'So it was you!'

'Yes,' he looks a bit embarrassed. 'Sometimes, when I was going to the studio I'd drive by your house. I'd park the van a bit down the road so you wouldn't suspect. I didn't think you'd want me to come in so I stood behind a tree and watched. Only for a minute or two. I hope you don't mind.'

'You watched over me. Just like in the song.'

'Yes, I suppose I did.'

'Thank you.'

'Anytime.' He kisses my eyelash softly.

My eyelash.

I get the feeling Charlie could kiss every part of me with love. The small cowering corners. The Creature from the

Swamp. The feisty lady. The fish with the smile. But he doesn't have to, because – because I realise I'm beginning to rather like them myself. I have to. It's the only way I can love him – letting go of this wish for someone to somehow save me. To show by loving me that I am lovable – deserving. I have to know that anyway. Before him. After him if needs be. Otherwise it just puts too much power in his hands, and I don't think Charlie wants that. It just wouldn't be fair.

'Charlie, you know that song – "Someone to Watch Over Me"?'

'Yes.'

'Well, it's about a woman who says she feels like a lamb who's lost in the woods, isn't it?'

'Those are part of the lyrics – yes.'

'Well, I don't want to be that little lamb any more, Charlie. I've done that.'

'I know.'

'I'm a bit different to what I thought I was. I'm – I'm more spacious somehow, inside.'

'I know.'

'How do you know all this stuff, Charlie?'

'I dunno, I just seem to.'

'I hope I know as much about you.'

'You do – when you want to.'

I look up at the sky. It's inky black now. There are stars and the moon looks very bright.

'Charlie, do you think they're watching over us?'

'Who?'

'The people we loved? The people who have – you know – gone?'

'That's something I don't know, Jasmine,' Charlie wraps me tightly in his arms again. 'I wish I did.'

'I don't think they are,' I sigh. 'I used to think they were. Susan says we even have Guardian Angels guiding us.

Susan says a lot of things like that. But now I think life's over when it's over. Like a marriage. Like love.'

Charlie buries his face in my hair and breathes deeply.

'I'll tell you something that may cheer you up,' he says.

'What?'

'I read somewhere that Mell Nichols is short-sighted. He only wears contact lenses for work. So that day he saw you in that hotel foyer – that day he turned away looking bored. He probably didn't see you at all. So there's still hope, Jasmine.' Charlie squeezes my shoulder reassuringly. 'You and Mell may still be an item.'

'I don't want Mell any more.' The words tumble out before I've thought of them. 'I want you, Charlie. It terrifies me, but I do.'

I feel the earth swaying again, like it did in that earthquake. Any moment now the ground will crack open.

But it doesn't.

'Is it going to stop you – that fear?' Charlie speaks the words slowly. Cautiously.

'I used to think it would. I was sure it would. But now – here – the fear – it feels different.'

'In what way?'

'It feels – and I know this might sound strange – it feels like a more ordinary kind of terror. Nothing that unusual after all.'

Charlie cups my face in his hands and kisses me. A long, deep kiss that's sweet and tender and somehow so familiar. That's full of a bruised kind of happiness and a sweet kind of sorrow.

And then, at the same time, our eyes are drawn upwards. Is it our imagination, or is something odd happening above the old tree? A strange light is playing through its branches. As I look more carefully I seem to be

able to discern…I grip Charlie's arm tightly…could it be?

For there, in the ghostly luminescence are many forms, including faces – faces from the photos I saved from the black plastic bags. I don't know all of them – but I recognise Mum and Dad, Aunt Bobs and Uncle Sammy. They're smiling and their eyes are full of love. A huge and endless kind of love. The kind of love I have only ever hoped for. But now I feel it. I feel it all around me.

And then – could it be – could it? Is that the faint shimmering image of a pink pig with large gossamer wings? Is that Rosie looking down on us from above – her snout quivering with pleasure?

'Charlie is that…are we…?'

'Shhhh, Jasmine,' Charlie says gently, his eyes full of wonderment. 'Let's just believe.'

And he's right – I know it suddenly. I know you can't analyse everything. I've tried that, and it doesn't work. In one moment I could rob this moment of its mystery. Say it was a meteor shower – something prosaic. Proven. I could turn away from Charlie too. But I choose not to as I stand here. I choose to listen to my heart.

The faces are fading now but the stars seem brighter.

'What a truly amazing, magical place the universe is,' I think, in a daze of happiness. I always suspected it somehow. Me. Jasmine Smith. Forty-one, going on fourteen.

I smile at the moon. And she beams calmly back at me. As if to say that what seems so amazing to me now, may one day seem more commonplace. When I've travelled further. When I'm less afraid. More commonplace, but no less precious. Something not outside the law of nature, but deep within it.

Something contradictory in words because it is far beyond them.

Like love itself. An ordinary miracle.

Grace Wynne-Jones was born and brought up in Ireland and has also lived in Africa, the US and England. She has a deep interest in psychology, spirituality and healing and she also loves to celebrate the strangeness and wonders of ordinary life and love. She has frequently been praised for the warm belly-laugh humour and tender poignancy in her writing and has been described as 'a novelist who tells the truth about the human heart'.

Her feature articles have appeared in many magazines and national papers in Ireland and in England and her radio play *Ebb Tide* was broadcast on RTE 1. Her short stories have been published in magazines in Ireland, England and Australia, and have also been broadcast on RTE and BBC Radio 4. She is the author of four critically acclaimed novels: *Ordinary Miracles*, *Wise Follies*, *Ready Or Not?* and *The Truth Club*. She has written and broadcast a number of talks for RTE's 'Living Word' and 'Sunday Miscellany' and has been included in the book 'Sunday Miscellany A Selection From 2004 - 2006' (New Island). She also contributed to the travel book 'Travelling Light' (Tivoli).

Please visit her website for more information:

www.gracewynnejones.com

Also by Grace Wynne-Jones:-

Wise Follies 1905170637 **£6.99**
Why waving goodbye to Mr Wonderful may be the
wisest folly of all...

Ready or Not? 1905170653 **£6.99**
Sometimes you've got to forgive the person you were
to be the person you can be....

The Truth Club 1905170661 **£6.99**
A tender, wry look at families, truth and love.